30 years
of
American
Printmaking

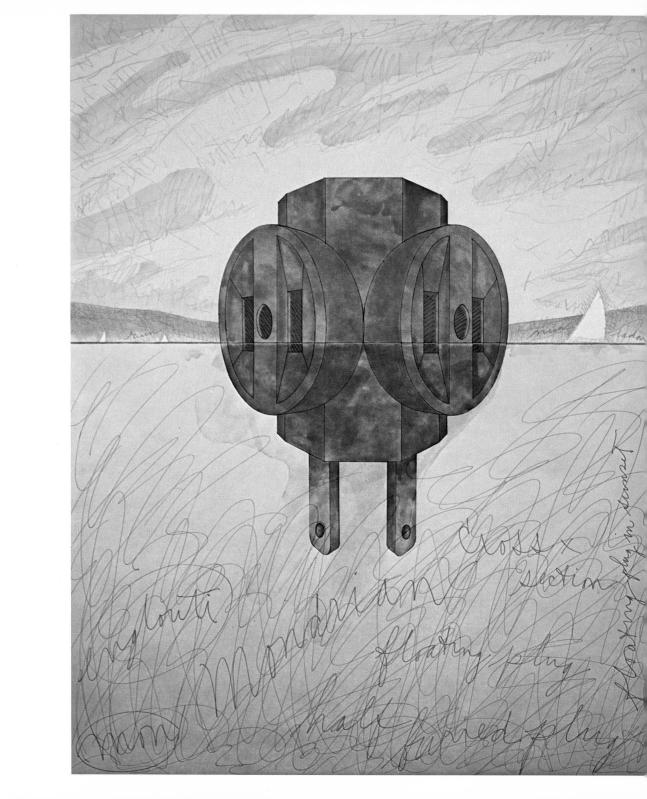

30 years of American Printmaking

INCLUDING

THE 20TH NATIONAL

PRINT EXHIBITION

by Gene Baro

The Brooklyn Museum

Published for the exhibition
30 Years of American Printmaking
The Brooklyn Museum
November 20, 1976–January 30, 1977

*This exhibition was made possible in part through
a grant from the New York State Council on the Arts.*

Designed and published by The Brooklyn Museum,
Division of Publications and Marketing Services,
Eastern Parkway, Brooklyn, New York 11238.
Printed in the USA by the Falcon Press, Philadelphia.

ISBN 0-87273-058-1 (paperback)
ISBN 0-87663-249-5 (clothbound)
Library of Congress Catalog Card Number 76-17486

Available to the Trade only through
Universe Books, 381 Park Avenue South,
New York, New York 10016.

Front cover:
Jim Dine 18☆
(b. Cincinnati, Ohio, 1935)
A Girl and Her Dog No. II 1971
Etching with hand-coloring in
watercolor, 27 x 21½ (34¾ x 28)
Ed: 75
*The Brooklyn Museum, National
Endowment for the Arts and
Bristol-Myers Fund*
Cat no 65

Back cover:
Warrington Colescott 5☆
(b. Oakland, California, 1921)
**A History of Printmaking:
S. W. Hayter
Discovers Viscosity Printing** 1976
Etching, 22 x 28 (25 x 35). Ed: 75
The artist
20th National Print Exhibition selection
Cat no 44

Frontispiece:
Claes Oldenburg 18☆
(b. Stockholm, Sweden, 1929)
Floating Three-Way Plug 1976
Etching and aquatint, 42 x 32¼
(49¾ x 38½). Ed: 60
Multiples, Inc.
20th National Print Exhibition selection
Cat no 217

Foreword

Since 1947 The Brooklyn Museum has surveyed the American print scene through the National Print Exhibition. Although the National began as an annual exhibition, it was not long before it became a biennial affair. The richness of the printmakers' output and the spread of printmaking activity beyond traditional boundaries—both technical and geographic—demanded that more time be devoted to the organization of each National. Under the leadership of Una E. Johnson, The Brooklyn Museum's outstanding Curator of Prints and Drawings from 1937 to 1969, the exhibition flourished. Under the guidance of Jo Miller, Curator from 1969 until 1975, it continued to grow. These two curators established a tradition that has made the National Print Exhibition a standard of excellence. They rejected the notion that the work had to come to them. They were tireless as they traveled the country, meeting with artists, seeking out new works and new ideas. Because of their commitment and sensitivity, they earned the respect of the entire artistic community.

After nineteen Nationals and almost thirty years, it seemed appropriate to further expand the horizons of the exhibition. We have really done two exhibitions. There is the National Print Exhibition, the largest we have ever had. Despite the increase in size, we have not neglected the careful examination of the most current concerns of printmakers. And there is a review of the artists who have been a part of the Nationals since their inception. "30 Years of American Printmaking" is not meant to be an exhaustive historical review. It is decidedly not a reprise of prints that have been seen before. Through the works produced during the past thirty years, some perspective is brought to this explosive period of American printmaking.

While the technical aspects of printmaking are always of interest and contribute importantly to our understanding of the prints themselves, the evaluative process must not stop there. Technique is a tool with which the artist achieves his artistic goals, not an end in and of itself. If we have learned anything about prints in the last few years, it has been to take them seriously as works of art. If "30 Years of American Printmaking" has a bias, it is that technical expertise alone is not enough.

The following individuals were particularly helpful in the preparation of "30 Years of American Printmaking": Brooke Alexander, Rosalie Brautigan, Sylvan Cole, Stephen Foster, Bill Goldstone, Jane Haslem, Colta Ives, Karen McCready, Rory McKeag, Roger E. Ramsay, Albert Stadler, Ellen Sragow, Tony Towle, Francine Tyler, Kenneth Tyler, William van Straaten, and Barry Walker. We are indebted to Gene Baro for the knowledge, commitment, and discerning eye that he brought to this project. His contribution goes beyond "30 Years of American Printmaking." His success has assured the continuation of the National Print Exhibition tradition. And to Una Johnson and Jo Miller go our respect and gratitude for creating something that it is an honor to continue.

Michael Botwinick
Director
The Brooklyn Museum

6

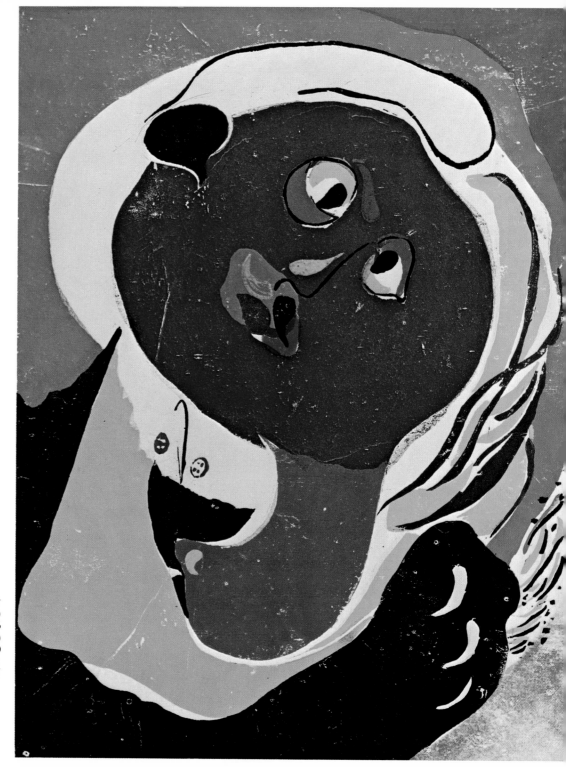

Adja Yunkers 2☆
(b. Riga, Latvia, 1900)
The Big Kiss 1946
Woodcut, 15¾ x 11½ (17⅝ x 13¼)
Ed: 50
The Brooklyn Museum
Cat no 326

Printmaking becomes artistically important when its mediums are used singly or in combination to project visual statements that cannot be made by other means. The quality of the statements, their significance to perception or to our habits of seeing, can raise printmaking from an adroit exploitation of technique—a virtuoso performance—to a high art.

But printmaking didn't begin as art primarily. It began as information made visual or, as in the case of printed fabrics, as applied decoration. In eighth-century China, woodblock prints illustrated Buddhist texts. In the West woodcuts served the purposes of religious and moral instruction. *Ars Moriendi* (*circa* 1465) is a book of instruction to comfort the sick and dying. The German painter Albrecht Dürer (1471–1528) produced two woodcut series based upon Christ's Passion; another, "Apocalypse," based upon the Book of Revelations; and a fourth, "The Life of the Virgin." But all was not solemnity in the world of the woodblock artists. The earliest surviving Western woodcuts are playing cards. During the eighteenth century, Japanese woodcuts celebrated actors and actresses in their admired roles, depicted subjects from folklore, and served as the equivalent of today's picture postcards with their views of famous and attractive places.

Engraving developed from the decorative pursuits of goldsmiths, and while we have come to see the prints of many engravers of the late fifteenth, sixteenth, and early seventeenth centuries as artistically superb, the impulse behind much of their production addressed practicalities. The emphasis both for the artist and for the consumer was often upon subject or content more than upon the skill or inventiveness of delivery.

When the more flexible medium of etching lured artists away from engraving during the seventeenth century, the latter declined to a reproductive art. In 1798 lithography was invented and developed by the German Alois Senefelder (1771–1834) as a means of publishing music cheaply, and this medium has continued to have commercial and informational applications, more now even than when Daumier (1808–79) published his cartoons and Toulouse-Lautrec (1864–1901) his posters. Photo-offset printing, the principal commercial application of lithography, has recently become a tool of artists without, however, declining as the printing trade's and advertising industry's preferred means of color reproduction. Silkscreen printing had only commercial uses before 1938 when a group of New York artists working in the Federal Art Project of the Works Progress Administration experimented with the medium and established its fine art potential.

It's plain to see that the development of printmaking as an art has been inconsistent both within the particular mediums and within the societies where they were practiced. However, it can be seen that each medium had its origin in some practical occupation or came into being as a result of commercial or social need. Artists have understood how the various print mediums could be turned to artistic uses, frequently even while they were at work on a trivial or limiting project. In short, originality of mind and artistic vision have many times transformed the mundane and ordinary into high art. Sometimes, too, commercial printmaking has been perceived by contemporary society or by later generations to have artistic merit. Daumier's cartoons are a case in point. The lithographs of Currier and Ives, popular images that almost literally papered America beginning in the late 1850s, are another. These days we see the artistic merit and the beauty of eighteenth- and nineteenth-century printed botanical illustrations and destroy the books for which they were made so that we may have the pleasure of the images on our walls.

What is clear is that first-class prints, whenever and however they are produced, use particular mediums for their intrinsic structural and expressive characteristics and present ideas or insights bearing upon perception or our way of seeing irrespective of literal content. Printmaking has additional artistic importance when the practitioner is also an innovator and uses or extends printmaking techniques to give a greater range of meaningful effects to the medium.

But there are some periods when, so to speak, printmaking stands still. Etching, for instance, did not "progress" beyond Rembrandt (1606–69), whose versatile use of drypoint circumscribed that particular technique for generations. Whistler (1834–1903) achieved tonalities in lithography that are in a sense absolute. There are techniques, manners, styles of facture that are unlikely to be improved upon. At the same time, printmaking is the art form most susceptible to new technologies. The last thirty years have seen the incorporation into printmaking of many new materials and processes. Both the printmaking field and our conceptions of what constitutes original art have been transformed as a result.

When The Brooklyn Museum launched its 1st National Print Exhibition in 1947, a so-called print renaissance was already under way in the United States. Renaissance was the customary, if excessive, word used to describe what was a moderate increase in printmaking activity among American artists. Printmaking in this country had been stimulated by the Great Depression when government subsidy for the arts became available. The Federal Art Project of the Works Progress Administration had a graphic arts section. Studios and printshops were organized and works of the artists enrolled were exhibited and distributed.

Another stimulus to printmaking was provided by the arrival in America during the 1930s of many artist-refugees from a Europe under Nazi threat. A more sophisticated visual vocabulary was encouraged among some of our own artists by growing familiarity with the work of Max Ernst (1891–1976), André Masson (b. 1896), Max Beckmann (1884–1950), George Grosz (1893–1959), Josef Albers (1888–1976), Lionel Feininger (1871–1956), and others. In 1940 Stanley William Hayter (b. 1901) established Atelier 17 in New York City for the exchange of ideas and technical information about printmaking. Hayter taught a generation of American artists that intaglio processes had virtually limitless potential for artistic expression. Hayter's seriousness and dedication were carried across the country in the persons of the men and women who had worked with him and had taken light from his enthusiasm and expertise. Mauricio Lasansky (b. 1914) at the University of Iowa and Gabor Peterdi (b. 1915) at Yale University embodied the ideal of the artist-educator formed in Hayter's workshop.

For that matter, American artists had printmaking traditions to look to, or if traditions seems too strong a word, then they might look to the example of Whistler, Mary Cassatt (1845–1926), Joseph Pennell (1857–1926), J. Alden Weir (1852–1919), Childe Hassam (1859–1935), Arthur B. Davies (1862–1928), George Bellows, (1882–1925), John Marin (1870–1953), John Sloan (1871–1951), and Edward Hopper (1882–1967).

In 1947 the American printmaking community and the public supporting it were small, certainly by present standards, but not therefore negligible. Even before the inauguration of The Brooklyn Museum's National Print Exhibitions, so ably organized by Curator of Prints and Drawings Una E. Johnson, there were many places in the United States for printmakers to exhibit. Print exhibitions were held regularly at the Library of Congress, the San Francisco Art Association, the Philadelphia Print Club, and the Northwest Printmakers Society. There were numerous smaller organizations that exhibited prints for or by their members.

Perhaps 1947 ought to be regarded as a threshold year. Not only was there the first of The Brooklyn Museum's National Print Exhibitions but also the Museum hosted a retrospective exhibition, "American Printmaking: 1913–1947." Shown were one hundred prints selected by the artist Jean Charlot (b. 1898) under the sponsorship of the American Institute of Graphic Arts in celebration of its forty-fifth anniversary. The two exhibitions together presented an outstanding survey covering more than three decades of American printmaking and bringing knowledge of the field almost up-to-the-minute.

The purpose of the 1st National Print Exhibition was "to recognize and encourage artists who are working in the graphic arts and to stimulate the public interest in fine contemporary printmaking." Any artist working in the United States was eligible to submit up to three prints, which might be in any of the fine print mediums. Works were limited to those executed in the previous year. The jury for this exhibition included, in addition to Miss Johnson, A. Hyatt Mayor, Curator of Prints, The Metropolitan Museum of Art; Elizabeth Mongan, Curator

of Prints, The National Gallery; Hermon More, Curator, The Whitney Museum of American Art; and Bertha von Moschzisker, Director, The Print Club, Philadelphia. This distinguished company was faced with entries from nearly six hundred artists working all over the United States. Two hundred and ten prints were selected and shown. Public and critical response were strongly positive.

This was a time important for American art as a whole. In New York in particular, and especially among painters, there was growing resistance to the dominance of European art—the School of Paris, the Cubists—and to American schools that propounded regionalism or left-leaning social realism. There was the desire for artistic expression on a scale that reflected the American experience, the vastness of the land, the apparently boundless energies released in World War II, the exhilaration of world leadership, the promise of the future. The American artist was beginning to see himself as an ethical instrument, recording where he stood by what he did and how he did it—not by an explicit program or through verbalizing a viewpoint but by fundamental artistic activity. To place a mark on a blank canvas, to load the brush and make the stroke, was to put oneself at risk, to begin to define oneself.

While they didn't function as a group, such artists as Jackson Pollock (1912–56), Clyfford Still (b. 1904), Willem de Kooning (b. 1904), Barnett Newman (1905–70), Mark Rothko (1903–70), Arshile Gorky (1904–48), Franz Kline (1910–62), and others were beginning to change our consciousness of American art. Within a few years the attitudes of these artists and the works they produced changed the way that American art was received in Europe. Cultural influence was flowing back to the Old World.

But the American avant-garde didn't figure in the print exhibitions of 1947. In the print world, just beginning to shake itself loose from academicism and mannerly restraint, the issue was not the ethical nature of the artist but the choice between representation and non-representation, between figuration and abstraction. There was then and for some time afterward among printmakers a concern with literal content. Could works without referential subject matter have meaning? Could art be made from a print medium's typical marks if those marks were not in the service of description but were used, say, solely for emotional and expressive ends?

Resistance to change didn't prevent change, of course, but conservative attitudes persisted and still persist to some degree in the world of American printmaking. And when one looks at the list of artists in that first National Print Exhibition in Brooklyn, one finds many brilliant and accomplished practitioners but no print revolutionaries except for S.W. Hayter (who won a Purchase Award). Hayter was, after all, a rediscoverer and adapter of intaglio, an extender and perfecter of its processes. Boris Margo (b. 1902) brought the technique of cellocut to the exhibition, but this invention of his, so convincing in his hands, has found little favor elsewhere. This can be said, too, of the technical improvements and variant procedures devised by some of the other exhibitors.

With the 2nd National Print Exhibition, The Brooklyn Museum entered into an agreement with The American Federation of Arts to circulate nationally a "large representative selection of prints" from the larger selection made by its jurors. The traveling exhibitions assured a heavy volume of submissions for the following Nationals. There were approximately twelve hundred submissions

for the 3rd, approximately fourteen hundred for the 4th; and while the number of selections varied from year to year, the exhibitions continued to attract entries from six hundred or more artists nationally. Some artists exhibited repeatedly; others disappeared after a single exposure. Artists established in other fields appeared infrequently as printmakers during these early years.

But the nature and aims of printmaking were changing under the influence of the changes that were taking place in American painting. Printmaking was changing, too, because the audience for American art was enlarging steadily and because more Americans aspired to become artists. The traveling print exhibitions themselves, the spread of printmaking to university and college campuses, meant increased activity and a questioning of standards.

In 1955, the year of The Brooklyn Museum's 9th National Print Exhibition, the jury selected only eighty-five prints from a thousand or more entries. The jurors—Miss Johnson, Mauricio Lasansky, and Louis Schanker, artist and teacher at the New School and at Bard College—didn't like what they saw. There was some puzzlement. Writing for the jury, Miss Johnson complained that some of the artists had submitted one representational and one non-representational work, "which merely weakened the individual statement and unfortunately left the jury unimpressed. . . . Professional artists, often well established in the graphic arts field, seemingly did not enter their best work. . . . Artists and students were sending for the jury's consideration their early if not their first efforts in printmaking." The jury simply couldn't find positive statements in much of the material submitted. But the jury was satisfied with what remained. Miss Johnson wrote: "The present Print Annual because of its formidable selectivity is a very

good one." Of the exhibitors, fewer than a handful had established a reputation outside the print field. Nevertheless, it was a time of change.

A year later Miss Johnson was chiding American artists with not being European, "secure within a long and accepted tradition, . . . content to state one thing well." Americans were trying to crowd too much into their compositions, too many ideas, too many forms. "A feeling of serenity and a willingness to make a small but apt observation is not the general attitude of the American artist," Miss Johnson wrote.

The fact is, printmaking was ceasing to be nice, ceasing even to be European-influenced in its notions of refinement and restrictions of subject and scale. As Miss Johnson had pointed out in another publication, American prints had come out of the portfolio and had gone onto the walls where they could be seen along with works of art in other mediums; and the prints had grown even as our paintings and sculptures had grown. Scale, a principal issue in American art, had reached the print field, and color, which had come of age in American painting, was also coming of age in printmaking. These developments required a rethinking of what prints were and what they could be. To some it seemed that prints that vied with paintings might lose their identity as graphics. Others felt that the subtleties of black and white were sufficient to the print mediums and were unfairly and unfortunately neglected for merely fashionable experiments in color printing.

Nevertheless, the momentum of experimentation gathered. America was becoming more sophisticated visually. Americans were traveling more, seeing more. Post-war affluence had brought with it design consciousness. Advertising art was accustoming Americans to crisply executed, attention-

grabbing images, vivid colors, emphatic scale. There was the feeling of a new age of American dominance, and people looked to the future rather than to the past. By the end of the Eisenhower years, there was a yearning among many educated and urban Americans for a bright contemporary culture. The visual arts would be part of it.

The decade of the 1960s saw an unprecedented expansion of the American art market. Not only were Americans buying art as never before but European museums and collectors were becoming active in acquiring American art as a result of post-war economic recovery. In this decade museums that had shunned contemporary art began to buy and exhibit current work. In fact, there was an increase in the number of American museums as universities and colleges established their own and developed teaching collections. Interest in art generated publicity, and publicity generated interest. There was an emphasis on the contemporary that had been almost wholly lacking a few decades earlier.

Printmaking began to flourish in this economic climate. Many painters and sculptors eager to supply a growing following turned to prints as a means of satisfying the market. But satisfaction often resulted in further stimulation. Prints were an easy, attractive and relatively inexpensive way of getting with it. Collectors who could not afford the steeply climbing prices for paintings and sculptures by the contemporary favorites could turn to prints. Corporations found in prints the means to enliven institutional headquarters and office blocks.

The desire for prints in color increased, with consequent boom in serigraphy. Americans traveling to England saw the fine screenprints produced by Christopher Prater's workshop, prints that were soon available in New York and other metropolitan

enters to show American collectors and artists the remarkable range of this medium. Editions Alecto and the Petersberg Press, both London-based organizations, published and brought the prints not only of British but of American artists to these shores—and still do.

An important ingredient in the ebullient print scene was the establishment in Los Angeles of the Tamarind Lithography Workshop. This project was the inspiration of the artist June Wayne (b. 1918), who felt that fine lithography was a dying art in America, owing to the gradual disappearance of master printers. By the late 1950s, lithography was a print medium not prospering but declining. June Wayne discussed the state of American lithography with W. McNeil Lowry, Director of the then newly formed Program in Humanities and the Arts of the Ford Foundation. The discussion resulted in a proposal that envisioned "half a dozen master printers, scattered around the United States, with a cluster of artists revolving around each." The Ford Foundation funded the Tamarind project throughout the decade. In ten years of activity, from July 1960 to June 1970, Tamarind awarded one hundred and three grants to artists, produced lithographs with sixty-six guest artists and funded seventy-one printer trainees. Twenty-nine hundred works were published by Tamarind during the decade.

Tamarind met its goals: it restored the prestige of lithography, stimulated new markets for the lithograph, developed artists into masters of the lithographic medium and accustomed them to work in intimate collaboration with printers, and fostered an experimental spirit. But perhaps Tamarind's most important contribution was the creation of a pool of master printers in the United States. The Hollander Graphic Workshop in New York, Gemini G.E.L. and Cirrus Editions in Los Angeles, the Collectors Press in San Francisco, Landfall Press in Chicago, Tyler Graphics Ltd. in Bedford Village, New York, print workshops at the Nova Scotia College of Art in Halifax, and the Graphicstudio of the University of South Florida in Tampa were all direct outgrowths of Tamarind or involved personnel trained there.

Another important workshop founded a bit before Tamarind and greatly influential since its establishment is that of Tatyana Grosman, Universal Limited Art Editions, West Islip, New York. In this intimate workshop, quality is not so much a credo as a mania. Years are not too long to perfect a project. ULAE established the printmaking careers of Larry Rivers (b. 1923), Robert Rauschenberg (b. 1925), and Jasper Johns (b. 1930). Fritz Glarner (b. 1899) worked at the studio as did Barnett Newman, Jim Dine (b. 1935), and James Rosenquist (b. 1933). More recent projects have involved Robert Motherwell (b. 1915), Claes Oldenburg (b. 1929), and Helen Frankenthaler (b. 1928). The quality of the prints produced in this environment has been outstanding from almost every point of view. The Grosman workshop has avoided the tendency to slickness and impersonality sometimes to be noted in the products of the larger print establishments.

The increased commitment to lithography that developed around 1960 fed the experimental spirit of the times. Innovation in woodcut, while possible and present, was limited to variations of cutting techniques, materials, methods of assembly, materials used to print upon, and choice of inks and inking. Intaglio processes offered a somewhat more fertile field for experimentation, especially when combined with relief printing, as in collagraph, where the artist works with collage elements. The most fruitful area for experimentation very often involved a combination of lithography and screenprinting or of lithography, screenprinting, and another of the print mediums.

New industrial materials were available to printmakers: plastics, metal foils, photosensitive papers, photosensitized fabrics, fluorescent inks, and many more. And there were many technologies evolved or adapted to meet particular printmaking conceptions or simply to solve problems encountered along the way when unusual effects were desired.

Technology that exists will be used. Printmaking has extended itself along lines suggested by a variety of industrial techniques from vacuum forming to metal embossing. But probably the most far-reaching change in printmaking was the acceptance of photomechanical processes as original art. The public began to understand that photographic images, not unlike elements of collage or paints of a particular hue, could be used as tools or materials in the production of an art work. Photomechanical reproduction can be validated in original art when it is not an end in itself, and photographic techniques have given printmakers the means with which to enrich their imagery and to diversify effects of tone and hue.

The Pop Art phenomenon is probably responsible for some of the easy public acceptance of printmaking innovations that relate to industrial and commercial processes. A popular imagery, one taken directly from mass culture, requires or at least benefits from a production analogue. The Pop artists were anti–fine art and therefore showed how manufacturing techniques used in the production of objects for the mass market could be turned to artistic purposes. There was, furthermore, the tendency to cannibalize the successes of the advertising industry and, indeed, some of the artists in question came out of commercial art; Andy Warhol (b. 1931) for instance.

12 A further stimulus to experimentation developed from the sheer competitiveness of the market, from the desire of the public for something new. Some artists, Roy Lichtenstein (b. 1923) for example, developed a grammar of images, techniques, materials, and forms of great consistency—the whole disciplined to a very personal style. When Lichtenstein made prints on Rowlux, they did not read as novelties but as logical extensions, brilliant extrapolations of ideas basic to his artistic personality. Other artists swung this way and that, seeking in gymnastics with the new techniques relief from their lack of ideas.

The print workshops that came into being in the 1960s brought experimentation out of the kitchen and into the lab. These organizations had the financial backing to make possible prints and multiples of great intricacy. Artists were fascinated to have at their beck and call technicians who either knew or could discover how to realize complicated effects or to work with non-standard materials. The amount of capital needed to complete many of these projects might have funded a printmaker for a lifetime during the nineteenth century. Results were sometimes not worth the effort, except financially. Large capitalization meant high prices, which meant in turn that the monied collectors and investors who had been paying top dollar for paintings began to see possibilities in prints.

An unfortunate aspect of the bull market in prints was that it attracted a number of artists who had no real feeling for printmaking. Some of these merely reproduced images from their paintings or sculptures—a kind of advertising art. Others simply turned over the problem of realizing their not very good ideas to the printshop. Eventually the market's vigor was sapped by overproduction and poor pro-

duction. At some moments during the 1960s, it seemed a collector couldn't go wrong. Not much later, there was a supermarket of dubious items for his inexpert selection. As prices went up and print novelties proliferated, so did the anxieties of the wheelers and dealers involved.

But the decade of the 1960s secured the printmaking reputations of some artists. In several instances, these had already established themselves as painters or as sculptors or as both. Jasper Johns, for instance, worked throughout the decade on lithographs, etchings, screenprints, lead reliefs, and embossed papers—not experimentally but in the central tradition of the print mediums, using fully and appropriately the resources of each. Robert Rauschenberg, unlike Johns, committed his energies heavily to print experimentation. He worked meaningfully and creatively with most of the print processes, stretching and extending each to produce complex evocations of emotion through an imagery equally layered and psychologically and socially interrelated. Jim Dine proved an etcher of extraordinary gifts, and James Rosenquist and Claes Oldenburg, in their individual styles, brought a wealth of inventiveness, wit, and technical insight to their considerable output of graphics. Andy Warhol contributed importantly, too, in changing our sense of the scale and content appropriate to prints.

The 1960s saw the emergence or establishment of a number of artists who used mainly the traditional print vocabulary of black and white: Peter Milton (b. 1930), Romas Viesulas (b. 1918), Richard Claude Ziemann (b. 1932), and Arthur Deshaies (b. 1920). The painter Vincent Longo (b. 1923), who is also among the finest etchers and woodcut artists of our time, established his reputation for printmaking during the 1960s.

I am not offering a list so much as a few names to indicate responses in the print mediums that had public and critical appeal. There are many others, but these few already cover a vast territory of sensibility and graphic power.

The Brooklyn Museum's 16th National Print Exhibition reviewed twenty years of American printmaking. This exhibition ran from October 29, 1968, to January 26, 1969, and was Brooklyn's last survey of the decade. It is interesting to note that Lee Bontecou (b. 1931), Alan D'Arcangelo (b. 1930), Paul Jenkins (b. 1923), Jasper Johns, Robert Rauschenberg, and Ernest Trova (b. 1927) all appear for the first time.

Jo Miller succeeded Una Johnson to the curatorship of The Brooklyn Museum's Department of Prints and Drawings and organized the next three National Print Exhibitions along the lines of the original mandate. The Nationals have been a showcase for the new and have afforded an opportunity to compare the new with the established. In her catalogue introduction for the 17th National, Miss Miller noted the persistence of hard-edged prints, the appearance of new realist and figurative styles, experimentation in printing upon plastic, a decline in woodcut, an increase in lithography (one-third of the exhibition). Most important, she noted that younger artists preferred to print their own editions. This is perhaps the single area in which the prints of the 1970s failed to meet the parameters set in the 1960s. Intimate involvement with the printmaking processes is relatively new, as is manipulation of the print after it has come from the press.

In short, the 1970s are seeing the reemergence—sometimes even in print workshops—of a craft-like approach to printmaking. For some artists, the process of printmaking begins with laying or molding

he paper. Dyeing, drawing, stamping, hand-coloring, and sewing are some of the ways in which prints of the 1970s are being altered when they leave the press or at another stage of the printmaking process. These operations are often the reverse of naive and sometimes create elegant and wholly new visual energies to enhance the image.

But this is not to say that workshops languish. They continue to generate and to collaborate in projects requiring ultimate printmaking skills. Yet there are individual artists who seem to be a workshop in themselves, capable of arresting technical feats. Mauricio Lasansky provides an example of this kind of mastery.

The Brooklyn Museum's 20th National Print Exhibition looks back at the previous nineteen, but emphasis is still upon the current scene and upon the individual print of quality. In my selection, I have also attempted to suggest the issues, byways, and avenues that have been important in American printmaking during the past three decades. I have not been able to present the work of every artist of merit, or even of importance—far from it. I have been more concerned with tendencies and alternatives than with evenhandedness. But any person's version of a large field is necessarily an interpretation. What seems clearest is the extraordinary vigor of American printmaking at the present time. I have examined thousands upon thousands of prints all over the country and have the impression of skillful printmakers everywhere.

But widespread technical excellence does not insure a genuinely creative scene. I saw many prints that were exquisitely made but empty. Of course, it must be understood that a huge market exists for what might be called decorator prints. Many printmakers spend their skills upon this market and have perhaps forgotten struggles of the artistic kind.

What I can applaud is the apparent destruction of the fallacy, promoted by formalist criticism, that printmaking is a second-class art. Rembrandt and Goya didn't think so. It's fine to see painters and sculptors of seriousness and capability expressing themselves in print mediums. This involvement, which became obvious during the 1960s, persists and grows in the present decade. It is good, too, to discover individualists, themselves brilliant technicians, who bring sound artistic insight to their work in the print field. Finally, it is heartening to see that contemporary printmaking is not a phenomenon solely of New York or Los Angeles, and certainly not of the workshops alone, but of many individuals all over this nation, graphic artists who have qualities that would command widespread respect and admiration were they better known.

Gene Baro

14

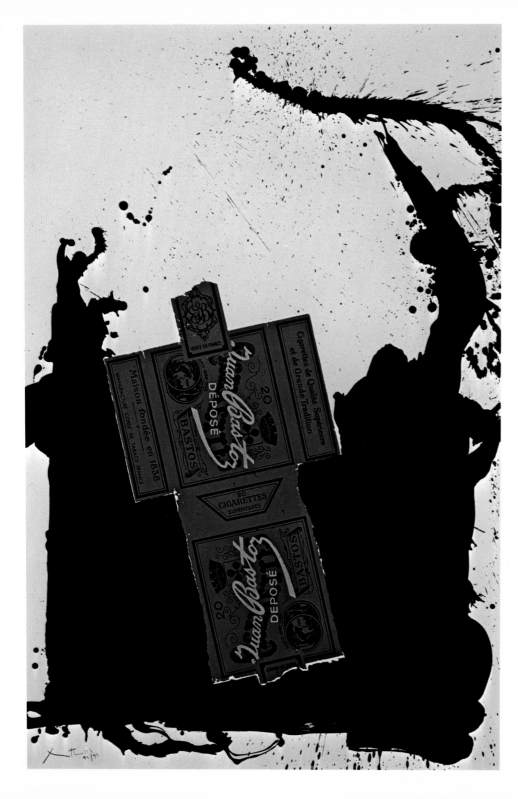

Robert Motherwell 15☆
(b. Aberdeen,
Washington, 1915)
Bastos 1975
Lithograph,
62⅜ x 40 (62⅜ x 40)
Ed: 49
Tyler Graphics Ltd.
20th National Print
Exhibition selection
Cat no 198

Catalogue

Note: ☆ indicates the first National Print Exhibition in which the artist's work was shown. Dimensions are in inches; height precedes width and, where applicable, a third figure indicates depth. The first set of dimensions given = image size. Dimensions in parentheses = sheet size. The collection is given in italics.

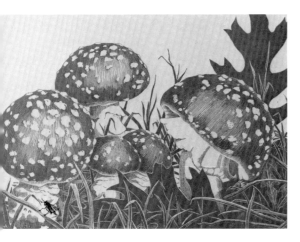

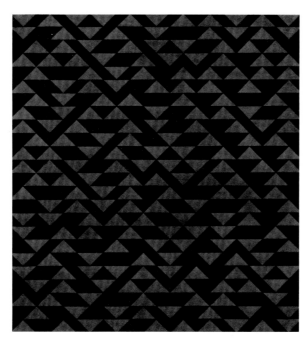

Grace A. Albee 1☆
(b. Scituate, Rhode Island, 1890)
Fly Agaric 1973
Wood engraving, 6 x 8 (8⅝ x 10⅝)
Ed: 25
The artist
20th National Print Exhibition selection

Albee began making wood engravings in the second decade of the century. Her characteristic delicacy and precision are abundantly evident in *Fly Agaric*. In this print the cutting is both descriptive and decorative. The flat silhouettes of the oak leaves are a foil to the linear energies of the grasses. Line and edge set off the domes of the poisonous fungus. The artist has not worked the top of the print; the foreground grouping is entirely the focus of attention, as if we were viewing at close range things normally seen at a distance. But if the objects seem large, scale is true and thus a believable space is created. The image of the fly is stamped on the print.

2
Anni Albers
(b. Berlin, Germany, 1899)
Triangulated Intaglio V 1976
Intaglio and aquatint, 12 x 11
(24 x 20). Ed: 20
Tyler Graphics Ltd.
20th National Print Exhibition selection

Anni Albers, widow of Josef Albers, has proved herself an expressive and elegant printmaker whenever she has taken to the press. Her output has been small. Particularly welcome, therefore, is a new series of etchings and aquatints realized at Tyler Graphics Ltd. between May 1975 and March 1976. Triangulated segments of grid units have been used to create light-inflected surfaces of varying saturation and density. *Triangulated Intaglio V* is an original drawn color aquatint printed in blue and black inks from two copper plates. This print involves more vigorous movements of the connected subunits and a more substantial play of positive and negative than the insubstantial, lacelike *Triangulated Intaglio I*. Plate preparation, processing, proofing, and hand-printing of the edition were by Betty Fiske.

3
Josef Albers 3☆
(b. Bottrop, Germany, 1888;
d. New Haven, Connecticut, 1976)
Gray Instrumentation Ie 1974
Silkscreen, 11 x 11 (19 x 19). Ed: 36
Tyler Graphics Ltd.
20th National Print Exhibition selection

Albers made two suites of silkscreens under the title "Gray Instrumentation" in 1974. The first had eight images, the second twelve. Both suites were printed on Arches 88 mold-made paper. *Gray Instrumentation Ie* was hand-printed from direct photo transfer film screens. It is a three-color silkscreen prepared, proofed, and printed by Master Printer Kenneth Tyler assisted by Charles Hanley. *Gray Instrumentation IIf* was hand-printed from hand-cut film screens. For both suites, Albers directed the mixing of each opaque mat color, which in the printing sequence was fitted side by side. Printing of both editions was at Tyler Graphics Ltd., Bedford Village, New York.

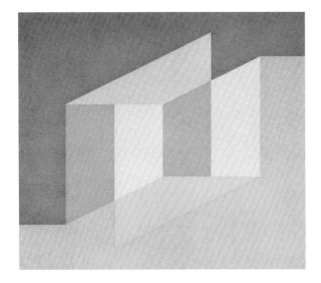

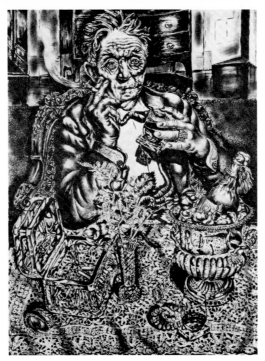

4
Josef Albers 3☆
(b. Bottrop, Germany, 1888;
d. New Haven, Connecticut, 1976)
Never Before f 1976
Silkscreen, 11 x 12 (19 x 20). Ed: 36
Tyler Graphics Ltd.
20th National Print Exhibition selection

Albers's "Never Before" series was his last print project.
He died while it was still in progress. This print is a
five-color silkscreen hand-printed from hand-cut filmed
screens. Albers directed the mixing of each opaque mat
color, which in the printing sequence was fitted side by
side—registered side by side, not by overlay. This registra-
tion technique achieves a flattened surface. The series was
printed at Tyler Graphics Ltd., Bedford Village, New
York.

5
Ivan Le Lorraine Albright 3☆
(b. Chicago, Illinois, 1897)
Self-Portrait at 55 Division Street 1947
Lithograph, 14⅛ x 10⅛ (16⅛ x 11⅝)
Ed: 250
The Brooklyn Museum,
Dick S. Ramsay Fund

Albright's famous self-portrait is a tour de force of
draughtsmanship, but also shows his extraordinary under-
standing of the resources of the lithographic medium. He
has used a full range of tones together with an intricate
patterning of black and white that imparts a flickering life
to his tabletop and its objects. This visual energy is played
against slower rhythms in the composition and is in con-
trast to the tensions developed in table, figure, and chair.
Albright's head, strongly modeled, is in effect the apex of
the pyramid. *Self-Portrait at 55 Division Street* won a Pur-
chase Award at the 3rd National Print Exhibition.

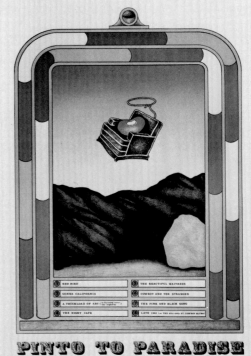

left

Ripley F. Albright
(b. Long Beach, California, 1951)
Coffee by the Pool 1975
Lithograph with hand-coloring, 20 x 24 (22 x 26). Ed: 8
Impressions Workshop Inc.
20th National Print Exhibition selection

Albright describes his lithographs as "a kind of visual diary which displays . . . personal reactions." He takes his themes from common life, but he wishes to transform them through a vocabulary of composition, color, and technique. His interest is to create a two-dimensional paradigm of his three-dimensional experience. He flattens his space, perhaps stretching or warping it in a way that will guide the viewer to a new perception of the pictorial element. Albright has a personal sense of color, refined and lyrical, that gives depth to the subject—the sense of something meditated. His prints are actions sustained in memory, with all the curious shifts that memory—gentle memory—might suggest. *Coffee by the Pool* was printed by the artist on Arches Cover paper in four press runs. Albright then added hand-coloring.

7 *not illustrated*

Ripley F. Albright
(b. Long Beach, California, 1951)
Merely Reflected 1976
Lithograph with hand-coloring, 20 x 25 (22 x 27). Ed: 10
Impressions Workshop Inc.
20th National Print Exhibition selection

Albright tends to leave characteristic touches of the lithographic medium in his prints. There is no striving after immaculate finish. Curiously enough, this apparent casualness conforms to the lyricism and romantic quality of the pieces. *Merely Reflected,* with its Japanese images and indicative drawing, has a mirror full of ink stains that seem exactly right. They might be any magical thing: bubbles of a stream or sprays of flowers. Albright printed this lithograph on Arches Cover paper in four press runs.

8 *left*

Terry Allen
(b. Wichita, Kansas, 1943)
Pinto to Paradise 1970
Lithograph, 24¾ x 17 (29 x 22½). Ed: 50
Cirrus Editions Ltd.
20th National Print Exhibition selection

Allen is a multimedia artist. He has written books, made recordings, created environments, worked in video, given theater and concert performances, and made prints. The titles of Allen's prints often refer to songs and performances associated with him. *Pinto to Paradise,* an eight-color lithograph, celebrates the well-known bean. The print has a dual character: narrative and emblematic. Cirrus Editions Ltd., Los Angeles, is co-publisher. The artist has also worked with Landfall Press, Chicago.

9 *above*

Jane Aman
(b. Bon Air, Virginia, 1943)
Untitled 1975
Serigraph, 5½ x 20½ (12 x 22)
Ed: unique
ADI Gallery
20th National Print Exhibition selection

Aman was the first woman hired as a professional printer by Cirrus Editions Ltd., Los Angeles. More important, she is an unusually gifted artist in the serigraphic medium. Her untitled print of 1975 projects atmospheric overlays of color that create ambiguous space and mood in her landscape image. The quality of the printing, the work of the artist, is outstanding.

10 *below*

Garo Antreasian 3☆
(b. Indianapolis, Indiana, 1922)
View 1959
Lithograph, 26 x 34 (28 x 35½). Ed: 15
The Brooklyn Museum,
Dick S. Ramsay Fund

Antreasian has been one of the movers and shakers of American printmaking. *View* won a Purchase Award at The Brooklyn Museum's 12th National Print Exhibition in 1960. This lithograph in color was worked from one stone, which the artist used over and over again with little grinding. A process of progressive proofing involved both additions and deletions. Antreasian considered the work and the work method "expressionistic, romantic." *View* is of no special place.

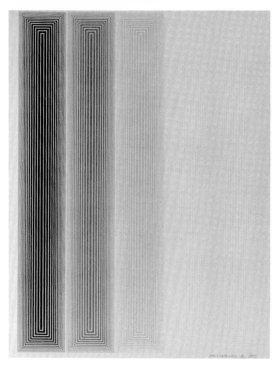

11
Richard Anuszkiewicz 16☆
(b. Erie, Pennsylvania, 1930)
Largo 1973
Lithograph, 29 x 20¼ (30¼ x 22½)
Ed: 50
The artist
20th National Print Exhibition selection

Anuszkiewicz's work both as painter and printmaker has moved steadily away from the optical manipulations with which he first made his reputation and into the serious investigation of color. Among the notable color statements he has made in recent years is a suite of five lithographs printed at the University of South Florida Graphicstudio, Tampa. *Largo* is one of these prints and shows the virtuosity of the medium as well as of the artist and Master Printer Theo Wujcik, with whom Anuszkiewicz had a happy collaboration. The opalescent hues of this lithograph have a fineness seldom seen in lithography. *Largo* was printed from five aluminum plates in yellow, orange, pink, purple, and blue. The execution was by photographic process from hand-cut Amberlith. The edition was printed on Arches Cover paper (buff).

12 *left*
Richard Anuszkiewicz 16☆
(b. Erie, Pennsylvania, 1930)
Soft Lime 1976
Photo silkscreen, 34¼ x 46
(36¾ x 48½). Ed: 100
The artist
20th National Print Exhibition selection

Anuszkiewicz's *Soft Lime* reflects, but does not imitate, preoccupations to be found in his recent paintings. The print is a photo silkscreen printed in eight colors from eight screens on Lenox paper at the New York Institute of Technology.

13 *bottom, left*
Arakawa 19☆
(b. Tokyo, Japan, 1936)
and/or in profile 1975
Lithograph and silkscreen with embossing, 31 x 42⅜ (31 x 42⅜)
Ed: 60
Multiples, Inc.
20th National Print Exhibition selection

Arakawa is a printmaker so gifted that his prints match his original conceptions despite formidable complications of process. The subtle, lovely color of *and/or in profile* was not the result of a happy accident or even a series of them. Control is everywhere evident. This is a thirty-four color print from six aluminum plates, two silkscreens, and three embossing plates, all hand-printed on Rives Roll Stock at Styria Studio, New York.

14 *right*
Milton Avery 3☆
(b. Altmar, New York, 1893;
d. New York, New York, 1965)
Nude with Long Torso 1948
Drypoint, 5⅞ x 14⅞ (13 x 16½). Ed: 100
Associated American Artists
20th National Print Exhibition selection

Avery made thirty drypoints between 1933 and 1950. Some of them reflected concerns familiar in his paintings and were fully composed, utilizing the entire sheet. Others were images isolated on the page, though sensitively placed. In *Nude with Long Torso,* the artist has treated the figure as if it were elements of the landscape. The simplified, stretched form extends between the right and left edges of the paper. The image is complete and is formally the most reduced of Avery's drypoints. This print was one of five drypoints published as "Laurals Portfolio No. 4" in 1948. Printing of the drypoints was by S.W. Hayter at Atelier 17, New York.

15 *below*
Milton Avery 3☆
(b. Altmar, New York, 1893;
d. New York, New York, 1965)
Sailboat 1954
Woodcut, 7⅝ x 12¼ (12 x 18¼). Ed: 25
Associated American Artists
20th National Print Exhibition selection

Avery began to make woodcuts in 1952. At first he received some help from Steve Pace, who showed him the technique and printed his first edition. Later Avery did his own printing, sometimes assisted by his wife or daughter. The woodcuts are more fanciful in subject matter than Avery's drypoints or lithographs. They are also the most painterly of his graphics. *Sailboat* is one of the most complex and expressive of Avery's woodcut images. The work was printed in black.

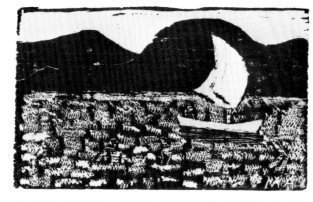

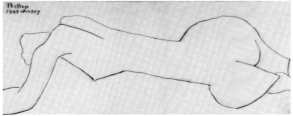

16 *above*
Will Barnet 1☆
(b. Beverly, Massachusetts, 1911)
Singular Image 1964
Woodcut, 32½ x 22 (37 x 25). Ed: 12
The Brooklyn Museum,
Dick S. Ramsay Fund

In a long career as a painter and printmaker, Barnet has gone in style from a kind of folk-like figuration to abstraction, then to figuration again, though in a restrained mode that combines clear low-keyed color with simply drawn forms. *Singular Image* belongs to the middle period, which, with its predecessor, had a vigor not to be found in the artist's more recent work. Barnet's woodcuts are usually developed from preliminary color studies and sketches. A drawing is then made that is the actual size of the woodcut. The image is rubbed onto the key block and transferred to other blocks as may be necessary. Barnet uses a woodcut knife, u-shaped gouge, and chisel to cut a knotless pine plank. He prints with Siebold litho ink mixed with transparent base to reduce opacity. Individual blocks are inked separately. Printing is done with a baren or large tablespoon on Japanese paper of medium to heavy weight. *Singular Image* had a model in a painting by Barnet of the same name and configuration.

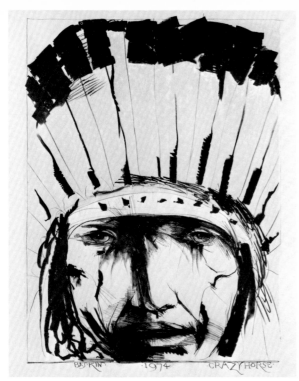

17 *left*
Leonard Baskin 2☆
(b. New Brunswick, New Jersey, 1922)
Crazy Horse 1974
Lithograph, 35 x 24⅝ (41½ x 29¾)
Ed: 100
Fox Graphic Editions Ltd.
20th National Print Exhibition selection

Baskin, a sculptor and prolific printmaker for more than thirty years, has worked with popular success in all the major print mediums. His bold, sketch-like woodcuts in particular have enjoyed public favor. A subtler and more complex aspect of Baskin's printmaking activity is to be seen in some of his recent lithographs (such as *Crazy Horse*), where presswork is fundamental to the concept. *Crazy Horse* was printed from stone in eleven Hanco inks and in Senefelder black on Arches paper. There were ten press runs. All prints were hand-pulled. Herb Fox was the Master Printer.

18 *bottom, left*
Leonard Baskin 2☆
(b. New Brunswick, New Jersey, 1922)
Eve 1976
Lithograph, 35 x 21¼ (41½ x 29½)
Ed: 100
Fox Graphic Editions Ltd.
20th National Print Exhibition selection

Eve, a three-color lithograph printed successively in yellow, orange, and peach, seems a model of effective economy for Baskin. His exuberant draughtsmanship is in check. The overlays of color contribute greatly to the structure of the figure and also create the mood of the print. *Eve* was printed from stone in Hanco inks on Arches paper. Herb Fox was the Master Printer.

19 *right*
Jack Beal 17☆
(b. Richmond, Virginia, 1931)
Self-Portrait 1974
Lithograph, 27 x 20½ (30 x 22½)
Ed: 52
Brooke Alexander, Inc.
20th National Print Exhibition selection

Beal has been counted as a realist in a number of important exhibitions over the past decade, perhaps because of his interest in representation. This strongly expressive self-portrait suggests a direct appeal to feeling: the upward look imposed upon the viewer; the jutting angle of the sitter's head; the downward, hooded gaze of the eyes; the whole figure framed against the grid of the studio skylight are elements of drama, though no doubt true to the studio situation. The merit of the piece as a lithograph—in distinction to its merit as a drawing—is mainly in the sensitive and expert use of translucent tones as a foil to the velvety blacks of lithographic ink.

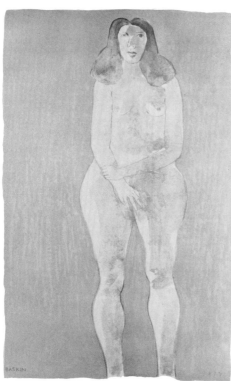

20 *right*
David Becker
(b. Milwaukee, Wisconsin, 1937)
A Tremble in the Air 1971
Etching and engraving, 17¾ x 24
(20¼ x 27¾). Ed: 75
The artist
20th National Print Exhibition selection

Becker's strange and memorable images ar developed from drawings made throug liquid hard ground on copper plates that ar then etched. In the final states, engraving i used for reinforcement of forms and to nalities. Work goes slowly, evolving as if b internal dictation. Becker takes at least year from the start of drawing to the fina proofing of a plate. *A Tremble in the Air* wa printed by the artist.

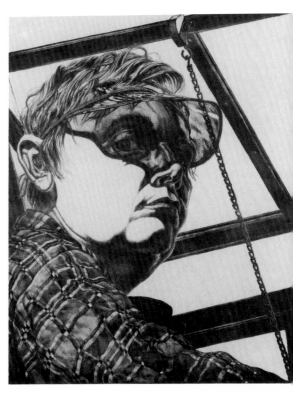

21 *top, right*
David Becker
(b. Milwaukee, Wisconsin, 1937)
In a Dark Time 1973
Etching and engraving, 15½ x 23½
(22⅛ x 30). Ed: 100
The artist
20th National Print Exhibition selection

Becker regards etching as an enrichment of drawing. The plate seems to invite or even to require elaboration. It may be that working on metal leads the artist to a closer concern with the marking systems that can carry his visualization through the acid and graver into ink. Where the issue is the directly drawn line, the tool itself supports and even sometimes dictates the stylistic idiom. With etching, and particularly with etching in a tradition of essentially conventional figuration, it is the image that suggests the system to be used. *In a Dark Time* is Becker's most admired plate. Printing was by the artist.

22 *right*
David Becker
(b. Milwaukee, Wisconsin, 1937)
Union Grove Picnic 1975
Etching and engraving, 17½ x 23⅝
(22¼ x 29⅞). Ed: 125
The artist
20th National Print Exhibition selection

Becker's *Union Grove Picnic* sets up a rhythm of white forms within the densely etched grove. This is a departure from his earlier prints, which are much more closely unified tonally and which open into space that is either explicit or implied. There is also less concern in this print with adjusting tone to a readable light source; there is less modeling and more purely linear contour. This leads to a simplification, like the use of roulette in the middle foreground. Printing was by the artist.

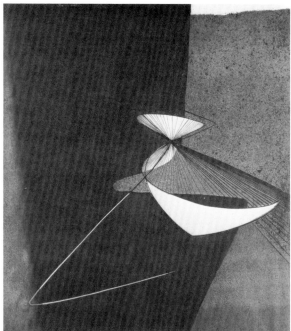

23
Fred Becker 1☆
(b. Oakland, California, 1913)
Inferno 1946
Etching and engraving, 7 ½ x 6 ⅛
(13 x 11). Ed: 5
The Brooklyn Museum

Becker's *Inferno* won a Purchase Award at The Brooklyn Museum's 1st National Print Exhibition. The image was developed on one copper plate by deep etching with some engraving. Color was first surface rolled, then further colors were applied with stencils. The print was created as an overall pattern. Becker worked with S.W. Hayter at the New School, at his New York workshop, and in the late 1950s at his workshop in Paris.

24
W. Roloff Beny 2☆
(b. Medicine Hat, Alberta, Canada, 1924)
A Time of War and a Time of Peace 1947
Etching, aquatint, lithography, and engraving, 14 x 11¾ (17¼ x 13)
Ed: 15
The Brooklyn Museum

Beny, who has achieved an international reputation as a photographer, was an arriving painter and printmaker in his youth. He came to this country on a scholarship to the State University of Iowa where, working under Mauricio Lasansky, he received an M.A. and an M.F.A. *A Time of War and a Time of Peace* won a Purchase Award at The Brooklyn Museum's 2nd National Print Exhibition. It is one of a set of six prints based on Ecclesiastes 3. The suite was presented by the prestigious E. Weyhe Gallery, and The Brooklyn Museum was among the first to buy the set. Beny's technical and imaginative gifts and the masculine elegance of his imagery must have seemed to promise well for his artistic future. He was represented once again at The Brooklyn Museum in the 7th National Print Exhibition.

25
Marc R. Bjorklund
(b. Seattle, Washington, 1949)
Void V/VI 1975
Etching and serigraph with hand-coloring
15 x 22 (15 x 22). Ed: 15
The artist
20th National Print Exhibition selection

Bjorklund's print is in two parts. An image was etched through hard ground on a zinc plate, printed once in black and color serigraphed on a frosted acetate overlay, with the color blended by the artist on the screen. The acetate is hand-cut. Bjorklund printed his own work.

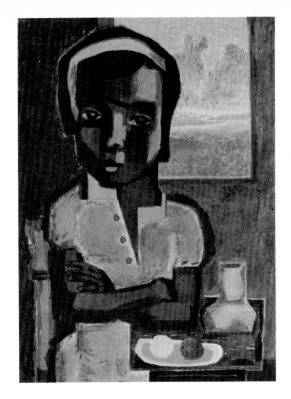

27
Nancy Anna Bonior
(b. Detroit, Michigan, 1947)
Effacement 1974
Intaglio and etching, 15 x 14⅜
(19½ x 18½). Ed: 4
The artist
20th National Print Exhibition selection

Bonior's prints are not so much images pressed on paper as amalgams in which ink and paper quality are inseparable from image. Her work is apt to be intimate and low-keyed. In *Effacement,* the inflections of surface—the delicate intaglio played against the properties of the paper—are important to follow. Printing was by the artist.

28
Dorr Bothwell 2☆
(b. San Francisco, California, 1902)
Memory Machine 1947
Serigraph, 9⅛ x 12⅛ (12⅜ x 17)
Ed: 35
The Brooklyn Museum

Bothwell's *Memory Machine* won a Purchase Award at The Brooklyn Museum's 2nd National Print Exhibition. This artist was much concerned with matters of human psychology (later in her career she was stimulated by the idea of subliminal communication). Her serigraph, with its machine reminiscent of a human heart and its other quasi-literary or narrative references, suggests a familiarity with surrealist idioms.

26 *above*
Robert Blackburn 1☆
(b. Summit, New Jersey, 1920)
Girl in Red 1950
Lithograph, 18 x 12⅝ (23¼ x 15¾)
Ed: unique
The Brooklyn Museum

Blackburn's *Girl in Red* won a Purchase Award at The Brooklyn Museum's 5th National Print Exhibition. With this image the artist was trying to join his social realist background with his awareness of the influences of the modern French school. Blackburn later left configuration for abstract art. He is presently director of the Printmaking Workshop, Inc., New York, an organization that makes facilities available to creative artists. *Girl in Red* was printed from five stones by the artist.

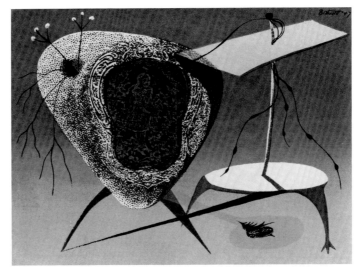

29 *not illustrated*
Elaine Breiger 17☆
(b. Springfield, Massachusetts, 1938)
Homage to Ben Cunningham III 1975
Etching, 17¾ x 31½ (26¾ x 40)
Ed: 20
Pace Editions Inc.
20th National Print Exhibition selection

Breiger's series in homage to artist Ben Cunningham is a triumph of superimposed printing of multiple plates. She has succeeded in building up layered colors, opaque, translucent, and transparent. The interplay of hues and tones creates an illusion of deep space, but also of vibrant light. In *Homage to Ben Cunningham III,* it's as if we look through mountain declivities toward a morning sky. Of course, there are no explicit natural references in these prints, but the sensation they give is of forms in nature.

30 *illustrated in color on facing page*
Elaine Breiger 17☆
(b. Springfield, Massachusetts, 1938)
Homage to Ben Cunningham VII 1975
Etching, 20 x 33½ (30½ x 42). Ed: 20
Pace Editions Inc.
20th National Print Exhibition selection

Breiger's series, "Homage to Ben Cunningham," involves the superimposition and multilayered printing of etched plates. Each print comprises between forty-five and fifty assembled metal plates (sections of metal), which passed through the press five times. Inking was both by surface rolling and intaglio.

31
Robert Broner 5☆
(b. Detroit, Michigan, 1922)
Quarry 1962
Etching and aquatint, 17¾ x 17¾
(22⅜ x 20). Ed: 25
The Brooklyn Museum

Broner studied painting with Stuart Davis and spent three years with S. W. Hayter at Atelier 17. At one time, he served as art critic for the Detroit *Times. Quarry* won a Purchase Award at The Brooklyn Museum's 14th National Print Exhibition. The etching was bitten deeply and both fine and coarse aquatint were applied before printing in color.

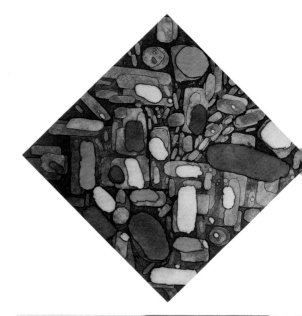

32
James Brooks
(b. St. Louis, Missouri, 1906)
The Springs 1971
Lithograph, 30 x 22 (30 x 22). Ed: 120
The Brooklyn Museum,
Gift of Mr. and Mrs. Samuel Dorsky

Brooks was a figurative artist and a noted muralist before he was persuaded by the Abstract Expressionist idiom in the late 1940s. After a while he developed the practice of painting on paper that had been joined to canvas by black paste. The paste would show through the paper irregularly, stimulating the artist to free composition. Brooks's painting practice has changed, but his lithographs still seem sometimes to reconcile their darker hues— particularly their blacks—even though these colors may be the last to go on. *The Springs* is typical of the artist's bold but controlled graphic language.

33
Ray Brown 9☆
(b. Los Angeles, California, 1933)
Figure in the Air *circa* 1955
Etching, aquatint, and engraving,
27¼ x 17¾ (29 x 21). Ed: 30
The Brooklyn Museum,
Dick S. Ramsay Fund

Brown's *Figure in the Air* won a Purchase Award at The
Brooklyn Museum's 9th National Print Exhibition. The
print is a line etching with soft ground etching, aquatint,
and engraving. The artist has described the subject as
"involved with memory and association, fragments of
thoughts that are represented by fragments of different
levels of abstraction and illusion." Brown is a painter and
sculptor as well as a printmaker.

34
David Capobianco
(b. St. Louis, Missouri, 1928)
B.A.L.L.& S. 1976
Lithograph and serigraph, 29½ x 30
(29½ x 30). Ed: 50
The artist
20th National Print Exhibition selection

Capobianco's use of mixed lithographic and serigraphic
techniques has produced an interesting quality of surface
and color. The hues seem intense yet mat; there is a
dreamlike clarity of modeling, as if the image were both
farther away and clearer than seems reasonable to expect.
The artist was the printer, assisted by Elfie Schuselka.

35
Jon Carsman
(b. Wilkes Barre, Pennsylvania, 1944)
Asbury Reflections 1976
Silkscreen, 27½ x 33 (31½ x 37)
Ed: 100
The artist
20th National Print Exhibition selection

Carsman is a painter who wishes to find in printmaking
the same qualities of light as those articulated in his can-
vases. He is not reproducing paintings, but finding equiva-
lences and similarities through print disciplines, which
impose different orders of creation to those that are natural
to painting. *Asbury Reflections* is a fifteen-color silkscreen
in which all acetate plates were hand-painted by the artist
and then shot onto screens. The inks are Advance fast
drying enamels; the paper Rives BFK. The printer was
Marie Dormuth.

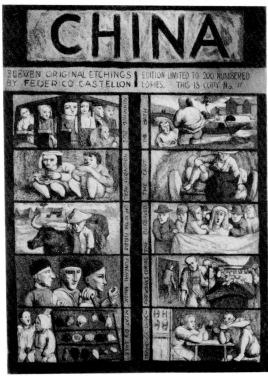

36
Federico Castellon 1☆
(b. Almeria, Spain, 1914;
d. New York, New York 1971)
Title page from the portfolio China
circa 1946
Etching 13¾ x 9⅝ (15 x 12½). Ed: 200
The Brooklyn Museum,
Gift of Leon Pomerance

Castellon was a self-taught artist whose exceptional draughtsmanship and feeling for lithography and intaglio work made him one of the important printmakers of the 1940s, '50s, and '60s. *Kunming Bus* from "China," a portfolio of eleven etchings, won a Purchase Award at The Brooklyn Museum's 1st National Print Exhibition. The title page of that portfolio records its images.

37
Federico Castellon 1☆
(b. Almeria, Spain, 1914;
d. New York, New York, 1971)
Roman Urchins 1953
Etching, 15½ x 11⅞ (20 x 14). Ed: 200
The Brooklyn Museum

Castellon was stimulated by a trip to Italy and made a great number of plates based upon his experiences there. *Roman Urchins,* one of these prints, shows the artist's fluency in the etching medium.

38 *not illustrated*
Vija Celmins 14☆
(b. Riga, Latvia, 1939)
Untitled 1971
Lithograph, 20⅞ x 27½ (22⅜ x 29)
Ed: 65
The Brooklyn Museum,
Gift of Mr. and Mrs. Robert Poster

Celmins's untitled lithograph of 1971 develops from her expert draughtsmanship. The idiom of the print has become familiar, a surface with rock- and stone-like objects stretching to the horizon (see Tchah-Sup Kim's *Between Infinities V* or Jim Nawara's *Deadwood*). Of particular interest in Celmins's print is the disposition of light, which makes a path through the rubble.

39
Vija Celmins 14☆
(b. Riga, Latvia, 1939)
Untitled 1975
Lithograph, 12 x 16½ (17½ x 20¼)
Ed: 75
Cirrus Editions Ltd.
20th National Print Exhibition selection

Celmins's five-color lithograph, one of a portfolio of four originals, was printed by Lloyd Baggs from three plates and two stones on white Twinrocker handmade rag paper at Cirrus Editions, Los Angeles. The first plate was printed gray; the first stone was printed black; a second stone was printed black and stone neutral; the second plate was printed transparent black; and the final plate was printed transparent blue-gray. The print has intriguing luminosity.

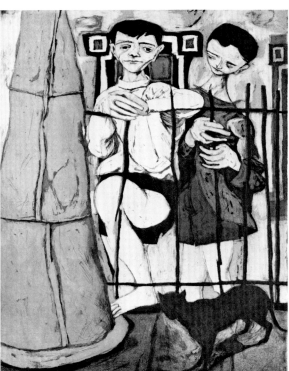

40
Lee Chesney 2☆
(b. Washington, D.C., 1920)
Engraving 1952 1952
Engraving, 10⅞ x 17⅞ (14¼ x 20¾)
Ed: 25
The Brooklyn Museum

Chesney's development as a printmaker was shaped by his study with Mauricio Lasansky at the print workshop of the State University of Iowa. Lasansky stressed craftsmanship and championed the supremacy of intaglio processes. Chesney met the challenge of a metal plate with engraving as well as with etching procedures.

41
Carl T. Chew
(b. Urbana, Illinois, 1948)
(PS) 1975
Collagraph, 20 x 25 (20 x 25). Ed: 7
Laura Chew
20th National Print Exhibition selection

Chew's collagraphs have a freshness and transparent delicacy of color that is unexpected in a medium in which rich saturations of hue are part of the common vocabulary. His textures too are light, his images fanciful and witty. The whole feeling is of buoyancy. Chew used four quarter-inch upsom board plates for *(PS);* he printed these in seven colors after intaglio wiping and relief rolling.

42
Carl T. Chew
(b. Urbana, Illinois, 1948)
MN-O 1975
Collagraph, 20½ x 17½ (25 x 22)
Ed: unknown
The artist
20th National Print Exhibition selection

Chew printed this collagraph from three upsom board plates in five colors after intaglio wiping and relief rolling.

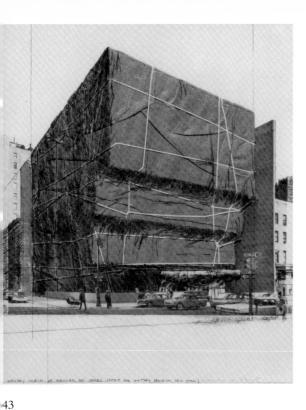

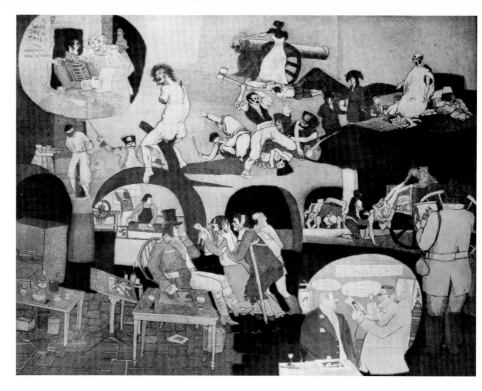

43
Christo 18☆
(b. Gabrovo, Bulgaria, 1935)
Whitney Museum Wrapped 1971
Lithograph and collage, 28 x 22
(28 x 22). Ed: 100
Landfall Press Inc.
20th National Print Exhibition selection

Christo's images of wrapped buildings have made some fine, if complex, lithographs. *Whitney Museum Wrapped* is one of the best. The print is in seven colors. First, an aluminum plate was printed in light gray. On this plate a flat area was made photomechanically by cutting a mask that was drawn out by the artist. A second aluminum plate was printed in black photomechanically from a negative supplied by the artist. Three further aluminum plates were printed: respectively gray, brown, and yellow from Korn's lithographic crayon. A last aluminum plate, with additions and deletions, was printed black from Korn's lithographic crayon. Writing at the bottom of this black plate was made photomechanically. Finally a stone was printed in black from Korn's lithographic crayon. The drawing was set in relief for printing on two collage elements (raw linen, string, and polyurethane). All impressions were printed on special Arjomari paper. A special 100 percent rag museum mounting board was adhered to the print for stability. The lithograph was printed, image bled, by Jerry Raidiger and Donald Holman with the assistance of Arthur Kleinman under the supervision of Master Printer Jack Lemon at Landfall Press, Chicago, between February 22 and September 28, 1971.

44 *illustrated in color on back cover*
Warrington Colescott 5☆
(b. Oakland, California, 1921)
**History of Printmaking: S. W. Hayter
Discovers Viscosity Printing** 1976
Etching, 22 x 28 (25 x 35). Ed: 75
The artist
20th National Print Exhibition selection

Colescott has always been a trenchant commentator on contemporary society, often with a glance at history to remind us of the past. Sometimes a print mirrors the violence of the times, as in the "Dillinger" series. Sometimes America's obsession with the past has been the subject. Now Colescott, who is an inventive technician and a formidable printer, has turned his attention to the history of printmaking. This open-ended series is colorful, comic, and full of technical puns on the great events of printmaking the artist is depicting. *S. W. Hayter Discovers Viscosity Printing* has something of Hollywood about it. This series is to be admired and enjoyed.

45 *above*
Warrington Colescott 5☆
(b. Oakland, California, 1921)
History of Printmaking: Goya Studies War 1976
Etching, 21¾ x 28 (25 x 35¼). Ed: 75
The artist
20th National Print Exhibition selection

Colescott's *Goya Studies War* is another plate in the "History of Printmaking" series. There is liberal quotation from Goya's images and techniques. Printing was by the Mantegna Press.

46 *below*
Robert Conover 6☆
(b. Trenton, New Jersey, 1920)
Early Spring 1976
Cardboard relief, 24 x 42 (29¼ x 47)
Ed: 25
The artist
20th National Print Exhibition selection

For cardboard relief prints, Conover works from a pre-
liminary color sketch. The sketch is either transferred or
redrawn on a sheet of fourteen-ply poster board. Other
smooth cardboards may be used. The surfaces are sealed
with gesso if the board is absorbent. The composition is
cut out with a mat knife, and the color areas are separated.
Each is inked with its individual color according to the
sketch. They are then assembled to form the color com-
position of the original sketch. A piece of rice paper is laid
over the inked cardboard and rubbed with a Japanese rice
spoon. When the ink has transferred to the paper, the sheet
is lifted carefully and hung up to dry. The technique of
cardboard relief allows many colors to be printed simul-
taneously.

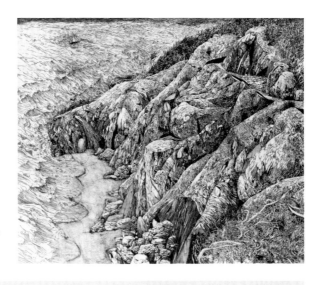

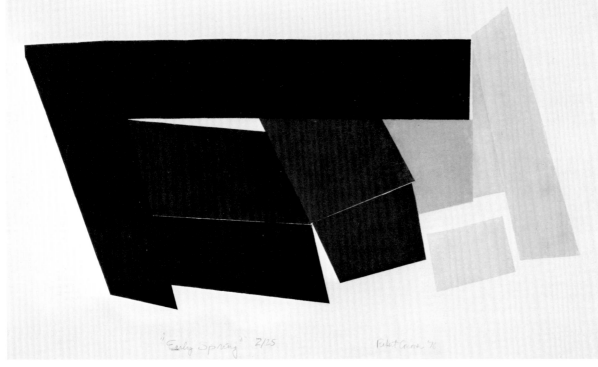

47
Gordon Scott Cook 10☆
(b. Chicago, Illinois, 1927)
Headlands V 1965
Etching and engraving, 14¾ x 17½
(18½ x 22). Ed: 25
van Straaten Gallery
20th National Print Exhibition selection

Cook's remarkable series of etchings with engraving of
the headlands at Land's End, an area of coast where the city
of San Francisco meets the sea, suggests a thorough famil-
iarity with the scene as well as a deep feeling for it. The
prints, with their abundant detail, reflect long-term study.
Each etching in the series was printed in black from a
single plate. Cook took as many as thirty trial proofs in the
making of a plate. Most of these images have been
destroyed.

48 *right*
Thomas Cornell 12☆
(b. Cleveland, Ohio, 1937)
Pig 1975
Engraving, 5¾ x 7⅞ (11¾ x 15¼)
Ed: unique
The artist
20th National Print Exhibition selection

Cornell's engraving on copper is a fine demonstration of
the force of his draughtsmanship meeting the natural resis-
tance of the plate. The vitality of the form is, in this sense, a
consequence of engraving technique. Means and ends are
brought together successfully. The artist printed this plate.

49 *right*
Thomas Cornell 12☆
(b. Cleveland, Ohio, 1937)
Resting Women 1975
Etching, 15½ x 18¾ (22 x 29½)
Ed: unique
The artist
20th National Print Exhibition selection

Cornell's interest in traditional subject matter has led him
to a series of etchings of nude female figures in nature. The
copper plate suggests—but does not explicitly refer to—
classical themes. The attempt is to see the experience
timelessly. Cornell printed the plate himself but has pub-
lished no edition. *Resting Women* was drawn directly from
life in a Maine woodland setting.

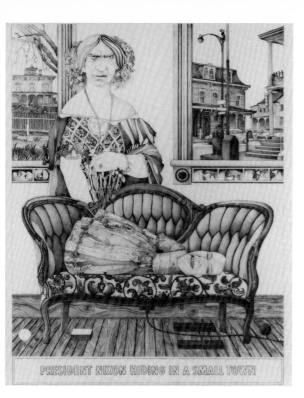

50
Dennis Corrigan 18☆
(b. Lakewood, New Jersey, 1944)
President Nixon Hiding in a Small Town
1974
Cronaflex film, 24 x 17¾ (25½ x 20)
Ed: 100
Associated American Artists
20th National Print Exhibition selection

Corrigan's satiric wit comes to us by way of a drawing done on frosted acetate with pencils ranging from H to 10H in hardness. The artist has written: "The mat side of the acetate surface provides an unusually subtle tooth for the graphite, especially for the harder pencils whose application shows up as tones instead of lines." Corrigan prints a continuous tone negative of the drawing. The negative is then contact printed on Cronaflex film (a DuPont product used mainly for architectural and engineering drawings) under a pinpoint light source. The final stage of the drawing—the film print—is also on a frosted acetate-like material, occurring as a silver emulsion. The artist feels that "the drawing has gained a new material richness" through the process, which also allows alterations of scale and contrast. For that matter, the process itself suggests the appropriateness of silverpoint clarity for Corrigan's drawing. How would a rougher draughtsmanship fare with Cronaflex?

51 *below*
Walter Cotten
(b. Kansas City, Missouri, 1946)
Untitled 1975
Serigraph, 8 x 10⅝ (22½ x 30). Ed: 12
The artist
20th National Print Exhibition selection

Cotten worked in a commercial screenprinting house full- and part-time for three years. In 1974 he took an M.F.A. in printmaking at the University of California at Santa Barbara. His secure technical grounding shows up not only in the expert finish of his images but in their imaginative flair. He elects, for instance, the subtleties available from the screenprint process. This untitled serigraph is in nine colors printed by the artist in nine press runs incorporating cut slits and glassine envelopes with graphite lines. Inks were stone lithography colors mixed with silkscreen transparent base extender.

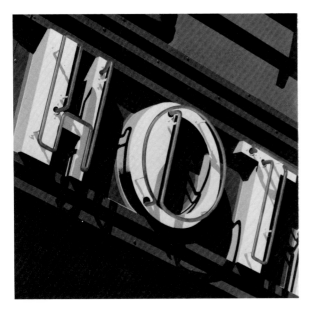

52 *above*
Robert Cottingham
(b. Brooklyn, New York, 1935)
Hot 1973
Lithograph, 20¾ x 20¾ (23 x 23)
Ed: 100
Landfall Press Inc.
20th National Print Exhibition selection

Cottingham's *Hot* glows with color—and not surprisingly—for the print is an extraordinary accommodation of hues and tones. The lithograph was hand-drawn on seventeen aluminum plates and printed on Special Arjomari paper at Landfall Press, Chicago. Processing, proofing, and printing were under the supervision of Master Printer Jack Lemon. Hand-printing of the edition was by Jack Lemon, Jerry Raidiger, and Tom Minkler assisted by Fred Gude and Jay Orbeck.

53 *not illustrated*
Robert Cottingham
(b. Brooklyn, New York, 1935)
F. W. 1974
Etching and aquatint, 10½ x 10½
(28 x 22). Ed: 50
Landfall Press Inc.
20th National Print Exhibition selection

Cottingham's tribute to Woolworths is a far simpler print than is usual for this artist. The partial image of the store sign and awning was hand-drawn on a copper plate and aquatinted with hand-burnishing. The plate was printed in black on Twinrocker and Japanese Gasen papers by Timothy F. Berry with the assistance of Carol Plummer at Landfall Press, Chicago.

54
Daniel Dallmann 19☆
(b. St. Paul, Minnesota, 1942)
Sunbather 1973
Lithograph, 31¾ x 23⅝ (31¾ x 23⅝)
Ed: 50
van Straaten Gallery
20th National Print Exhibition selection

Dallmann's superior draughtsmanship and careful color work have made *Sunbather* a formidable presence. We confront not merely an image of nudity but a person, enigmatic perhaps, but complete. The commonplace setting lends additional resonance to this image of a woman past her first youth. The lithograph was printed in six colors (in order: ochre, rusty red, blue, orange, red, and black) from nine hand-drawn, ball-grained aluminum plates. Printing was by the artist.

55
Daniel Dallmann 19☆
(b. St. Paul, Minnesota, 1942)
Bath 1974
Lithograph, 16 x 13 (18 x 15). Ed: 40
van Straaten Gallery
20th National Print Exhibition selection

Dallmann's *Bath* was printed in six colors (in order: yellow, red, blue, black, transparent blue, and transparent gray) from four hand-drawn and two cut stencil photo-processed aluminum plates. In formal terms, the print is solidly realized and made still more attractive by the quality of light Dallmann has given the room. Printing was by the artist.

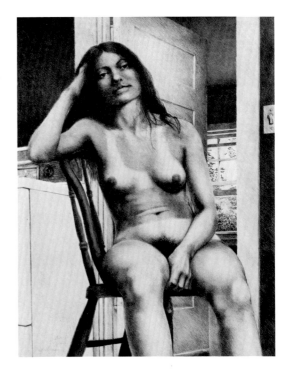

56 *not illustrated*
Ronald Davis 18☆
(b. Santa Monica, California, 1937)
Double Slice 1971
Lithograph and silkscreen with
embossing, 20¼ x 39½ (20¼ x 39½)
Ed: 65
Gemini G.E.L.
20th National Print Exhibition selection

Davis's *Double Slice* is an eleven-color litho-
graph and silkscreen embossed and printed
on Arches Cover paper by Serge Lozingot at
Gemini G.E.L., Los Angeles. This print is part
of the "Rectangle Series," a suite of seven prints
Davis executed with Gemini in 1972.

Ronald Davis 18☆
(b. Santa Monica, California, 1937)
Pinwheel, Diamond and Stripe 1975
Intaglio on multicolored paper, 19¾ x 23½
(19¾ x 23½). Ed: 42
Tyler Graphics Ltd.
20th National Print Exhibition selection

Davis's *Pinwheel, Diamond and Stripe* was printed on a
special multicolored paper developed for the project by
Kenneth Tyler and papermaker John Koller. Dyes and
pigmented pulp were used to create color areas. In all,
twenty-four colors went into the papermaking process.
Three further colors were printed from intaglio plates,
with drypoint and aquatint worked by the artist. Davis
blended and registered the colors from his hand-drawn
copper plates with the colors in the paper. All plate prep-
aration, proofing, and edition printing was by Betty Fiske
at Tyler Graphics Ltd., Bedford Village, New York.

58

Bill Davison 19☆
(b. Burlington, Vermont, 1941)
Decoy—Providence Island 1976
Screenprint, 9¼ x 33 (25¼ x 38)
Ed: 12
The artist
20th National Print Exhibition selection

Davison used a color offset grid and screenprinted enamel
inks with white flock on Arches paper. The print presents a
handsome enigmatic surface animated by bright accents of
color.

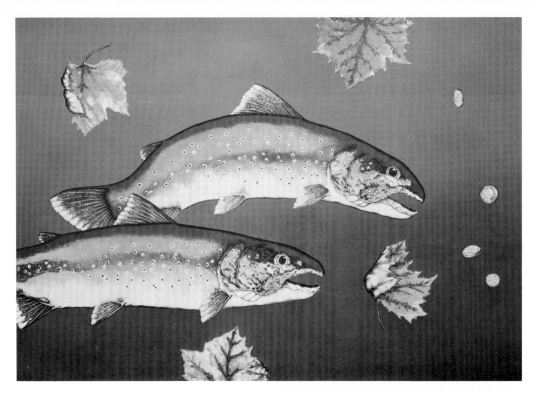

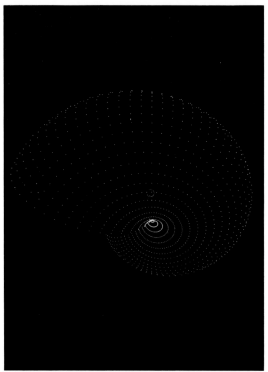

59

Gary Day
(b. Great Falls, Montana, 1950)
Fishing is Another 9-to-5 Job 1974
Lithograph, 20 x 28 (20 x 28). Ed: 6
The artist
20th National Print Exhibition selection

Day has achieved a dreamlike intensity with his image o
fish, leaves, and coins floating in a brilliant blue medium
The ten-color lithograph was printed with Sinclair and
Valentine inks on Italia paper at Montana State University
in Bozeman. The print is in the Montana State University
Collection and in the collection of the Southeastern Center
for Contemporary Art in Winston-Salem, North Carolina

60

Agnes Denes 18☆
(b. Budapest, Hungary, 1941)
From the suite **Map Projections** 1974
Lithograph, 10 x 7 (14 x 9⅞). Ed: 25
Associated American Artists
20th National Print Exhibition selection

Denes's lithograph is from a suite of eighteen image
published in 1974. The artist is attracted to the prin
medium by the flexibility it affords her: the printmaking
process provides a wide range of possibilities for working
on paper. At the same time, the technical procedures o
printmaking themselves impose a discipline that keep
experimentation in perspective. Denes's lithographs are
discovery of forms, not a recording of them. *Map Projec
tions* deals with defined/undefined boundaries and spac
relations. Six basic shapes were created in variou
mathematical projections, of which the snail is one. Thi
print was executed on Arches paper by John Hutcheson a
the Nova Scotia College of Arts and Sciences Litho Work
shop. The suite is published by Editions 99, New York.

61
Arthur Deshaies 3☆
(b. Providence, Rhode Island, 1920)
Cycle of a Large Sea: Night Sea Rider
Virgin, Night Sea Rider Love, and Night
Sea Rider Death 1962
Lucite engraving, 60¼ x 37 (64 x 40)
Ed: 15
The artist
20th National Print Exhibition selection

Deshaies's *Cycle of a Large Sea* was an ongoing project in
1961 and 1962. The artist worked from plaster blocks that
he printed in relief. The blocks provided the possibility of
an enlarged scale and allowed the artist to moderate the
edges of his cuts towards softness as he desired. The
quickset molding plaster was cut by Deshaies with chisels,
gravers, and electric tools as well as with wire brushes,
rasps, and sanders. The intention of the prints is symbolic:
to reflect human unrest in the restless imagery of the series
with its sea-like motions.

62 *right*
Richard Diebenkorn 17☆
(b. Portland, Oregon, 1922)
Cup and Saucer 1965
Lithograph, 11¼ x 11¼ (17 x 17)
Ed: 50
Smith Andersen Gallery
20th National Print Exhibition selection

Diebenkorn has worked in etching, lithography, and
monoprint. His greatest success has been in the two latter
mediums, where the drawing element is more direct and
results more easily anticipated. Lithography might seem to
be a natural to an artist with Diebenkorn's facility of hand,
but his output has been small. *Cup and Saucer,* a two-color
lithograph printed by Joseph Zirker, shows the force of
Diebenkorn's drawing and his understanding of litho-
graphic language.

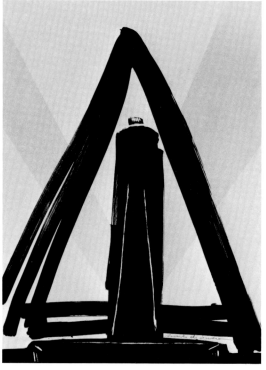

63
Jim Dine 18☆
(b. Cincinnati, Ohio, 1935)
The Swimmer 1976
Etching with hand-coloring, 20 x 24
(41½ x 30¾). Ed: 30
Pyramid Arts, Ltd.
20th National Print Exhibition selection

Dine is an etcher of the first rank. *The Swimmer* is from the suite "Eight Sheets from an Unfinished Novel." The vigor of Dine's etched drawings, the incidental markings on the plates, and the hand-coloring of each plate give these prints an extraordinary physical interest beyond the seductive wit and stylishness of the figuration. The images were etched on roofer's copper and all plates were steel faced. Trial proofing was in the charge of Mitchell Friedman; bon à tirer was by Donald Saff. The edition was printed with LeFranc and Bourgeois black on white German Etching paper by Tom Kettner with the assistance of Ralph Durham at Pyramid Arts, Ltd., Tampa, Florida. Titles were impressed into each print in the series by the editioners with Sinclair and Valentine Stone Neutral Black. Dine then hand-colored each print.

64
Jim Dine 18☆
(b. Cincinnati, Ohio, 1935)
Flesh Palette in a Landscape 1965
Lithograph, 26 x 19¼ (26 x 19¼)
Ed: 22
The Metropolitan Museum of Art,
John B. Turner Fund, 1965
20th National Print Exhibition selection

Dine's palette image is proving durable through a number of transformations. Here is one of the best: a lithograph printed in four stones on Auvergne French handmade paper at Universal Limited Art Editions, West Islip, New York.

65 *illustrated in color on front cover*
Jim Dine 18☆
(b. Cincinnati, Ohio, 1935)
A Girl and Her Dog No. II 1971
Etching with hand-coloring in
watercolor, 27 x 21½ (34¾ x 28). Ed: 75
The Brooklyn Museum, National Endowment for the Arts
and Bristol-Myers Fund

Dine's *A Girl and Her Dog No. II* is etching with aquatint on J. Green mold-made paper. The heart was embossed and hand-colored. Printing was by Maurice Payne at Petersburg Press, London.

66
Mark di Suvero
(b. Shanghai, China, 1933)
Jak 1976
Lithograph and silkscreen, 41½ x 29½
(41½ x 29½). Ed: 100
Tyler Graphics Ltd.
20th National Print Exhibition selection

Di Suvero's sculptures are widely known for a rough geometry of forms in balanced motion. The materials are usually mixed and fundamentally inelegant: wooden or steel beams, chain, stone. But the effect can be of refinement, even of delicacy, behind the raw power of these elements in combination. Scale, too, is important to the sculptor in establishing a sense of strength in his work. Di Suvero's prints, if not outright sketches for sculpture, capture something of the spirit of these works. There is no overt self-imitation, but there is a commitment through drawing to the energies that so often inform the three-dimensional pieces. The print mediums impose their particular clarities. *Jak* was hand-printed from one drawn stone in black and one silkscreen in yellow. Both the black and yellow images suggest possible expression as volume. The paper is mold-made Arches Cover. Preparation and proofing were by Kenneth Tyler; printing was by Tyler and Robert Bigelow assisted by Kim Halliday.

57 *below*
John E. Dowell, Jr. 16☆
(b. Philadelphia, Pennsylvania, 1941)
Letter to My Betty I and II 1970
Lithograph, 2 parts,
each 15 x 12 (15 x 12). Ed: 20
The artist
20th National Print Exhibition selection

Dowell's letter lithographs are printed by him in five colors from zinc plates and are typical of the sketch-like character of his graphic work of the period. The softness of the marks and the richness of the hues suggest the use of color pencils. We are looking at prints that mimic drawing technique and configuration, in the way in which planes are defined and dissolved, and in the creation of space on the sheet. The printing quality of *Letter to My Betty I and II* is outstanding. Owing to the personality of ink, these prints are perhaps just a touch less lively than drawings. Still, these small works are a visual feast and prefigure the daring spatial manipulations that were soon to occupy the artist.

68 *right*
John E. Dowell, Jr. 16☆
(b. Philadelphia, Pennsylvania, 1941)
Sound Thoughts of Tomorrow 1973
Etching and aquatint, 23½ x 17½
(30 x 22½). Ed: 15 artist's proofs
The artist
20th National Print Exhibition selection

Dowell's *Sound Thoughts of Tomorrow* is remarkable for its open, lyrical form, for the delicacy of its white calligraphy, and for the depth of its black field. The artist created his fluid white lines by drawing on a plate with a French lithographic ink. The ink served as a resist when the plate was etched. In pursuit of the intense black of the background, Dowell applied enamel spray paint in place of rosin powder for the aquatint.

69 *not illustrated*
Roy R. Drasites
(b. Chicago, Illinois, 1945)
Releaf Chessboard 1975
Lithograph, 23 x 17 (25⅞ x 19⅞)
Ed: 15
The artist
20th National Print Exhibition selection

Drasites's lithographs are produced from ball-grained aluminum plates. The artist begins with a carbon paper tracing of a drawing. This first drawing layer is then buffed with gum arabic, washed out with lithotine, and developed in asphaltum. Certain parts of the plate are then stopped out with gum arabic before the next layer of drawing material—it may be lacquer, rubbing ink, crayon, tusche, transfers, or something else—is applied. This procedure is repeated ten or twenty times for each plate in order to achieve a sufficient richness of image before the plate is etched.

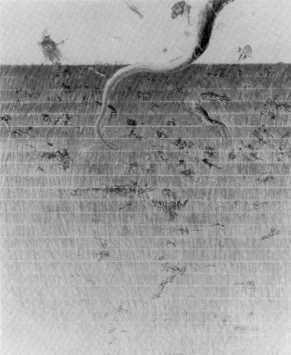

70
Roy R. Drasites
(b. Chicago, Illinois, 1945)
Leaf-Like Chessboard 1976
Lithograph, 23 x 17 (25⅞ x 19⅞)
Ed: 15
The artist
20th National Print Exhibition selection

Drasites, whose primary training as a printmaker was in intaglio, wrote: "I attack a lithograph more like an etcher than a lithographer." The result of his technique is an unusual surface rich in visual incident and carrying strong rhythms both of shape and of light and shade. The pulsations of black and white, along with the variously inflected surface, project a sense of complex movement, layer upon layer. The image is a paradigm of the technical method, in which processes are repeated many times to give the plates depth.

71
Michael W. Ehlbeck
(b. Dickson, Illinois, 1948)
Untitled 1976
Intaglio, 32¾ x 23¾ (32¾ x 23¾)
Ed: 20
The artist
20th National Print Exhibition selection

Ehlbeck's whimsical, spirited intaglio was cut and mounted to project his image in three dimensions. The imposed element of depth is played against the black printed images, creating rhythms that might be seen in a cut out theater or puppet show. The energy of the rhythms is in Ehlbeck's figurative forms.

72
Fritz Eichenberg 1☆
(b. Cologne, Germany, 1901)
The Book of Jonah 1955
Wood engraving (endgrain), 12 x 6
(16 x 9¼). Ed: 200
The Brooklyn Museum,
Gift of the Artist

Eichenberg came to America in 1933 as a refugee from Hitler's Germany and soon established himself as a cartoonist for *The Nation*. Somewhat later he worked as book illustrator for the Limited Editions Club with great success (and still does), and his wood engravings and lithographs began to reach a diverse, appreciative public. His prints from wood are the more popular. They show Eichenberg's narrative gifts to great advantage in a medium that immediately displays both his stylistic personality and his craftsmanship. *The Book of Jonah* is one of a series of ten biblical engravings. It was cut on endgrain boxwood with a burin, an elliptic tint tool (spitsticker), and a straight line tool.

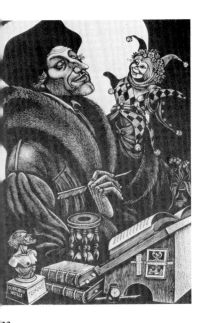

73
Fritz Eichenberg 1☆
(b. Cologne, Germany, 1901)
Dame Folly Speaks 1972
Wood engraving (sidegrain), 18 x 14
(22 x 16). Ed: 150
Impressions Workshop Inc.
20th National Print Exhibition selection

Eichenberg prefers that all his prints from wood be called wood engravings, since he feels that all of them have the character of fine line engravings. The traditional distinction is that wood engravings are made from endgrain blocks and that woodcuts are made from sidegrain blocks. *Dame Folly Speaks* is denominated by the artist as "an engraving on sidegrain Swiss pearwood." It is one of a series of ten woodblocks for the portfolio "Erasmus, In Praise of Folly" published by the Aquarius Press. The artist used fine Japanese v- and u-shaped gouges for cutting.

74
Marsha Feigin 18☆
(b. New York, New York, 1946)
Tennis 1974
Etching, 29¾ x 44 (33 x 48). Ed: 50
Impressions Workshop Inc.
20th National Print Exhibition selection

Feigin's etchings are remarkable for management of tone. She constructs her images additively by spraying layers of liquid hard ground in varying densities on copper plates. This control established, the artist etches the plate only once to create her many tonal gradations. Feigin will sometimes make modifications in the etched plate by sand blasting. Printing of *Tennis* was by Impressions Workshop Inc., Boston.

75 *not illustrated*
Marsha Feigin 18☆
(b. New York, New York, 1946)
Farrier 1975
Etching, 48 x 31¼ (52½ x 35½). Ed: 50
Impressions Workshop Inc.
20th National Print Exhibition selection

Feigen's *Farrier,* the image of a man shoeing a horse, is remarkable for its tonal subtleties, suave and yet dramatic, and for its effective use of white. The etching was printed by Impressions Workshop Inc., Boston.

76
Richard Fiscus
(b. Stockton, California, 1926)
The Presidio 1975
Screenprint, 22 x 30 (29¼ x 36¾)
Ed: 125
ADI Gallery
20th National Print Exhibition selection

Fiscus's screenprint is one of a series dealing with scenes famous in the San Francisco Bay Area. The general scheme of the print is realistic: it closely approximates the scene rendered. But the artist's treatment of the screenprint process has abstracted the visual experience. Fiscus's color is more decorative than descriptive. The print attracts by the vibrancy of its hues and by its patterns.

77 *right*
Janet Fish
(b. Boston, Massachusetts, 1938)
Preserved Peaches 1975
Lithograph, 26 x 19 (29½ x 21¾)
Ed: 75
Kornblee Gallery
20th National Print Exhibition selection

Fish has dealt authoritatively with reflective surfaces. Her loose draughtsmanship and sense of color have given her visual command of a variety of glassware (and their contents). *Preserved Peaches* is a lithograph printed from five plates on Arches paper (buff) at George C. Miller and Son, New York.

Patricia Tobacco Forrester 18☆
(b. Northampton, Massachusetts, 1940)
Daphne's Garden 1970
Etching, 12 x 18 (22 x 30). Ed: 75
The artist
20th National Print Exhibition selection

Forrester's etchings depend upon her long acquaintance with and attraction to a particular natural site. The artist will make repeated visits to a site once chosen—often over months—and will develop her drawings, without preliminary studies, directly from the subject on the grounded plate. Her work has an intensity and apparent specificity that can seem obsessive. Actually, the subject is transformed by the artist's evolving vision of it; for Forrester, getting into the subject is getting into something intangible about it—a mood, a quality of feeling. The subject is looked at so hard, so concentratedly, that it seems to yield an essence, something invisible to a more casual view. In *Daphne's Garden,* we alternate between the forceful overall image and the etching's beguiling intricacies.

80

Patricia Tobacco Forrester 18☆
(b. Northampton, Massachusetts, 1940)
Great Palm 1974
Etching, 16¼ x 21¾ (22 x 30). Ed: 80
The artist
20th National Print Exhibition selection

Forrester is no realist. She is not after the gross characteristics of her natural subjects, but searches the subtleties of form. What concerns her is form that magnetizes or impinges upon feeling, form as an affective element in perception. Her method, which involves longtime acquaintance with her subject and drawing on her etching plates on site, is one of alteration and refinement. But the refinement is in definition of mood, not in the making of an immaculate plate. This accounts for a certain ruggedness in her work. *Great Palm* has boldness and energy of attack.

81 *not illustrated*
Sam Francis 14☆
(b. San Mateo, California, 1924)
Very First Stone 1959–68
Lithograph, 20 x 15¼ (31¼ x 22⅜). Ed: 25
*Museum of Modern Art, New York, Gift of
the Celeste and Armand Bartos Foundation*
20th National Print Exhibition selection

Francis's *Very First Stone* is in fact two stones printed nine years after the artist prepared his first lithograph. The image is still among the finest Francis has produced. The lithograph was printed on Crisbrook English handmade paper at Universal Limited Art Editions, West Islip, New York.

78 left
Karl L. Folsom
(b. Seattle, Washington, 1938)
K 1975
Photo intaglio with embossing,
3 x 21 (22½ x 30). Ed: 20
The artist
20th National Print Exhibition selection

Folsom is trying to extend the boundaries both of etching and of photography within images partaking of both. Typically, he moves out of the literal photoengraved image into abstractions suggested by its dominating forms. A new spatial sense is given by the stretching or repetition of a particular image. In *K,* hedges and path are echoed in fluid black shapes and in linear embossments. What we respond to is a sense of organic development, of natural if mysterious consequence. That a design has been worked out is not apparent. In *K,* Folsom transferred his original 35-mm negative to a presensitized zinc plate. Embossing was blind, using a collagraph base. In all, four plates were used and were printed by the artist in one press run.

82
Sam Francis 14☆
(b. San Mateo, California, 1924)
Red Again 1972
Silkscreen, 24¾ x 30¾ (24¾ x 30¾)
Ed: 100
Gemini G.E.L.
20th National Print Exhibition selection

Francis has translated his splashed and layered color into painterly screenprints quite successfully, though his graphic ideas and use of color seem sometimes better suited to lithography. Some of Francis's finest screenprints (*Red Again* is one) have been made at Gemini G.E.L., Los Angeles. This is an eleven-color silkscreen printed on Arches Cover paper by Jeff Wasserman.

83
Sam Francis 14☆
(b. San Mateo, California, 1924)
Untitled 1974–75
Lithograph, 35 x 26 (42 x 29¾)
Ed: 30
SmithAndersen Gallery
20th National Print Exhibition selection

Francis's lithographs in black and white are a reduction to tonal terms of the issues of space, form, and energy established in his color prints and in his paintings. The artist exploits the liquidity of tusche and the character of lithographic ink to present a dynamic field in which shape and regularity are seen to be deteriorating under a bombardment of energy; or perhaps the splashes, globs, and lines are adhering to become the roughly rectilinear form that mimics the paper shape. These black and white prints suggest that there is perhaps less to Francis's color than meets the eye. The print is on Rives BFK paper and was produced at The Lithoshop Inc., Santa Monica, California. The printer was George Page.

84

Helen Frankenthaler 18☆
(b. New York, New York, 1928)
Savage Breeze 1974
Woodcut, 29½ x 24⅞ (31¼ x 26¾)
Ed: 31
The Metropolitan Museum of Art,
John B. Turner Fund, 1974
20th National Print Exhibition selection

Frankenthaler's woodcuts are perhaps her most successful prints. The process allows her a freedom in the deployment of shapes, colors, and surface images that relates to her painting style. *Savage Breeze* was printed from eight blocks on handmade Nepalese paper at Universal Limited Art Editions, West Islip, New York.

85 *not illustrated*
Helen Frankenthaler 18☆
(b. New York, New York, 1928)
Sky Frame Orbit 1964–73
Etching and lithograph, 21¼ x 15
(29⅞ x 22½). Ed: 6
Museum of Modern Art, New York,
Gift of Celeste Bartos
20th National Print Exhibition selection

Frankenthaler's *Sky Frame Orbit* is a print that includes an image of an earlier print. The original, a lithograph entitled *Sky Frame,* was printed from stone in 1964 in an edition of eight. In 1973 the artist combined a stone printing image with a plate etched that year. The two together were printed on Arches paper (buff) at Universal Limited Art Editions, West Islip, New York.

86
Antonio Frasconi 1☆
(b. Buenos Aires, Argentina, 1919)
Self-Portrait with Don Quixote 1949
Woodcut, 33 x 18⅝ (36 x 23⅞). Ed: 25
The Brooklyn Museum,
Dick S. Ramsay Fund

Frasconi was born in Buenos Aires and grew up in Montevideo, where the social awareness of artists was a fact of life. Early on, he became a political cartoonist for *Marcha,* the Uruguayan weekly journal; the narrative and descriptive force imposed by illustration and portraiture have continued to characterize his woodcuts. Social awareness too remains part of the fabric of his life—witness his work involving contemporary themes like the Kennedy assassinations and personalities like George Jackson and Charlie Mingus. But Frasconi has also a fanciful, humorous, and literary side, reflected in his vigorous but touching self-portrait (not without its social points). Frasconi printed this impression especially for The Brooklyn Museum in 1949 as an artist's proof. Frasconi emigrated to the United States in 1945. He studied on scholarship with Yasuo Kuniyoshi at the Art Students League of New York. A year later he moved to California, where he worked as a guard at the Santa Barbara Museum of Art. He had his first one-man show at that museum in 1946. The same year he had a one-man show of woodcuts at The Brooklyn Museum (April 19–June 9).

87
Ernest B. Freed 1☆
(b. Rockville, Indiana, 1908)
Battle of the Sexes 1946
Engraving, 17¾ x 28¾
(21¼ x 31¼). Ed: 100
The Brooklyn Museum

Freed's spirited *Battle of the Sexes* won a Purchase Award at The Brooklyn Museum's 1st National Print Exhibition and was described as "a triumph in the art of burin engraving" in the June 1947 *American Artist*. The work gives a nod to the semi-abstract style encouraged by Mauricio Lasansky, with whom Freed worked at the University of Iowa. But it also inclines to the contrasts of light and dark and to the figural contortions of engravings of Italian Mannerism.

88
Jane Freilicher
(b. New York, New York, 1924)
Still Life and Landscape 1971
Lithograph, 24 x 21½ (29½ x 23½)
Ed: 100
Fischbach Gallery
20th National Print Exhibition selection

Freilicher is a painter with a light touch and a feeling for fresh, vivid color. She has brought the same finesse of hand and quality of eye to lithography. *Still Life and Landscape,* probably her most popular print, is in eight colors and was proofed by hand and pulled by machine from one stone and seven zinc plates. The paper is Arches. The work was completed at the Bank Street Atelier on November 19, 1971.

89 *right*
Jane Freilicher
(b. New York, New York, 1924)
Untitled 1975
Lithograph, 24¼ x 18 (29 x 22)
Ed: 100
Fischbach Gallery
20th National Print Exhibition selection

Freilicher's untitled landscape of 197 was commissioned by the Women' Division of The American Jewis Congress as part of the program Explorations in the Visual Arts. Th lithograph is in six colors and is printe on Arches paper. Printing was done a the American Atelier.

90
Tom S. Fricano 9☆
(b. Chicago, Illinois, 1930)
Erosion of Red Square 1962
Collagraph, 17¾ x 23½ (19¾ x 25½)
Ed: unique
The artist
20th National Print Exhibition selection

Fricano is a formidable colorist among printmakers. Whatever medium he elects, the color experience will be dominant, the image a vehicle for the exploration of color. His interest in color has deepened from the period of his early woodcuts of the 1950s. *Erosion of Red Square* draws the elements of collage together in a rich configuration of hues. The collagraph was printed by Fricano as a combined intaglio and relief plate.

91
Tom S. Fricano 9☆
(b. Chicago, Illinois, 1930)
Drifting 1974
Assemblegraph, 26¼ x 33 (26¼ x 33)
Ed: unknown
The artist
20th National Print Exhibition selection

Fricano has experimented with printmaking techniques and counts himself as the inventor of assemblegraph, a process that permits the simultaneous printing of many colors. Individually inked segments are placed directly on the press bed and printed at the same time. A great variety of solid materials may be used in combination, offering a wide range of textures. But central to the technique is its flexibility for color printing, an issue that is paramount for this artist. *Drifting* demonstrates the assemblegraph technique and presents Fricano working in a subtle color range.

92
Thomas R. George 8☆
(b. New York, New York, 1918)
The Tower, Scheme No. 3 1954
Woodcut, 21¼ x 8⅛ (29¾ x 15)
Ed: unknown
The Brooklyn Museum

George has achieved a substantial reputation as a draughtsman. *The Tower, Scheme No. 3* finds him drawing in wood with many fine small cuts. The artist used two blocks. These were printed in three colors on Japanese paper. The print won a Purchase Award at The Brooklyn Museum's 8th National Print Exhibition.

93 *above*
Sam Gilliam
(b. Tupelo, Mississippi, 1933)
Wave 1972
Lithograph, 26 x 19¾ (26 x 19¾)
Ed: 67
Fendrick Gallery
20th National Print Exhibition selection

Gilliam's *Wave* is from a series of three images commissioned by the Fendrick Gallery, Washington, D.C. The artist approached the lithographic medium experimentally. He was especially interested in the possibility of using multiple colors and in being able to fold the paper before it passed through the press. *Wave* relates to the language of Gilliam's paintings, but the overlaid inks give a muted resonance to the color that belongs to this print medium.

94 *above*
Daniel Joshua Goldstein
(b. Mount Vernon, New York, 1950)
Evening Iris 1976
Woodcut, 2 parts, each 29 x 29 (29 x 29). Ed: 75
ADI Gallery
20th National Print Exhibition selection

Goldstein's woodblock prints use the flat surface of the wood rather than relief areas. The block is cut into many pieces, and each piece is inked separately. The pieces are reassembled, and the etching press is used for printing. Variations of tone in one color are achieved either through wiping or by running the pieces through the press several times before the final printing. Materials such as cloth and paper are glued to the wood surface in order to obtain special textures.

95 *below*
Milton Goldstein 1☆
(b. New York, New York, 1944)
Pompei 79 A.D. 1969
Etching and aquatint, 13 x 19¾ (15 x 21¾). Ed: 10
*The Brooklyn Museum, Gift of the Society of
American Graphic Artists in memory of John Von Wicht*

Goldstein studied at the Art Students League of New York and also with Harry Sternberg, Morris Kantor, and Will Barnet. *Pompei 79 A.D.* was inspired by a sabbatical visit to the site. The relief etching and aquatint was printed by the artist in encaustic printing inks developed by him.

96
Christine Goodale
(b. East Lansing, Michigan, 1959)
Untitled 1973
Serigraph, 20 x 20 (24¾ x 24). Ed: 5
The artist
20th National Print Exhibition selection

Goodale has a gift for delicate color and clear forms in a medium—serigraphy—that is more often used for muscular statements. She has achieved in this print a misty transparency of color quite unlike the powdery flatness usually found in lyrical attempts with screens. This is perhaps because the colors have been allowed to interact without heavy-handed intervention on the part of artist or technician. In this sense, Goodale may have rediscovered a language of possibilities intrinsic to the medium. But note the size of the edition.

48

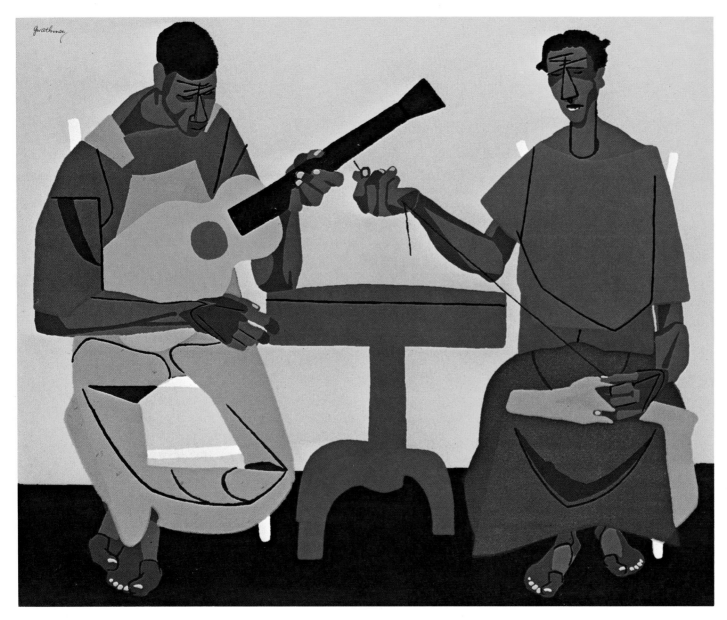

Robert Gwathmey 1☆
(b. Richmond, Virginia, 1903)
Singing and Mending *circa* 1946
Serigraph, 12 x 14⅛ (15 x 18¼)
Ed: 50
The Brooklyn Museum
Cat no 108

7 *above*
oe Goode 18☆
. Oklahoma City, Oklahoma, 1939)
Untitled 1971
ithograph and silkscreen, 14 x 23 (14 x 23). Ed: 50
Cirrus Editions Ltd.
0th National Print Exhibition selection

Goode was among the first artists to be published by
Cirrus Editions, Los Angeles, where he developed the
rint imagery for which he is best known. Goode's prints
f this type propound space (or, if you prefer, spacious-
ess) with runs of modulated or muted color. An area or
reas will be presented as torn from the continuous or
radated spatial image. Later in the evolution of his idea,
Goode literally tears or slashes the print to show an under-
ying color on a second sheet. In this particular print, the
ntegrity of the sheet has been maintained. The print is a
multicolor lithograph from stones and aluminum plates
with silkscreen printing. It was produced in five press runs:
irst, purple, red, orange, pink, and yellow by the blended
nk method; second, blue; third, red; fourth, gray; fifth,
lear varnish (silkscreen printing). The edition was printed
n Copperplate Deluxe.

8 *right*
oe Goode 18☆
. Oklahoma City, Oklahoma, 1939)
Untitled 1974
Lithograph, 28½ x 40½ (30 x 41½). Ed: 25
Cirrus Editions Ltd.
20th National Print Exhibition selection

Goode's lithograph (Cirrus 167c-JG74) consists of two
eparate sheets of paper, one in a single color and the other
n two colors printed from three plates by Master Printer
Chris Cordes on roll Rives BFK. One sheet is medium
blue (one run); the second is dark gray and light gray (two
uns each). There are two states within the edition. In State
the blue sheet is on top; in State II the gray sheet is on top.
After printing and arranging, the top layer of each print
was cut and slashed with a razor by the artist. The sheets
were then machine sewn along the top border.

99 *left*
Anthony Gorny
(b. 1952)
H.T.A.D. 1974
Aquatint, 10¾ x 16⅛ (14½ x 19⅝). Ed: 25
Jane Haslem Gallery
20th National Print Exhibition selection

Gorny's ancient children don't seem quite anchored to the
blanket they are sitting on. The image has a dreamlike
insistence, a sense of slow time and reflection as if we were
viewing it through an invisible barrier. The effect is
achieved by the recession into darkness in the upper right
and by the print's division, which reads as a shadow on its
right-hand side. Management of tone is expert.

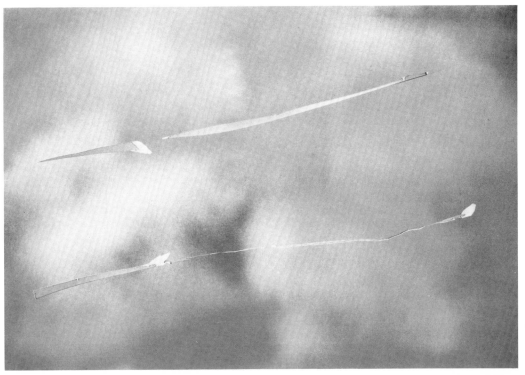

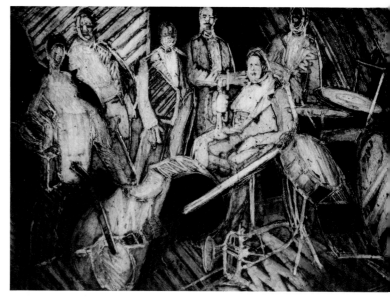

100
Kenneth Grebinar
(b. Brooklyn, New York, 1948)
Triptych 1975
Etching, 25 x 6 (14½ x 32)
Ed: 3 artist's proofs
The artist
20th National Print Exhibition selection

Grebinar's attractive etchings of landscape subjects have the softness of pencil sketches treated with watercolor. In fact, the artist prints a soft ground intaglio and stencils on colors using inks of different viscosities. He uses scale interestingly and gives a large feeling to his small prints.

101 *right*
Marty Greenbaum
(b. New York, New York, 1934)
Bklyn Local in Weege Wisconsin 1974
Mixed media, 21½ x 21 (21½ x 21)
Ed: 11
Ellen Sragow, Ltd./Prints on Prince St.
20th National Print Exhibition selection

Greenbaum's *Bklyn Local in Weege Wisconsin* was one of eight editions printed by the artist during his two-month visit to Jones Road Printshop in Barneveld, Wisconsin, in the fall of 1974. Procedures were similar for these projects. Initial drawings would be photo lithographed onto a metal plate and printed. The print would then be worked into by the artist. Greenbaum would continue to add to the print by further drawing and by watercoloring, dyeing, burning, embossing, and a variety of other means to texturize and overlay the print surface.

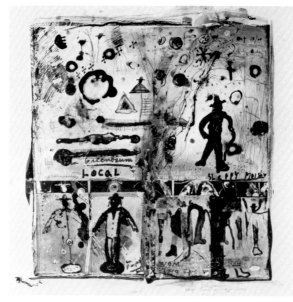

102 *not illustrated*
Marty Greenbaum
(b. New York, New York, 1934)
Blue Flames 1974
Mixed media, 17¾ x 13¼ (17¾ x 13¼). Ed: 12
Ellen Sragow, Ltd./Prints on Prince St.
20th National Print Exhibition selection

Greenbaum spent October and November of 1974 working with Master Printer and publisher William Weege a the Jones Road Printshop in Barneveld, Wisconsin. H developed his book project one page at a time. Greenbaum would draw; Weege would transfer the drawing to a meta plate by photographic process; the artist would then re work the drawing directly on the plate in various ways (fo instance, with crayons or by scratching). Greenbaum worked to enrich and energize the surface and to achiev the sense of layers, of depths. He wanted the pages to b permeated with drawing. Since he was working on othe projects at the time, there was some interchange. If he wer dyeing for another project, he might also apply dye to on of the book pages. The book was assembled from suc individual leaves.

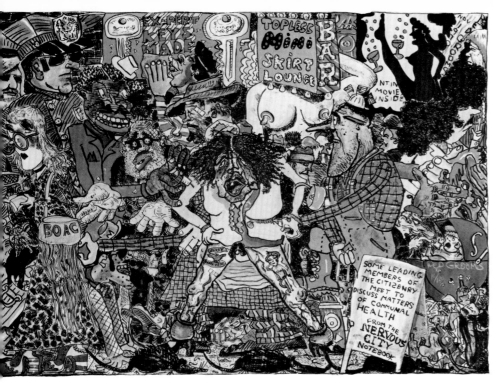

103 *facing page, top right*
Bernard Greenwald 15☆
(b. Newark, New Jersey, 1941)
Creole Jazz Band III 1974
Intaglio, 26¼ x 38½ (30 x 42½)
Ed: 100
The artist
20th National Print Exhibition selection

Greenwald often works from old posed photographs. The arrangement of figures stimulates the artist to reorganize and elucidate the image. Greenwald works through built-up drawings in crayon. He has developed a process for crayon lift ground. When his drawing is finished in soft wax crayon, he coats the plate with a special varnish and the drawing is washed out under it, exposing the metal where the drawing was. The plate is then etched normally.

104 *above*
Red Grooms
(b. Nashville, Tennessee, 1937)
Nervous City 1972
Lithograph, 22¼ x 30⅛ (22¼ x 30⅛)
Ed: 120
The Brooklyn Museum,
Gift of Mr. and Mrs. Samuel Dorsky

Grooms's *Nervous City,* a lithograph in color, is typical of his ideographic idiom in imagery and pictorial energy. While his three-dimensional figures are often static, the prints will be rich in implied activity. The sense of naive drawing is reinforced by the unsubtle color. *Nervous City* was printed at Bank Street Atelier for the Skowhegan School in Skowhegan, Maine.

105
Red Grooms
(b. Nashville, Tennessee, 1937)
Gertrude 1974
Lithograph with acrylic sheeting,
19 x 22 x 11. Ed: 46
Brooke Alexander, Inc.
20th National Print Exhibition selection

Grooms's witty portrait multiple of Gertrude Stein was assembled from two lithographs printed from aluminum plates in six press runs (valentine red, warm brown, blue-green, primrose yellow, bluish green-black, and black) on Arches paper at the American Atelier, New York, under the supervision of Mauro Giuffred. Each multiple was assembled by Chip Elwell under the supervision of the artist. The acrylic sheeting boxes in which the multiples are housed is the work of Stanley Poler, Inc., New York.

106
Laura Grosch
(b. Worcester, Massachusetts, 1945)
Gloxinia on an Oriental Rug 1974
Lithograph, 30 x 22¼ (30 x 22¼)
Ed: 75
The artist
20th National Print Exhibition selection

Grosch's lithographs develop a stong sense of pattern even within the shapes of the objects she pictures. She employs a method of cross-hatching and overlays of transparent color that gives depth and vibrancy to the lithographic translations of her drawing. One hue will vibrate against another, inflecting the surface, defining the forms. *Gloxinia on an Oriental Rug* is in four colors, printed on Rives BFK paper at Impressions Workshop, Boston. The image is bled. The printer was Lisa Mackie.

107
Laura Grosch
(b. Worcester, Massachusetts, 1945)
Iris on Bokhara 1976
Lithograph, 22 x 30 (22 x 30). Ed: 100
The artist
20th National Print Exhibition selection

Grosch's *Iris on Bokhara* is perhaps even subtler and richer in color than *Gloxinia on an Oriental Rug,* which is itself a rewarding print. The lithograph is in four colors, printed on Rives BFK paper by Paul Maguire at Impressions Workshop, Boston.

108 *illustrated in color on p48*
Robert Gwathmey 1☆
(b. Richmond, Virginia, 1903)
Singing and Mending *circa* 1946
Serigraph, 12 x 14⅛ (15 x 18¼)
Ed: 50
The Brooklyn Museum

Gwathmey's *Singing and Mending* won a Purchase Award in The Brooklyn Museum's 1st National Print Exhibition. The subject matter is presented in a manner made famous by the artist. Simplified figuration and flat color portray ordinary events in the lives of the Southern poor.

109
Richard Haas 19☆
(b. Spring Green, Wisconsin, 1936)
Great Hall, Kip Riker Mansion 1975
Aquatint, 16⅞ x 14¾ (26 x 22⅜)
Ed: 30
Brooke Alexander, Inc.
20th National Print Exhibition selection

Haas's *Great Hall, Kip Riker Mansion* is unusual for the aquatint medium. It is structured as much with pattern and with light and dark contrasts as with tone. Here, tone contributes somberness and patina. Haas's architectural studies are interesting for their mixture of descriptive systems and evocative sentiment. The print is in four colors on Arches paper.

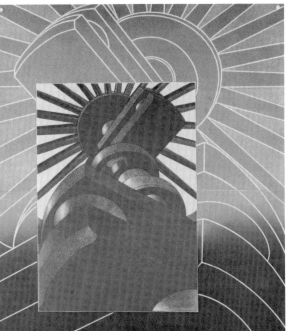

110
Katherine Halton
(b. Bryn Mawr, Pennsylvania, 1952)
Untitled 1975
Serigraph and offset lithograph with
hand-drawing, 9½ x 11½ (19⅛ x 21½)
Ed: unique
The Print Club
20th National Print Exhibition selection

Katherine Halton's prints are notable for sensuous low-keyed color and involve simplified forms and color fields close in value. The artist uses serigraphy and offset lithography. Drawing elements are then added. Printing is by the artist.

111
John Hannah 8☆
(b. Buffalo, New York, 1923)
Deity 1971
Intaglio and relief, 19¾ x 17
(26¾ x 22¾)
Ed: 15
The artist
20th National Print Exhibition selection

Hannah's *Deity,* a color intaglio and relief, was printed in London in the studio workshop Bergit Skiöld. The central image came from a photograph the artist took at the Transport Museum, London. This was reinterpreted in scraped and burnished aquatints and reinforced with engraving. The surrounding plate was printed in two parts in relief with a rainbow roll.

Kieko Hara
(b. Korea, 1942)
Lu' Lu'' Lu'' 1976
Mixed media, 3 parts, each 14⅛ x 12
(17⅜ x 12¼). Ed: unique
The artist
20th National Print Exhibition selection

Hara came to the United States from Japan and has worked here for several years as an exchange student. She has worked recently in association with Irwin Hollander at the Cranbrook Academy of Art, Bloomfield Hills, Michigan, and has executed prints there of great interest for their color manipulations and textural subtleties. She is technically adventurous and uses interdisciplinary means to realize her images.

113 *below*
Kieko Hara
(b. Korea, 1942)
Heart in America 1976
Mixed media, 5 parts, each 7 x 7
(7 x 7). Ed: unique
The artist
20th National Print Exhibition selection

Hara's *Heart in America* is in five sections, printed on both sides and made up as a screen to be set up on two pieces of Mylar supplied by the artist. The movement of the modulated images in the reflected surface of the Mylar is the issue in this print.

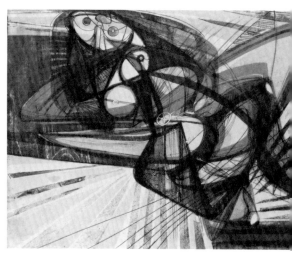

114 *left*
Marven Harden
(b. Austin, Texas, 1939)
**The Thing Seen Suggests, This and
Other Existences** 1974
Lithograph, 9½ x 5¼ (20¼ x 13½)
Ed: 30
Cirrus Editions Ltd.
20th National Print Exhibition selection

Harden's philosophical essay is a two-color lithograph printed on Arches paper from one plate and one stone. A remarkable spatial ambiguity was achieved by printing a flat gray-green and then printing in black the image drawn in litho crayon on the stone. The printer was Ed Hamilton; the publisher is Cirrus Editions Ltd., Los Angeles.

115 *below*
James Havens 1☆
(b. Rochester, New York, 1900;
d. Fairport, New York, 1960)
Rabbit Fence 1946
Woodcut, 6¼ x 10 (10 x 13). Ed: 70
*The Brooklyn Museum,
Dick S. Ramsay Fund*

Havens was an expert woodcut artist and illustrator. He had a fine art side to his production (aside from illustration). He produced color woodcuts for the membership of such organizations as the Woodcut Society and the American Color Print Society. *Rabbit Fence* won a Purchase Award at The Brooklyn Museum's 1st National Print Exhibition. Color work is outstanding in this print; quality of printing is exceptional.

116
Stanley William Hayter 1☆
(b. London, England, 1901)
Unstable Woman 1947
Etching, engraving, and offset
14¾ x 19½ (19½ x 25½). Ed: 50
The Brooklyn Museum

Hayter was probably the most influential figure in printmaking until the experimental boom of the 1960s. He showed countless artists what could be done with intaglio processes and established printmaking as a serious and truly creative art. *Unstable Woman* won a Purchase Award at The Brooklyn Museum's 1st National Print Exhibition.

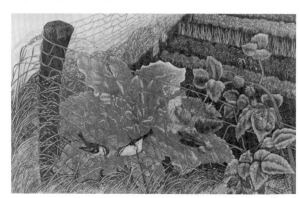

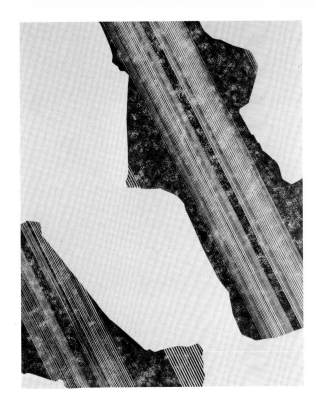

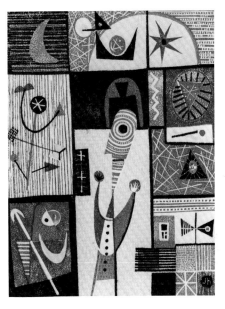

117

Stephen Hazel
(b. Goshen, Indiana, 1934)
Biloxi Beach Liner 1971
Intaglio and relief, 18½ x 13⅞
(25⅝ x 19⅝). Ed: 10
The artist
20th National Print Exhibition selection

Hazel has an accurate sense of what is necessary to make a visual idea explicit as experience. There is nothing extra, only a sufficiency of means to achieve the desired end. It's his functionalism as much as aesthetic sensibility that gives Hazel's prints their clean and clear look. Of course, his fine craftsmanship and technical mastery are significant. *Biloxi Beach Liner* combines intaglio and relief. A copper plate was etched and photo etched, inked in three reds, three yellows, and four blues (one with pearlescence); watercolors (manganese blue, Naples yellow and a permanent magenta) were then airbrushed onto the plate before printing by John Overton on Van Gelder Zonen (Netherlands) paper. Inks were from Sinclair and Valentine and Handschy Chemical Company; watercolors were Winsor and Newton.

118

Stephen Hazel
(b. Goshen, Indiana, 1934)
Beautiful Display 5 (Amor sin Lingua)
1973
Woodcut, 13¾ x 17¾ (13¾ x 17¾)
Ed: 10
The artist
20th National Print Exhibition selection

Hazel's prints are full aesthetic statements, with no part of the process or the materials incidental. This woodcut is from two blocks, one cherry veneer, one birch. Winsor and Newton red, green, and blue and black sumi were printed on Zaan Board (Netherlands) by the artist.

119

Jon Henry 1☆
(b. New York, New York, 1916)
The King in His Counting House 1946
Woodcut, 7 x 5 (9½ x 6⅝). Ed: 20
The Brooklyn Museum

Henry was a student both of Louis Schanker and Robert Motherwell. The vibrations for woodcutting must have been more powerful, for some of Henry's most engaging work is in this medium. *The King in His Counting House* won a Purchase Award at The Brooklyn Museum's 1st National Print Exhibition. Henry appeared in the Museum's National Print Exhibition again in 1968.

120
Janet Hildebrand
(b. Denver, Colorado, 1942)
Eagle's Nest—Gore Range 1975
Etching, 18 x 18 (22 x 30). Ed: 25
The artist
20th National Print Exhibition selection

Hildebrand teaches printmaking at The Brooklyn Museum Art School. Her own etchings—images of barren mountains seen at a distance—make a forceful personal statement. Colors are sensitively adjusted to develop the expressive impact of the images.

121
Clinton Hill 10☆
(b. Payette, Idaho, 1922)
21 1975
Handmade paper dyed and bleached,
22½ x 17½ (22½ x 17½). Ed: 5
The Brooklyn Museum,
Gift of the Artist through the
Creative Artists Public Service Program

Hill's handmade paperworks have great overall variety and unusual consistency within their small editions, mainly because of the artist's simplified and standardized method. For *21,* Hill stitched plastic and wire to the paper mold; these areas became the holes and lines on the paper. The bars of color were made by laying down a template and filling the spaces with spooned dyed pulp. Dye accounts for the remaining linear element.

122
Sue Hirtzel
(b. Buffalo, New York, 1945)
Little Notes II 1974
Cliché verre, 4 x 4 (8 x 6). Ed: unique
The artist
20th National Print Exhibition selection

Hirtzel's *Little Notes II* was drawn on film with stencils and light-emitting tools and then printed on specially prepared paper through the dye transfer and gum bichromate processes. This is a method akin to the nineteenth-century process, cliché verre, in which a glass plate is covered with a light-resistant emulsion. A drawing is then made that scratches through the coating to reveal the glass. This drawn glass is like a negative. It is placed on photographic paper, exposed to light, and is thus printed.

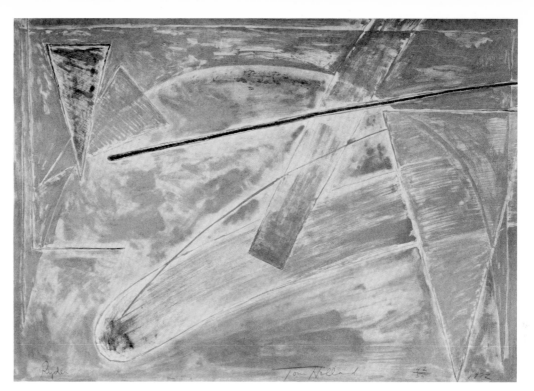

123 *above, top*
George Hofmann
(b. New York, New York, 1938)
Temtie 1974
Aquatint and engraving, 11⅜ x 17½
(22¼ x 30¾). Ed: 50
The artist
20th National Print Exhibition selection

Hofmann is doing color printing of great interest, but his main concern is with linearity. For *Temtie,* he printed three plates in three colors, using repolished old zinc plates. There were many trial proofs made for color adjustment. The three colors were greatly varied within their hues. Printing was by Prawat Laucharoen.

124
George Hofmann
(b. New York, New York, 1938)
Untitled 1975
Etching, 7¾ x 13¾ (21 x 30⅜)
Ed: unique
The artist
20th National Print Exhibition selection

Hofmann's untitled etching of 1975 was printed from three plates in three colors. There were five or six color proofs for color adjustment. No edition has been printed. Proofing was by Prawat Laucharoen.

125
Tom Holland
(b. Seattle, Washington, 1936)
Ryder 1972
Lithograph, 29⅞ x 41⅞ (29⅞ x 41⅞)
Ed: 55
Cirrus Editions Ltd.
20th National Print Exhibition selection

Holland made his reputation in painting and sculpture, but he is also a gifted lithographer whose work in the medium is too little known. The images he employs in his prints are close to those that preoccupy him in his other mediums, but his prints are not imitations or reproductions of paintings or sculptures. They have entirely the lithographic impulse and use lithography characteristically in works that belong to printmaking. *Ryder,* a five-color lithograph printed from stones and metal plates at Cirrus Editions, Los Angeles, is representative of Holland's forms and sensitivities of surface.

126 *not illustrated*
Tom Holland
(b. Seattle, Washington, 1936)
Nichols 1973
Lithograph, 30 x 42 (30 x 42). Ed: 55
Cirrus Editions Ltd.
20th National Print Exhibition selection

Holland's *Nichols* partakes of his characteristic lithographic imagery. Three-sided shapes—curved triangles—contend and overlap with linear elements in a space of ambiguous depth and indeterminate plane. The lithograph was hand-printed from two stones and one aluminum plate, the first stone in black, the second in silver, and the aluminum plate in dark blue. The paper was Copperplate Deluxe. The print is a publication of Cirrus Editions, Los Angeles.

127
Irwin Hollander
(b. Brooklyn, New York, 1927)
Bread 1976
Lithograph, 11 x 15 (11 x 15). Ed: 18
The artist
20th National Print Exhibition selection

Hollander began his career at The Brooklyn Museum Art School. In 1961 he received a Ford Foundation Grant to the Tamarind Lithography Workshop. He became a full-time printer of lithographs and a collaborator in many important print projects during the 1960s. The Hollander workshop was an important element in the New York scene between 1964 and 1973. Thereafter Hollander stopped printing for others and began producing and printing his own imagery. *Bread* shows him playfully exploring the lithographic medium.

128 *not illustrated*
Irwin Hollander
(b. Brooklyn, New York, 1927)
Litho Suite #1 Ab 1976
Lithograph, 2 parts, each 11 x 30 (11 x 30). Ed: unique
The artist
20th National Print Exhibition selection

Hollander taught printmaking for three years at the Cranbrook Academy of Art in Bloomfield Hills, Michigan. In 1976 he held an exhibition there of his recent graphic work. Hollander showed a number of small lithographic suites in which he added hand variations to printed forms. The original lithographs from zinc plates were pulled in editions up to eighteen, each different.

129
Donald Hopkins
(b. Alpena, Michigan, 1945)
Somewhere near the Border 1975
Etching and chine collé with
hand-coloring, 17 x 22 (20 x 25)
Ed: 4 artist's proofs
The artist
20th National Print Exhibition selection

Hopkin's mysterious *Somewhere near the Border* was printed by the artist in three press runs. The first printing was of a zinc plate photo etched with a wave image and inked in medium blue; cadmium yellow was relief rolled onto the upper right of the plate. The second printing in cadmium yellow etching ink was of hand-drawn lines registered to the waves photo etched on the zinc plate. The third printing was of chine collé shapes established by stencil and colored in pencil on lightweight Rives. Aquatint was used for shadow areas in the zinc plate and printed in vine black. Graphic Chemical Company inks were used. Printing was on black Arches.

130 *not illustrated*
Donald Hopkins
(b. Alpena, Michigan, 1945)
Burning of the Shrine 1976
Intaglio, 17 x 20½ (19½ x 23). Ed: 5
The artist
20th National Print Exhibition selection

Hopkin's *Burning of the Shrine* has the logic of impact bu brings images together in dreamlike improbabilities Buildings burn at the center of the plate. Balloons fly overhead. The silhouette of a human figure cast from ar unseen source leans toward the conflagration. Hopkin printed two zinc plates in one press run each. The first wa aquatinted using spray can lacquer paint as the resist with asphaltum stop out. This plate was printed in cadmiun yellow etching ink with an uninked outer plate of lac quered matboard. The second plate was photo etched with images of the balloons, using Kodak KPR photo emulsion and developer. This plate was printed in cadmium red with a Mylar stencil of shadow relief rolled on the zinc and ma plates in vine black. Graphic Chemical Company ink were used. The artist printed on black Arches.

131 *left*
Richard Hunt 18☆
(b. Chicago, Illinois, 1935)
Composition 1969
Lithograph, 21¾ x 30⅝ (21¾ x 30⅝)
Ed: 90
The Brooklyn Museum,
Bristol-Myers Fund

Hunt is primarily a sculptor, but he has made effective use of the lithographic medium to deploy shapes and energies that interest him. These prints need not be read as notations for sculpture. They have things to say about form and space that are entirely appropriate to a two-dimensional medium. This lithograph was printed from a stone in black at Lakeside Studio, Lakeside, Michigan.

132 *left*
Robert Indiana 17☆
(b. New Castle, Indiana, 1928)
Polygons #4 1975
Screenprint, 24 x 22 (30¾ x 28)
Ed: 100
Editions Denise René
20th National Print Exhibition selection

Indiana is internationally known for his paintings and prints involving flat areas of high-keyed color in patterns with language and numbers worked into the design. His is certainly graphic art, whatever the means. Indiana has the ability to attract and hold the eye. Color, pattern, and scale of statement are crucial to his effectiveness. "Polygons," typical of the forceful visual quality of his work, is a series of seven screenprints executed under his direction at the Ives-Sillman Studio, North Haven, Connecticut.

133 *above*
Herb Jackson
(b. Raleigh, North Carolina, 1945)
Bloom 1975
Intaglio, 17¾ x 23¾ (22 x 30)
Ed: 70
The artist
20th National Print Exhibition selection

Jackson's prints are notable for their elegant abstract structures, which combine formal with informal elements, and for their apt color. This work operates on a number of sensational levels and may be thought of as something happening before our eyes: a presentation, not of objects or images, but of processes. *Bloom,* in three colors, was printed from three copper plates on Rives BFK paper by Robert Townsend at Impressions Workshop Inc., Boston.

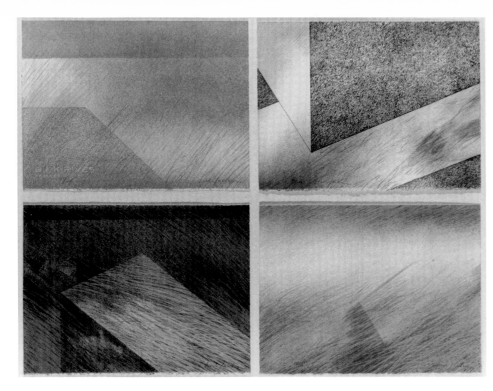

134

Herb Jackson
(b. Raleigh, North Carolina, 1945)
**22 x 30: Luna, Eclipse, Down Wind,
Sand Dust** 1975
Lithograph, 4 parts, each 11 x 15 (11 x 15). Ed: 100
The artist
20th National Print Exhibition selection

The lithographs in Jackson's suite vary in mood but not in color interest. All are in four colors printed on Rives BFK paper from two stones and two aluminum plates and bled. The printer was Paul Maguire at Impressions Workshop Inc., Boston.

135

Yvonne Jacquette
(b. Pittsburgh, Pennsylvania, 1934)
Traffic Light Close Up 1975
Monotype, 18 x 23½ (19½ x 25½)
Ed: unique
Brooke Alexander, Inc.
20th National Print Exhibition selection

Jacquette's monoprint is a freer use of the thematic materials she has developed in such lithographs as *East 15th Street* (1974). The traffic signal seen close up takes on a luminous diffusion of color that approximates the glow of its signals. There is also present in this print a sense of color as seen through city air. The print has a quality of personal touch not to be found in the more elaborate transfers of lithography. The plate was printed by the artist.

136 *right*
Angela Jansen 17☆
(b. New York, New York, 1929)
Cactus and Cabbage 1974
Etching, 9 x 11½ (15 x 22). Ed: 25
Ellen Sragow, Ltd./Prints on Prince St.
20th National Print Exhibition selection

Jansen often explores the relationship between photography and etching, trying in her prints for a dialogue between the two mediums. In *Cactus and Cabbage,* she has relied directly upon draughtsmanship. Her drawing here suggests both tentativeness (the spidery lines) and labor (the pressure of the bite). A lack of fussiness in the treatment of the plate gives an augmented sense of the organic. Jansen's etchings involving photography are not so unified in effect. The artist printed the plate.

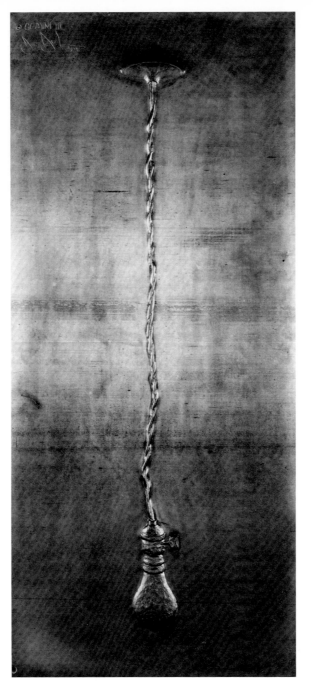

137 *above*
Jasper Johns 16☆
(b. Augusta, Georgia, 1930)
Two Maps I 1965–66
Lithograph, 33 x 26 (33 x 26). Ed: 30
Museum of Modern Art, New York, Gift of
the Celeste and Armand Bartos Foundation
20th National Print Exhibition selection

Johns produced a masterful print in this double image of
America pulled on black Fabriano paper. *Two Maps I* was
printed in white from one stone and one plate by Ben
Barns at Universal Limited Art Editions, West Islip, New
York.

138 *not illustrated*
Jasper Johns 16☆
(b. Augusta, Georgia, 1930)
Paintbrushes 1967
Etching and aquatint, 26 x 21¾ (26 x 21¾). Ed: 40
The Metropolitan Museum of Art,
Gift of Dr. Joseph I. Singer, 1972
20th National Print Exhibition selection

Johns's *Paintbrushes* is one of a suite of seven etchings and
aquatints plus six etchings over photoengraved plates
printed on handmade Auvergne paper by Donn Steward
at Universal Limited Art Editions, West Islip, New York.
The prints in this series are all second states of "First
Etchings," a boxed suite issued in 1968 by Universal Li-
mited Art Editions.

139 *left*
Jasper Johns 16☆
(b. Augusta, Georgia, 1930)
Light Bulb 1969
Lead relief, 39 x 17 (39 x 17). Ed: 60
Gemini G.E.L.
20th National Print Exhibition selection

Johns's *Light Bulb* is one of a series of five lead reliefs
published in 1969 by Gemini G.E.L., Los Angeles. The
direct antecedent for *Light Bulb* was *Recent Still Life*
(1965–66), a lithographic poster Johns produced for the
Rhode Island School of Design. Printing was by Kenneth
Tyler.

140 *not illustrated*
Jasper Johns 16☆
(b. Augusta, Georgia, 1930)
Flags II 1967–70
Lithograph, 34 x 25 (34 x 25). Ed: 9
Museum of Modern Art, New York, Gift of
the Celeste and Armand Bartos Foundation
20th National Print Exhibition selection

Johns's *Flags II* is a print of experimental character, depen-
dent on the artist's visualization rather than simply on his
skill as a draughtsman. The image was printed from five
stones and five plates with the addition of two rubber
stamps. Printing was done at Universal Limited Art Edi-
tions, West Islip, New York.

141 *below*

Jasper Johns 16☆
(b. Augusta, Georgia, 1930)
Decoy I 1971
Lithograph, 40⅜ x 29⅝ (40⅜ x 29⅝)
Ed: 55
The Metropolitan Museum of Art,
Gift of Dr. Joseph I. Singer, 1973
20th National Print Exhibition selection

Johns's *Decoy I* is among the most elaborate and effective prints the artist has made in the 1970s. The lithograph, from one stone and eighteen plates, was printed on Rives BFK paper at Universal Limited Art Editions, West Islip, New York.

142

Jasper Johns 16☆
(b. Augusta, Georgia, 1930)
Scent 1975–76
Lithograph, linocut, and woodcut,
31½ x 47 (31½ x 47). Ed: 42
Private collection
20th National Print Exhibition selection

Johns's *Scent* is lithograph, linocut, and woodcut, four plates and four blocks, respectively and appropriately. The print is on Twinrocker Mill handmade paper and was printed at Universal Limited Art Editions, West Islip, New York.

143
Jacob Kainen 3☆
(b. Waterbury, Connecticut, 1909)
Sun in the Hills 1951
Woodcut and stencil, 12¼ x 15
(15 x 18). Ed: unique
The artist
20th National Print Exhibition selection

Kainen produced this lively print with woodcut and stencil. Forms and marking systems found in *Sun in the Hills* appear elsewhere in the artist's work. Kainen's visual language has had consistency over a lifetime of painting and printmaking, not by self-imitation but through a way of seeing and feeling that have retained creative suppleness.

144
Jacob Kainen 3☆
(b. Waterbury, Connecticut, 1909)
Cloudy Trophy 1975
Intaglio, 20 x 15¾ (27 x 22¼). Ed: 40
The artist
20th National Print Exhibition selection

Kainen is inventive, consistent, and at ease in woodcut, lithography, and etching. *Cloudy Trophy* was worked with hard ground drawing, elements of drypoint, sugar lift and hand-brushed aquatint, and aquatint. It was printed from two copper plates in orange and black respectively on Arches Cover paper (creme) by Timothy Berry at Teaberry Press, Chicago.

145
David J. Kaminsky
(b. Miami, Florida, 1950)
Cigar Box 1972–74
Collotype, 8⅛ x 5½ (10½ x 10⅛)
Ed: 2
The artist
20th National Print Exhibition selection

Kaminsky's *Cigar Box* was done from color separation negatives and printed by the collotype method. The acid color is particularly pleasing.

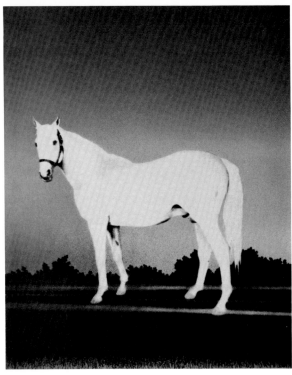

146 *above*
Howard Kanovitz
(b. Fall River, Massachusetts, 1929)
The Horse 1974
Lithograph, 30 x 23 (35½ x 24⅞)
Ed: 100
Ellen Sragow Ltd./Prints on Prince St.
20th National Print Exhibition selection
Kanovitz's *The Horse* is an excellent example of what can
be done when an artist prints color to enhance white shape.
The figure of the animal is treated minimally with color
accents mainly in the head. The body white, which is
simply the white of Arches paper, comes over with an
unearthly intensity.

147 *below*
Susan Kaprov
(b. New York, New York, 1944)
Self-Portraits 1975
Color Xerox, 3 parts, each 14 x 8½
(14 x 8½). Ed: unique
The artist
20th National Print Exhibition selection
Kaprov used color Xerox to produce these monoprints.
The element of distortion and the transparencies and over-
lays of color and texture give evidence of the technical
range of the process. With these self-portraits, the artist
has used the medium expressively, inventively, and
aesthetically.

148 *left*
Alex Katz 17☆
(b. New York, New York, 1927)
Anne 1973
Lithograph, 27 x 36 (27 x 36). Ed: 83
Brooke Alexander, Inc.
20th National Print Exhibition selection

Judged by the drawing, coloring, and the
color printing of Katz's *Anne,* it is one of the
best prints of this considerable artist. The
lithograph was printed in nine colors on
seven plates and two stones on Arches Cover
paper. Printing was by Paul Narkiewicz.

149 *right*
Bryan Kay
(b. Sea Isle City, New Jersey, 1944)
Crowhill State 3 1975
Etching, 10¾ x 7⅞ (18¾ x 15). Ed: 25
Jane Haslem Gallery
20th National Print Exhibition selection

Kay is an unusually gifted etcher in the tradi-
tional mood. His study of trees, *Crowhill,*
deals not only with their explicit images but
with the space and atmosphere among them.
The artist's management of tones is discreet
but brilliantly effective.

150 *right*
Ellsworth Kelly 18☆
(b. Newburgh, New York, 1923)
Red Orange/Yellow/Blue 1970
Lithograph, 42½ x 30 (42½ x 30)
Ed: 75
Gemini G.E.L.
20th National Print Exhibition selection

Kelly's paintings, radically simplified in
form, find an echo in his prints. Often, how-
ever, the image will sit in the space of the
paper sheet without necessarily creating the
tensions that are a feature of so many of Kel-
ly's painted works. When the print is success-
ful, the adjustment of color and shape to the
paper's dimensions of height and width is
crucial. *Red Orange/Yellow/Blue* is a three-
color lithograph printed by Ron Olds on
Special Arjomari paper at Gemini G.E.L., Los
Angeles.

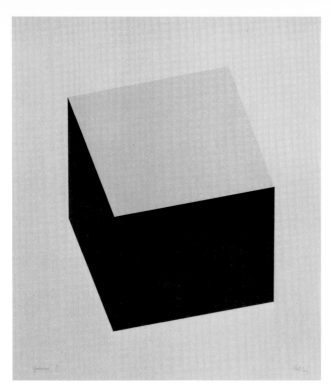

151
Ellsworth Kelly 18☆
(b. Newburgh, New York, 1923)
Yellow/Black 1970
Lithograph, 41⅜ x 36 (41⅜ x 36)
Ed: 75
Gemini G.E.L.
20th National Print Exhibition selection

Kelly's *Yellow/Black* presents its cube image with force. Illusion and flatness are in effective interplay. This two-color lithograph was printed by Timothy Huchthausen on Special Arjomari paper at Gemini G.E.L., Los Angeles.

152
Hugh Kepets 18☆
(b. Cleveland, Ohio, 1946)
Sixth Avenue 1976
Screenprint, 36 x 30 (41¼ x 35)
Ed: 85
The artist
20th National Print Exhibition selection

Kepets is a painter for whom printmaking is a separate but equally important involvement. The print under review is from a suite of three titled "Escapes," that was published by G. W. Einstein. *Sixth Avenue* is a ten-color screenprint. The screens were hand-cut by the artist, who supervised the printing by Sheila Marbain.

153
Kenneth A. Kerslake 12☆
(b. Mount Vernon, New York, 1930)
The Magic House: Reverie 1974
Intaglio and photo etching, 9 x 12
(17 x 22). Ed: 20
The artist
20th National Print Exhibition selection

Kerslake has described his printmaking activity as having a collecting phase. He is attracted to the idea of combining in one print images from different places and times. To this end he has developed a film file. He draws on paper or Mylar to reconcile the images he has selected. When he has assembled his material, he will often begin work on the actual print by combining several negatives or drawings on photoprint paper using standard photographic techniques to manipulate the image. Collage may also be used to create new and surprising relationships. Again, drawing may be employed for transitions or to add accents. There will then be further camera work (some of which is experimental). In the platemaking phase, Kerslake uses mainly presensitized zinc plates. His printing method follows traditional methods for inking, wiping, and printing intaglio plates.

154
Kenneth A. Kerslake 12☆
(b. Mount Vernon, New York, 1930)
A Sense of Place 1976
Photo intaglio, 18 x 24 (22 x 30)
Ed: 50
The artist
20th National Print Exhibition selection

Kerslake's prints require a long gestation period and often a long production process. The artist manages every phase of production himself and is meticulous in matters of registration, clear transition, and tonal consistency. The quality of the camera work must never be less fine than the elements provided by hand.

155 *not illustrated*
Tchah-Sup Kim
(b. Kyoungsu, Korea, 1942)
Between Infinities 5 1976
Etching, 5¾ x 23½ (22½ x 30)
Ed: 15
The artist
20th National Print Exhibition selection

Kim's "Between Infinities" series demonstrates complex responses within the etching technique. Here, tones are managed by a careful draughtsmanship translated into depth of etch. Normal perspective is used; atmosphere is simply implied through suggestions of shadow.

156
Tchah-Sup Kim
(b. Kyoungsu, Korea, 1942)
Between Infinities 6 1976
Etching, 5⅞ x 24 (21⅞ x 30)
Ed: unknown
The artist
20th National Print Exhibition selection

Kim has given the sense of a grid or screen in this remarkable etching. The image is established as much by its invaded edges as by the apparently translucent surface of the image center. The etching was printed by the artist.

157
Misch Kohn 1☆
(b. Kokomo, Indiana, 1916)
Disappearing 8 1976
Etching and engraving, 5½ x 23¾
(19 x 36½). Ed: 25
SmithAndersen Gallery
20th National Print Exhibition selection

Kohn has worked successfully and often with great distinction in the intaglio processes. *Disappearing 8* shows his imaginative and technical flexibility, the rich variety of forms at his command, and his secure color sense.

158 *above*
Misch Kohn 1☆
(b. Kokomo, Indiana, 1916)
Labyrinth 1974
Aquatint and engraving, 6 x 4¾
(30¾ x 20½). Ed: 25
SmithAndersen Gallery
20th National Print Exhibition selection

Kohn's *Labyrinth* presents a glowing surface, delicately inflected with silver. This aquatint with color engraving demonstrates the elegant formulations of which this artist is capable.

159
Aris Koutroulis
(b. Athens, Greece, 1938)
Fallup 1973
Cliché verre, 20 x 16 (20 x 16). Ed: 6
The artist
20th National Print Exhibition selection

Koutroulis has experimented successfully with printing on photosensitive materials. *Fallup* is the first color state of a cliché verre printed by the artist.

160
Ronald T. Kraver 16☆
(b. Brooklyn, New York, 1944)
Untitled 1970
Intaglio, 23½ x 17½ (23½ x 17½)
Ed: unknown
The artist
20th National Print Exhibition selection

Kraver's prints in three dimensions, subtle in color and refined in form, avoid heavy reliance upon object quality for their effects. They are essentially visual and invite the viewer into their processes instead of presenting him with a thing to be looked at. They have no optimal viewing distance and can be appreciated, or read, close up. Kraver himself prints and assembles the intaglios.

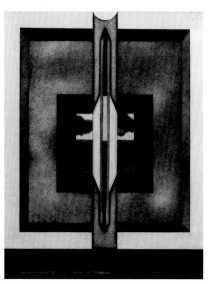

161
Armin Landeck 1☆
(b. Crandon, Wisconsin, 1905)
Rooftops—14th Street 1947
Drypoint, 8¼ x 14 (12⅜ x 18⅜)
Ed: unknown
The Brooklyn Museum,
Dick S. Ramsay Fund

Landeck lived for some time in the old Delmonico Hotel overlooking Union Square, and the streets and rooftops of the area figure in many of his prints. A number of these plates suggest at least sympathy for the work of Martin Lewis, Charles Sheeler, and Edward Hopper. Later Landeck came under the influence of S.W. Hayter.

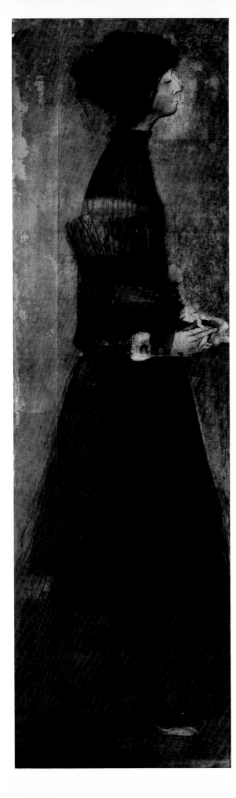

162 *left*
Mauricio Lasansky 1☆
(b. Buenos Aires, Argentina, 1914)
La Jimena 1960 or 1961
Intaglio, 65¼ x 16¾ (68 x 21). Ed: 50
The Brooklyn Museum,
Dick S. Ramsay Fund

Lasansky was a well-established artist in his native Argentina when he received a Guggenheim Fellowship to study printmaking in the United States in 1943. Once in New York, he worked with S. W. Hayter at Atelier 17, an experience that revolutionized his thinking and committed him securely to intaglio printing. His fellowship was renewed and, in 1945, he left New York for the University of Iowa for the purpose of organizing a graphic art department. His success with this endeavor is well documented; he became one of the most influential teachers of printmaking in America. He produced a body of work that both recapitulated a number of important styles and developments in modern intaglio printing, and he created a personal style of portraiture whose subjects are mainly family, friends, and Lasansky himself. The portraits are notable for tender feeling and gentle humor. *La Jimena* is Lasansky's daughter, Marie Jimena. The print is an etching with soft ground, drypoint, electric stippler, scraping, burnishing, and engraving. It was printed from four plates: one color plate and three copper master plates.

163 *right*
Mauricio Lasansky 1☆
(b. Buenos Aires, Argentina, 1914)
Quetzalcoatl 1972
Intaglio, 75⅜ x 33½ (78 x 35½)
Ed: 50
Jane Haslem Gallery
20th National Print Exhibition selection

Lasansky believes that mastery of technique releases creativity. But mastery for him has also had its seductions. *Quetzalcoatl* is a case in point. The print is a virtuoso performance, dazzling in its display of expertise: at the same time a textbook or one of those incredible records that demonstrate the agility of hi-fi equipment. The print involved etching, drypoint, soft ground, reverse soft ground, electric stippler, aquatint, engraving, scraping, and burnishing. The artist used fifty-four plates: one galvanized color master plate; forty-five plates assembled and shaped with copper, zinc alloy, and galvanized steel; and eight copper master plates.

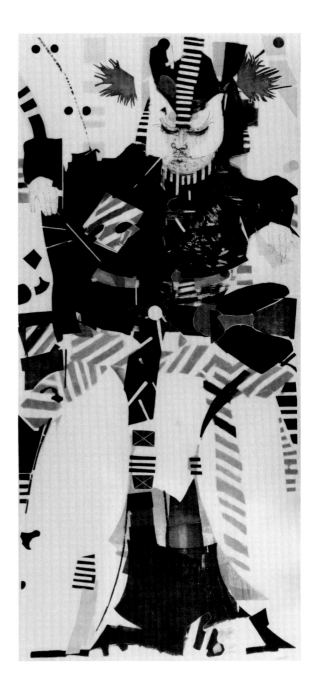

164 *not illustrated*
Carolyn Law
(b. Morgantown, West Virginia, 1951)
Made Paper Series No. VI 1976
Intaglio, 2 images, each 12⅜ x 8¾,
1 sheet (23 x 31½). Ed: 20
The artist
20th National Print Exhibition selection

Law's *Made Paper Series No. VI* was printed by the artist from two zinc plates etched with hard ground and polished with pomade. Printing was on English Etching paper in a single run with both plates. These were inked intaglio by finger with five to eight colors, then relief rolled. Pieces of rice paper and found paper from old prints were placed on the plate and treated with arrowroot starch paste so that they adhered to the plate by chine collé during printing. Sinclair and Valentine and Hanco lithographic inks were used, balanced with burnt plate oil. The artist printed the edition (each print different) at Triangle Studios in Seattle.

165 *bottom, left*
Carolyn Law
(b. Morgantown, West Virginia, 1951)
Paper Layers 1975
Relief with embossing, 16 x 15½
(28⅝ x 22¼). Ed: 5
The artist
20th National Print Exhibition selection

Law increasingly discovers the print in the process of making it. The idea is developed, though not necessarily elaborated, in terms of available or inventible technical procedures. The process of decision-making will be familiar to painters for whom the act of painting is the subject matter of art or to those who prefer improvisatory risk to preliminary studies and compositional foresight. *Paper Layers* involves embossing and relief. The two plates are rag matboard, torn and fixed with lacquer. Printing by the artist on German Etching paper was in one press run with both plates relief rolled, the larger plate with medium gray, the smaller with registered yellow and blue-gray.

166 *top, right*
Merle Leech
(b. Columbus, Kansas, 1941)
Divine Power 1976
Serigraph, 24 dia (30 x 34). Ed: 55
The artist
20th National Print Exhibition selection

Leech's *Divine Power* imposes an orientation problem upon the viewer, for no single perspective or referent will tell him where he is. The flat color and uninflected surfaces possible in serigraphy give resonance to what might have seemed an exercise in Esher-like design. The whole has a vitality that is not mere optical busyness. A spiritual purpose lies behind this work.

167 *right*
Mark A. Leithauser
(b. Detroit, Michigan, 1950)
Horological Fascination 1974
Etching and engraving, 2 images, each
8½ x 6¾, 1 sheet (11⅜ x 16¼). Ed: 75
The artist
20th National Print Exhibition selection

Leithauser seems to have tapped into the North European etching tradition with good effect. His plates, detailed and meticulous, are involved with a sense of focus—there is everything to be seen, and everything is seeable. The viewer is led subtly through visual complexities; at the same time, the overall image is arresting. *Horological Fascination* delights and amuses, but not at the expense of the artist's technical mastery.

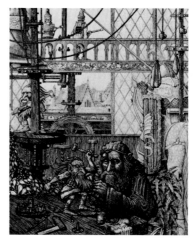

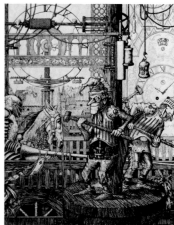

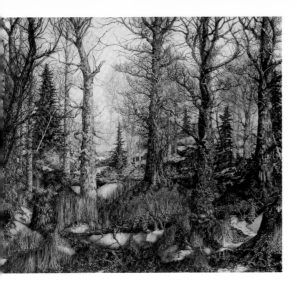

168
Mark A. Leithauser
(b. Detroit, Michigan, 1950)
The Migration 1976
Etching and engraving, 12 x 15
(14¼ x 17). Ed: 125
The artist
20th National Print Exhibition selection

Leithauser's forest is worthy of the Brothers Grimm. This wilderness beguiles with its splendid trees and dense undergrowth—and its creatures. Please find them. Again the artist's wit plays upon a magical subject—upon a common subject made magical by imagination. Leithauser uses engraving to heighten some of his effects. He prints his own etchings.

169 *not illustrated*
Alfred Leslie
(b. New York, New York, 1927)
Frank Fata 1974
Lithograph, 40 x 30 (40 x 30). Ed: 50
Landfall Press Inc.
20th National Print Exhibition selection

Leslie's portrait of Frank Fata is in the idiom of his own self-portrait, a dramatic and technically mannered drawing of head and upper body. Again the lithographic medium provides a bit of distance and impersonality for the viewer against the demand for attention implicit in the draughtsmanship. The portrait was hand-printed by David Keister in one block from a single stone on Arches Cover (white) at Landfall Press, Chicago.

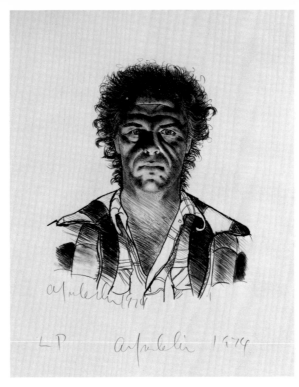

170 *above*
Alfred Leslie
(b. New York, New York, 1927)
Alfred Leslie 1974
Lithograph, 40 x 30 (40 x 30). Ed: 50
Landfall Press Inc.
20th National Print Exhibition selection

Leslie's dramatically lit self-portrait is essentially a product of draughtsmanship. At the same time, lithographic inks and presswork move the image slightly away from the intimacy of drawing. Given that this self-portrait is personality in every sense, more neutral marks are a plus, allowing the viewer a little more emotional distance. Of course, Leslie has heightened and emphasized for involvement; the mechanical intervention of print plays against this sense of the immediate. The lithograph was hand-printed by David Keister in black from stone at Landfall Press, Chicago.

171 *below*
Martin Levine
(b. New York, New York, 1945)
The Barn 1974
Intaglio, 10½ x 10½ (22 x 18½)
Ed: 125
ADI Gallery
20th National Print Exhibition selection

Levine's prints are a combination of all the intaglio processes: etching, engraving, drypoint, aquatinting, and various soft ground techniques. The artist has a consciousness—perhaps even an acute consciousness—of the historical development of intaglio printing. His images are often worked out in impressive detail. *The Barn,* sufficiently detailed, operates admirably in the realm of feeling.

172 *above*
Martin Levine
(b. New York, New York, 1945)
The Pardee House (West View),
Oakland, Ca 1976
Etching, 5¾ x 8½ (11 x 14). Ed: 100
ADI Gallery
20th National Print Exhibition selection

Levine's etching was produced on a commission from Clorox Corporation. It is an accurate documentation of an Oakland landmark. But Levine has gone beyond mere description without resort to the gimmickry of dramatic lighting or other underscoring in conveying the period character of the building.

173
Paul M. Levy
(b. Brooklyn, New York, 1944)
Commonwealth of Massachusetts
Building Code 1975
Serigraph, 16 x 16 (23 x 23). Ed: 50
Ellen Sragow Ltd./Prints on Prince St.
20th National Print Exhibition selection

Levy's *Commonwealth of Massachusetts Building Code* is one of a series of prints by him that play upon the idea and image of coding and dating as currently practiced by American business. The prints, on Strathmore paper, were made with a combination of hand- and film-cut silkscreens. The silkscreen technician for the project was Richard Wilman of the Cincinnati Silkscreen Company, Cincinnati.

174 *above*
Roy Lichtenstein 5☆
(b. New York, New York, 1923)
Entablature II 1976
Lithograph, screenprint, and collage
with embossing, 19¾ x 38 (29¼ x 45)
Ed: 30
Tyler Graphics Ltd.
20th National Print Exhibition selection

Lichtenstein's "Entablature" series required sophisticated print technology. *Entablature II* involves an embossed four-color hand-printed screen and lithograph with embossed gloss metallic copper foil and mat pink metallic foil. The light yellow and dark red screens were made from hand-cut film; the black color was printed from a direct photo screen. Foil was collaged to Rives paper under pressure using a flexible adhesive. Transparent white color was litho printed over the copper foil from a photographic metal plate. The metal embossing plate was photoengraved with a machined aluminum insert for the flute section. The work was done at Tyler Graphics Ltd., Bedford Village, New York.

175 *below, left*
Roy Lichtenstein 5☆
(b. New York, New York, 1923)
Entablature VIII 1976
Screenprint and collage with embossing,
21⅝ x 38 (29¼ x 45). Ed: 30
Tyler Graphics Ltd.
20th National Print Exhibition selection

Lichtenstein's *Entablature VIII* is an embossed six-color
hand-printed screenprint with collaged gloss metallic foil.
The bright yellow, orange, pink, and gray screens were
made from hand-cut film; the black color was printed
from a direct photo screen. The foil was collaged to the
Rives paper under pressure using a flexible adhesive. The
metal embossing plate was photoengraved with a
machined aluminum insert for the cove section. Printing
was at Tyler Graphics Ltd., Bedford Village, New York.

176 *right*
Roy Lichtenstein 5☆
(b. New York, New York, 1923)
Homage to Max Ernst 1975
Silkscreen, 21 x 15¾ (26 x 20). Ed: 100
Tyler Graphics Ltd.
20th National Print Exhibition selection

Lichtenstein's *Homage to Max Ernst* is a six-color silkscreen
hand-printed from five hand-cut film screens and one
direct photo transfer film screen. The black printing is
from the photo screen. The print was produced at Tyler
Graphics Ltd., Bedford Village, New York.

177 *below, right*
Roy Lichtenstein 5☆
(b. New York, New York, 1923)
Still Life with Crystal Bowl 1976
Lithograph and silkscreen, 32 x 43¼ (38 x 49½). Ed: 45
Multiples, Inc.
20th National Print Exhibition selection

Lichtenstein's unmistakable visual idiom is seen at its best
in prints like *Still Life with Crystal Bowl,* where the artist
comments upon some traditional or familiar system of
visual presentation through his own system. This is an
eight-color print hand-printed from three lithographic
plates and five silkscreens on Rives BFK Roll Stock. Print-
ing was at Styria Studio, New York.

178
Richard Lindner 16☆
(b. Hamburg, Germany, 1901)
Fun City 1971
Lithograph, 26¾ x 39⅝ (28 x 40⅛)
Ed: 175
The Brooklyn Museum,
Gift of Mr. and Mrs. Samuel Dorsky

Lindner painted a series of watercolors in 1968 and 1969 on the theme of New York as Fun City. These watercolors became the basis for a suite of fourteen lithographs printed from stone in 1971 by the Shorewood Graphic Workshop under the artist's supervision and published by Shorewood Publishers, New York. There were three editions, one for the American market (numbered 1–175), another for the non-American market (numbered I–L), and a third (twenty-six alphabetized) denominated deluxe for those who might care. The American edition was printed on Arches Vellum. The project has appeal because Lindner's images are fundamentally graphic.

179 *top, left*
Vincent Longo 7☆
(b. New York, New York, 1923)
ABCD 1971
Etching and aquatint, 11⅝ x 8⅞ (20 x 15). Ed: 10
The artist
20th National Print Exhibition selection

Longo's *ABCD* is an ongoing project. The artist uses four interchangeable plates in varying sequences and color combinations. The prints in this series are extraordinary for softness and richness of color. Plates A and B are lift ground etchings with open bites and with additions of aquatint in a loose grid pattern. Plates C and D are deeply etched grids with additions of aquatint. Longo has pulled numerous proofs as well as small editions in three states. Printing is by the Etchers Press.

180 *bottom, left*
Vincent Longo 7☆
(b. New York, New York, 1923)
First Cut, Second Cut, Third Cut 1974–75
Woodcut, 24 x 18 (30 x 23). Ed: 25
The artist
20th National Print Exhibition selection

Longo's woodcuts have always been a provocative and satisfying part of his considerable output in printmaking. The vigor and freedom of his cutting has added a new fluency to a medium where the current discriminations are either too broad or too nice. *First Cut, Second Cut, Third Cut* demonstrates how a sense of evolving formalities can be achieved without design. The artist carved directly on a pine drawing board in three states. Each state is an autonomous work; the three together make a functioning triptych. Printing was by the Etchers Press.

181 *right*
Vincent Longo 7☆
(b. New York, New York, 1923)
Untitled 1976
Aquatint, 14 x 12 (23½ x 19). Ed: unique
The artist
20th National Print Exhibition selection

Longo has been interested in grids and mandalas virtually from his earliest days as an artist, and these images have appeared and continue to appear in his paintings and in his graphic work. In this print, the mandalic shape is floated on the grid, which itself has a flickering pattern. Shape and apparent regularity are used to create an ambiguity of surface and hence an indeterminate space and scale. The glowing orange-bronze color contributes to visual equivocation by being both substantial and luminous. The artist printed this proof. As of this writing, there is no edition.

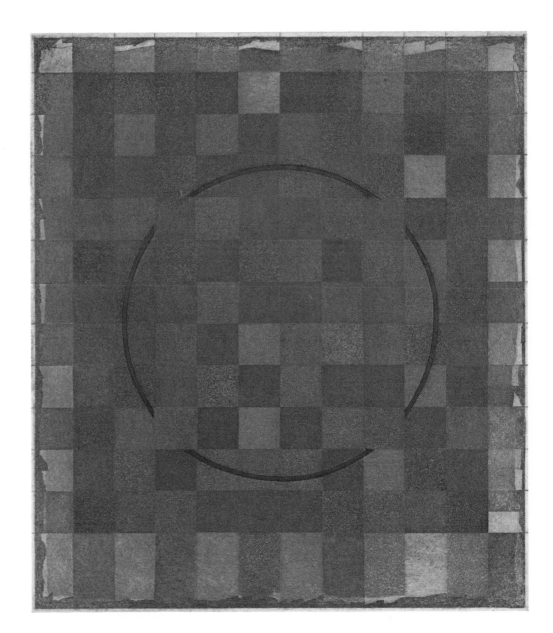

182 *below*
Louis Lozowick 4☆
(b. Kiev, Russia, 1892;
d. Orange, New Jersey, 1973)
Design in Wire 1949
Lithograph, 8⅝ x 11⅜ (12 x 13¾)
The Brooklyn Museum

Lozowick taught himself lithography and over the years developed techniques in the medium that were not at all standard. Characteristically this artist worked from the deepest to the palest tones. He often rubbed his inks for effects of softness or light diffusion. *Design in Wire* won a Purchase Award at The Brooklyn Museum's 4th National Print Exhibition.

183 *above*
Bruce McCombs
(b. Cleveland, Ohio, 1943)
Street Corner 1975
Etching, 23¾ x 36 (26¼ x 37½)
Ed: 150
Jane Haslem Gallery
20th National Print Exhibition selection

McComb's *Street Corner* is one of a series of large etchings he has done that use imagery out of the 1930s and '40s. These derive in a general way from a variety of photographic sources but are not copied from photographs. *Street Corner* is no particular corner in an actual city but is a composite. The work, which was originally a line etching, was further developed with aquatint, roulette, engraving, and mezzotint. The print took five months to complete. Printing was by McCombs.

184 *right*
Jim McLean 14☆
(b. Gibsland, Louisiana, 1928)
Flight over Busch Gardens 1975
Relief etching, 22⅞ x 30¼
(28½ x 35¼). Ed: 20
The artist
20th National Print Exhibition selection

McLean's current printmaking procedure is to photograph what he has called "original bits of junk" with four-by-five Kodak Autoscreen film, which has a built-in halftone pattern. He enlarges the negatives to make positives in various sizes. These he cuts up, assembling new images from the pieces. The collage positives are photoengraved on micrometal and etched in nitric acid. The finished plates are rolled up and printed as relief prints. McLean adds colors by cutting shapes from thin offset plates, inking these separately and positioning them on the photoengraved plates. All colors are printed at the same time in a single trip through the etching press. McLean personally handles every aspect of the process, from finding his junk to final printing. *Flight over Busch Gardens* is typical of the imaginative verve and technical finish of his work.

185 *not illustrated*
Jim McLean 14☆
(b. Gibsland, Louisiana, 1928)
Primitive Plant—State I 1975
Relief etching, 23⅝ x 17½
(28½ x 21⅝). Ed: 10
The artist
20th National Print Exhibition selection

McLean's early prints often depended upon found objects
or images. These would be drawn or photographed for the
purposes of printmaking and transformed through altera-
tions of scale or color or through unfamiliar juxtaposi-
tions. In his more recent prints, such as *Primitive Plant,*
McLean's typical materials are further transformed by
being cut up and reassembled into forms that often bear
little relation to the source object or image.

186 *left*
Brice Marden 18☆
(b. Bronxville, New York, 1938)
Painting Study II 1974
Silkscreen with wax and graphite
applications, 9½ x 6¾ (30 x 22)
Ed: 50
Multiples, Inc.
20th National Print Exhibition selection

Marden's *Painting Study II* is one of those rare prints that
suggests new (if difficult) avenues of development for
printmaking. In this instance, an unusual surface quality
and depth of black has been achieved by applying wax and
graphite. The basic print is silkscreen. There were eleven
printings (including the wax and graphite applications) on
Dutch Etching paper. The printing was done at Styria
Studio, New York. The publisher is Multiples, Inc., New
York.

187 *not illustrated*
Boris Margo 1☆
(b. Wolotschisk, Russia, 1902)
Alchemist #2 *circa* 1947
Cellocut, 33½ x 23 (36 x 24). Ed: 10
The Brooklyn Museum

Margo's *Alchemist #2* won a Purchase Award at The
Brooklyn Museum's 1st National Print Exhibition. The
print is a cellocut, which is a process developed by Margo
in the 1930s that involved dissolving celluloid in acetone
and creating an image from it on an etching plate or other
rigid surface that could be printed. The material is versatile
and can be teased into interesting shapes with a great range
of textures. When it has dried, it can be worked on with a
variety of tools and can be combined with other print
processes. Inking can be intaglio or relief or both. Margo
has also printed cellocut images uninked.

188 *left*
Boris Margo 1☆
(b. Wolotschisk, Russia, 1902)
Jewels in Levitation 1949
Cellocut, 16 x 22¼ (18 x 24). Ed: 10
The Brooklyn Museum

Margo's *Jewels in Levitation* shows the free shapes, textural variety, and refined color that is possible in the cellocut.

189
Sherry Markovitz
(b. Chicago, Illinois, 1947)
Ovulation II 1975
Gum bichromate with watercoloring,
16 x 19 (16 x 19). Ed: unique
The artist
20th National Print Exhibition selection

Markovitz's gum bichromate print is based upon a series of photographs taken over the course of a menstrual cycle, but the images become part of a quasi-abstract pattern under impact of the print process. The artist has added watercolor, taking her material still farther away from realism.

190
Michael Mazur 12☆
(b. New York, New York, 1935)
Smoke 1975
Engraving and aquatint, 17¾ x 35¼
(26 x 54). Ed: 25
Jane Haslem Gallery
20th National Print Exhibition selection

Mazur's print can be considered a play between solidity and atmosphere, between the dominating heavy table and the smoke rising from the ashtray. These two elements fill the visual field and are so insistently the focus of attention that a narrative purpose may seem suggested. But the print is not an illustration; the meaning is internal, in the relationship of images. *Smoke* was engraved on magnesium metal with a combination of machine tools that, according to the artist, "make a rather shallow cut akin to drypoint." Aquatint was added. Printing was done by the artist.

191 *illustrated in color on p98*
Nancy Mee
(b. Oakland, California, 1951)
A Modesto Truck Driver 1975
Diazo and Xerox transfer with
hand-coloring, 24 x 35½ (25 x 36¾)
Ed: 10
The artist
20th National Print Exhibition selection

Mee studied during 1971 and 1972 with S. W. Hayter at Atelier 17, Paris. But her prints are not what one would have expected from this encounter. They are visually episodic and narrative. They require the viewer to bend into them and to read them. The story is usually one of transformation. Process, too, is non-standard and mixed. For *A Modesto Truck Driver,* the artist made Xerox transfers, drew, and glued Kodalith films on translucent graph paper. She made a transparency of this work, which was printed by commercial process on light-sensitive paper. She then worked further on the print with colored pencils, paint, and film blockout.

192 *not illustrated*
Nancy Mee
(b. Oakland, California, 1951)
Scoliosis in a 15-Year-Old Girl 1976
Serigraph and Xerox transfer with
hand-coloring, 17⅞ x 26
(17⅞ x 26). Ed: 8
The artist
20th National Print Exhibition selection

Mee's *Scoliosis in a 15-Year-Old Girl* is a five-color photo serigraph with Xerox transfer printed and hand-colored by the artist. Text in the print is hand-written and consistent throughout the edition.

80

193 *left*
Peter Milton 14☆
(b. Lower Merion, Pennsylvania, 1930)
Card House 1975
Etching and engraving, 22 x 27½
(27⅜ x 33⅜). Ed: 160
The artist
20th National Print Exhibition selection

Milton's *Card House* was developed from photographic images and drawings on Mylar collaged and contact-printed from high contrast film onto a presensitized copper plate. Considerable engraving completed the plate preparation. Printing was by Robert Townsend at Impressions Workshop Inc., Boston.

194 *below, left*
Peter Milton 14☆
(b. Lower Merion, Pennsylvania, 1930)
Daylilies 1975
Etching and engraving, 19⅞ x 31⅞
(25⅜ x 37¾). Ed: 160
The artist
20th National Print Exhibition selection

Milton's *Daylilies* derives from a preliminary drawing o acetate. This drawing was then transferred to a coppe plate treated with a photosensitive ground. The centra part of the image also involves a graphite drawing phot transferred from a high contrast film contact-printed s that the particles of photographic grain are a visual issue i the print. Milton developed the image through muc straight burin engraving. The edition was printed b Robert Townsend at Impressions Workshop Inc., Boston

195 *left*
Peter Milton 14☆
(b. Lower Merion, Pennsylvania, 1930)
A Sky-Blue Life 1976
Etching and engraving, 25¾ x 32½
(30¾ x 42). Ed: 160
The artist
20th National Print Exhibition selection

Milton's *A Sky-Blue Life* is probably his most complex work. To begin with, he printed the copper plates of two previous prints, *Free Fall* and *Pastoral,* in reverse on acetate. He produced a film negative from this print using high-contrast film. This image became the basis of a collage along with new material drawn on Mylar. Milton contact-printed this image on copper. After considerable engraving, the image became *Second Opinion,* but Milton was dissatisfied with the print. He added three sections from other works to the plate, as well as more drawing on Mylar. He then contact-printed this image over the old plate and, after five more months of engraving, voilà, the print was done! The edition was printed by Robert Townsend at Impressions Workshop Inc., Boston.

196 *left*
Gordon Mortensen
(b. Arnegard, North Dakota, 1938)
Summer Pond 1976
Woodcut, 18¾ x 26 (21¼ x 29). Ed: 100
ADI Gallery
20th National Print Exhibition selection

Mortensen is not a realistic landscape artist. He uses natural forms as a pretext for investigating relationships of color, shape, texture, and line. *Summer Pond* is a reduction woodcut printed on Toronoko paper. It has twenty-three colors put down in nineteen press runs. The artist printed his own work.

197 *right*
Ed Moses 19☆
(b. Long Beach, California, 1949)
Broken Wedge Series No. 6 1973
Lithograph on silk, 24 x 18½
(24 x 18½). Ed: 50
Cirrus Editions Ltd.
20th National Print Exhibition selection

Moses's *Broken Wedge Series No. 1* was shown in The Brooklyn Museum's 19th National Print Exhibition. The present variation shows the artist dealing with greater complications of color. The print is a six-color lithograph printed on four sheets of paper by Master Printer Ed Hamilton. First, pink was printed on silk tissue; second, peach, green, and yellow washes were printed on A. T. tissue; third, green was printed on silk tissue; fourth, black was printed on Arches paper. The image was bled. The sheets were overlaid and fixed.

198 *illustrated in color on p14*
Robert Motherwell 15☆
(b. Aberdeen, Washington, 1915)
Bastos 1975
Lithograph, 62⅜ x 40 (62⅜ x 40)
Ed: 49
Tyler Graphics Ltd.
20th National Print Exhibition selection

Motherwell's *Bastos* is a six-color hand-printed lithograph from one hand-drawn and five photo aluminum plates. The paper is mold-made Arjomari. Plate preparation, proofing, and printing were by Master Printer Kenneth Tyler assisted by Don Carli at Tyler Graphics Ltd., Bedford Village, New York.

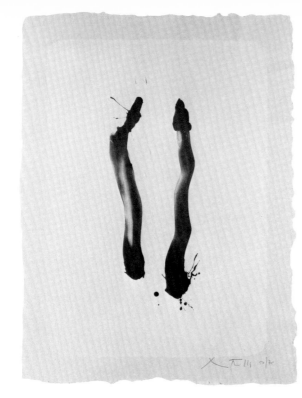

199
Robert Motherwell 15☆
(b. Aberdeen, Washington, 1915)
The Stoneness of the Stone 1974
Lithograph, 35 x 24 (41 x 30). Ed: 75
Brooke Alexander, Inc.
20th National Print Exhibition selection

Motherwell used a laminated paper for this edition whose image mimics a lithographic stone in shape and color. Twinrocker Mill created the two-color gray paper by bonding together two moist sheets of pulp during the papermaking process. There was a single hand-printing in black from one drawn stone. Stone preparation, proofing, and printing were by Master Printer Kenneth Tyler assisted by Don Carli at Tyler Graphics Ltd., Bedford Village, New York. The simple, effective idea was the artist's.

200
Robert Motherwell 15☆
(b. Aberdeen, Washington, 1915)
Untitled (beige/blue/black) 1975
Aquatint, 9⅞ x 11¾
(30 x 22¼). Ed: 96
Brooke Alexander Inc.
20th National Print Exhibition selection

Motherwell is a major graphic artist. Even in his paintings, he often reaches towards solutions that are essentially graphic. This three-color aquatint, so indeterminate in scale, so sensitively managed as to surface, reveals painterly qualities intrinsic to the aquatint medium. Three colors were printed as follows: beige, blue, and black on Arches paper (buff) by Catherine Mousley at Greenwich, Connecticut.

201
Frances Myers 16☆
(b. Racine, Wisconsin, 1936)
Monte Alban I 1976
Aquatint, 22 x 27½ (25 x 35½). Ed: 35
The artist
20th National Print Exhibition selection

Myers's concern with architectural imagery is no documentary. It has a spiritual impulse. Man is what h builds. The "Monte Alban" series seems to express th monumental character of building, both in the striving fo distinguished scale and in the intent to memorialize, t carry aspiration into time. *Monte Alban I* was printed o Arches Cover paper by the artist from two stage-bitte aquatinted copper plates. The first plate carried the blu tones; the second plate carried the orange-brown tone and was printed over the first plate, wet into wet.

202 *not illustrated*
Frances Myers 16☆
(b. Racine, Wisconsin, 1936)
Monte Alban III 1976
Aquatint, 22 x 28 (25 x 35¼). Ed: 35
The artist
20th National Print Exhibition selection

Myers's printed *Monte Alban III* on Arches Cover pape from a single sixteen-gauge copper plate that had bee aquatinted and bitten in acid in five stages. It was printed *la poupée* with the orange ink blended into the gray ink

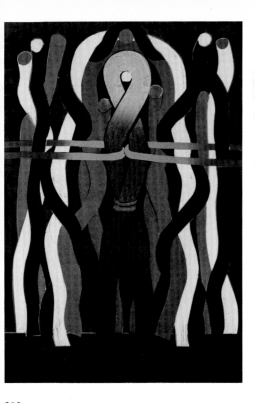

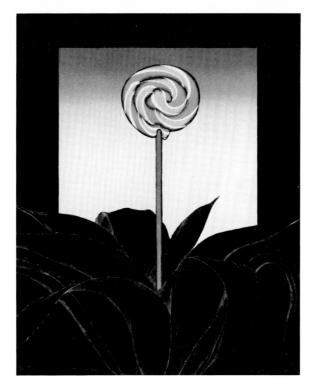

205 *below*
Bruce Nauman 18☆
(b. Fort Wayne, Indiana, 1941)
Untitled 1971
Lithograph, 30 x 42 (30 x 42). Ed: 75
Cirrus Editions Ltd.
20th National Print Exhibition selection

This three-color lithograph of 1971 has greater lightness of touch and lyrical feeling than can be found in Nauman's later prints, which involve language or lettering. Printing was in three runs: first, gray; second, transparent black; third, red-orange. The image was bled. The paper is Rives BFK.

203
George Nama 14☆
(b. Pittsburgh, Pennsylvania, 1939)
Reeds 1975
Collagraph, intaglio, and serigraph,
34 x 22 (43 x 30). Ed: 30
The artist
20th National Print Exhibition selection

Nama's graphics are distinguished for bold, personal color and for an imagery of forms under tension. He is a sculptor who also studied printmaking for three years in Paris with S. W. Hayter at Atelier 17. Nama's works begin as collagraphs. They are printed as intaglios from masonite plates that have been engraved and prepared with gesso, modeling cement, and fabrics and sealed with a layer of polymer medium. Later the artist adds color through serigraphy. He does his own printing.

204
Kenjilo Nanao 18☆
(b. Aomori, Japan, 1929)
Further Variations on a Sucker 1973
Lithograph, 28 x 22 (28 x 22). Ed: 20
SmithAndersen Gallery
20th National Print Exhibition selection

Nanao showed another print (*Dream over the Hills*) on the sucker theme in The Brooklyn Museum's 18th National Print Exhibition. The present print is a more complex variation. The key image is the reversal of a drawing that was executed with crayon on a stone. Four color runs (black, red, purple, and a blue rainbow roll) were printed from aluminum plates by the artist on German Etching paper. Nanao showed work at The Brooklyn Museum Art School in 1964. He was the recipient of a Ford Foundation Grant to the Tamarind Lithography Workshop for 1968–69.

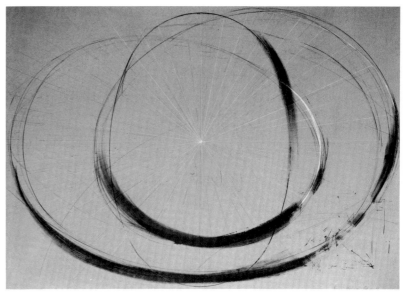

206
Bruce Nauman 18☆
(b. Ft. Wayne, Indiana, 1941)
M. Ampere 1973
Lithograph, 31 x 45⅛ (31 x 45⅛)
Ed: 50
Cirrus Editions Ltd.
20th National Print Exhibition selection

Nauman's feeling for the tonal vigor of the lithographic medium is revealed in *M. Ampere.* The print, which reads like a relief, was pulled from two stones (the first, black; the second, transparent tan) by Master Printer Ed Hamilton at Cirrus Editions Ltd., Los Angeles. The paper is roll Rives BFK.

207 *above, right*
Jim Nawara
(b. Chicago, Illinois, 1945)
Deadwood 1975
Lithograph, 20 x 24¾ (25 x 35¾)
Ed: 25
The artist
20th National Print Exhibition selection

Nawara's prints resemble high aerial views of the earth and present a crawling surface of marks and tones. In one sense they are spaceless. All incident appears to be virtually in the same plane. But there is also the suggestion of vast extent, as if we overlook miles, perhaps of wasteland. The artist has kept drawing foremost. He has not been at pains to exploit the lithographic medium and has made only minimal demands upon lithography. In *Deadwood,* the image was drawn directly upon an aluminum plate with Charbonnel lithographic ink. The artist has reported that pen nibs wore quickly against the plate grain and that he used many of them. The plate was printed in black on Arches paper by Douglas K. Semivan.

208 *not illustrated*
Jim Nawara
(b. Chicago, Illinois, 1945)
Mosaic 1975
Etching, 23¾ x 18 (27¼ x 21¼)
Ed: 50
The artist
20th National Print Exhibition selection

Nawara made a line drawing through liquid hard ground on a zinc plate for *Mosaic.* This was etched once and printed in black on Rives BFK paper by Paul Martyka of the Michigan Workshop of Fine Prints, Detroit, Michigan.

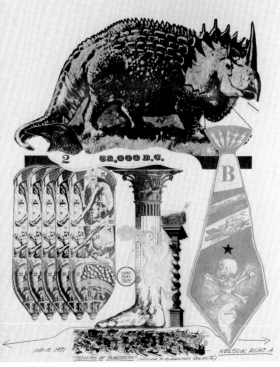

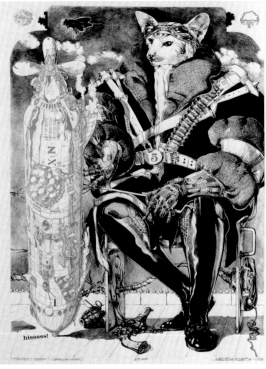

210 *below*
Robert A. Nelson 14☆
(b. Milwaukee, Wisconsin, 1925)
Cat and Mice 1975
Lithograph, 25 x 35½ (29½ x 38½)
Ed: 20
The artist
20th National Print Exhibition selection
Nelson's splendidly drawn lithograph is in two colors.
The paper is Arches (white). Metal type stampings are in
red lithographic ink. There was a single press run, the artist
printing.

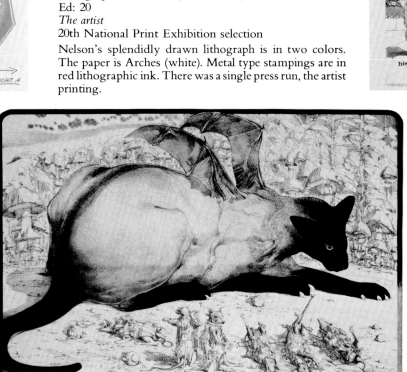

209 *above*
Robert A. Nelson 14☆
(b. Milwaukee, Wisconsin, 1925)
Bombs of Barsoom 1971
Litho-gravure and collage, 32¾ x 24
(37½ x 28¾). Ed: 15
The artist
20th National Print Exhibition selection
Nelson is one of our most imaginative and
technically proficient printmakers. In his fan-
tastic *Bombs of Barsoom,* there are seven at-
tached parts, the smaller of them rubber
stamped in lithographic inks on white and
buff Arches paper. The base printing stock
was Copperplate. Glue attachments are
P.V.A. Printing was by the artist. There were
four press runs.

211 *above*
Robert A. Nelson 14☆
(b. Milwaukee, Wisconsin, 1925)
Torpedo Tabby 1974
Litho-gravure and collage, 35¾ x 25½
(40 x 29½). Ed: 25
The artist
20th National Print Exhibition selection
Nelson is an outstandingly fluent
draughtsman. The figure of the uniformed
tabby is an extraordinary invention, executed
with fitting verve and grace. Here's romantic
dash with a vengeance. The print is in three
colors; the paper is French Arches, with three
attached parts; the glue is P. V. A. Four rubber
stampings are in lithographic ink (red and
black), and there is green verithin pencil
around the word "hiss" at the bottom. The
print made two press runs. The printer was
Nelson.

212
Lowell Nesbitt 18☆
(b. Baltimore, Maryland, 1933)
Lily State I 1975
Drypoint, 9⅛ x 5¾ (28⅝ x 21). Ed: 16
Brooke Alexander, Inc.
20th National Print Exhibition selection

Nesbitt's lilies are from a set of six drypoints that take the flower from the line drawing of State I through augmentation to a richly black image in State VI. Each state is considered by the artist a finished work. Nesbitt has been a prolific printmaker. These simple flower studies show him at his best. The suite was printed by Mohammed Khalil.

213
Lowell Nesbitt 18☆
(b. Baltimore, Maryland, 1933)
Sandstone Tulip 1976
Lithograph, 38½ x 31 (38½ x 31)
Ed: 100
Brooke Alexander, Inc.
20th National Print Exhibition selection

Nesbitt often benefits from simplicity as a graphic artist. *Sandstone Tulip* is a lithograph in one color drawn with a minimum of detail and printed as if it were floating on the handsome deckle-edged paper.

214 *below*
Louise Nevelson 8☆
(b. Kiev, Russia, 1900)
The Ancient Garden 1954
Etching, 27¼ x 21½ (29½ x 23⅝)
Ed: 20
The Brooklyn Museum,
Dick S. Ramsay Fund

Nevelson briefly studied etching with S.W. Hayter in 1947. For a three-year period beginning in 1953, she executed a series of thirty etchings with little consistency of papers or editions. The work was done at Atelier 17, New York. In 1965 and 1966, these intaglio plates were editioned formally under the supervision of Irwin Hollander at the Hollander graphic workshop, New York. The printer was Emiliano Sironi and the paper Rives BFK. *The Ancient Garden,* one of the original prints made at Atelier 17, is titled *Solid Reflections* in the formal edition by Hollander. The present etching is, in fact, a first state. In the Hollander edition (the second state), soft ground was added to the plate.

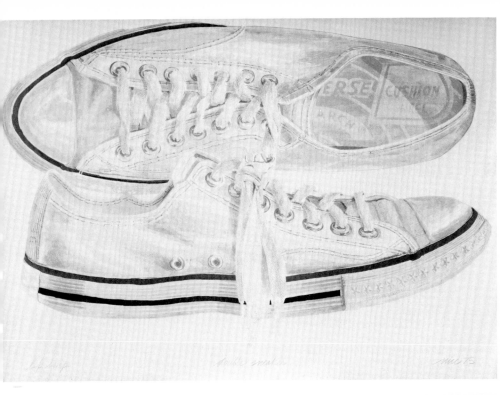

215
Don Nice 18☆
(b. Visalia, California, 1932)
Double Sneaker 1975
Lithograph, 34 x 47¾ (34 x 47¾)
Ed: 50
Landfall Press Inc.
20th National Print Exhibition
selection

Nice, who does fine drawing in col-
ored pencil, has a remarkable feel for
the potential clarity and transparency
of lithographic inks. Perhaps only
Claes Oldenburg has a comparable
sensitivity to the watercolor aspect of
lithography. *Double Sneaker* has a
glow to it, subdued and pearly. The
lithograph was printed from four
stones and six aluminum plates (one
color each to stones and plates) at
Landfall Press, Chicago, on paper
handmade by Twinrocker Mill. Pro-
cessing, proofing, and printing were
under the supervision of Jack Lem-
on. Hand-printing of the edition was
by David Keister assisted by Ron
Wyffels and Tom Hayduk. The
collaboration ran from June 11, 1974,
to January 10, 1975.

216
Don Nice 18☆
(b. Visalia, California, 1932)
Tootsie Pops 1974
Lithograph, 28½ x 41 (28½ x 41)
Ed: 50
Nancy Hoffman Gallery
20th National Print Exhibition
selection

Nice wants to get light and trans-
parency into his lithographic colors.
He doesn't use white ink in his mix-
tures or print with white, but uses
transparent base to thin his hues. He
likes to show as much brushwork as
possible, and he prefers papers that
print little ink. *Tootsie Pops* is a seven-
color lithograph printed from alumi-
num plates on J. Green paper at Fred
Genis Workshop, Friesland, Holland.

217 *illustrated in color as*
 frontispiece
Claes Oldenburg 18☆
(b. Stockholm, Sweden, 1929)
Floating Three-Way Plug 1976
Etching and aquatint,
42 x 32¼ (49¾ x 38½). Ed: 60
Multiples, Inc.
20th National Print Exhibition
selection

Oldenburg's *Floating Three-Way
Plug* combines two of his formidable
styles of draughtsmanship. The plug
itself is rendered with a certain for-
mality and precision, as if it were a
study for a template. Sky, land, sail-
boat, and water are broadly, expres-
sively drawn. In addition, there is the
calligraphic element of Oldenburg's
writing in the water, words generat-
ing ideas that, so to speak, plug artist
and viewer into the image. In one
sense, the language is a gloss on the
work process that gave rise to the
print. In another, it serves to em-
phasize that the outsize plug, which
seems real in the pictorial space be-
cause it is so much a part of it, is an
illusion itself, part of a still larger illu-
sion. The print is beautifully man-
aged both in etching quality and in
color. The printing is exemplary.
Floating Three-Way Plug is a color
etching with aquatint printed from
nine copper plates with five hand-
made colors on Rives BFK Roll
Stock with torn deckle edge. The edi-
tion was printed by John Slivon at
Crown Point Press, Oakland, Cali-
fornia, and published by Multiples,
Inc., New York.

218 *left*
Claes Oldenburg 18☆
(b. Stockholm, Sweden, 1929)
Mickey Mouse 1968
Lithograph, 22⅝ x 15¾ (22⅝ x 15¾)
Ed: 100
Gemini G.E.L.
20th National Print Exhibition selection

Oldenburg has manipulated the image of Mickey Mouse almost as much as Walt Disney has. He has made the form do a variety of visual and formal tricks. In this nine-color lithograph, the image is seen as a flat schematization, as an implied sculptural form in roughly two and a half dimensions. The artist's draughtsmanship and secure feeling for transformations keep things lively, but the medium provides a gloss upon the proceedings. The print is on Rives BFK paper. Printing was by James Webb at Gemini G.E.L., Los Angeles.

219 *not illustrated*
Claes Oldenburg 18☆
(b. Stockholm, Sweden, 1929)
Spoon Pier 1974
Etching and aquatint, 12½ x 10¼
(28 x 22). Ed: 50
Landfall Press Inc.
20th National Print Exhibition selection

Oldenburg's *Spoon Pier* is one of his monument series. The spoon extends out from shore over blue waters in a scale that makes the image persuasive. The printing was from four copper plates: the first, aquatint printed blue; the second, aquatint and sugar lift printed silver; the third, aquatint printed orange; and the fourth, soft ground drawing printed black. The paper was handmade by Twinrocker Mill. Master Printer Jack Lemon supervised processing, proofing, and printing. Hand-printing of the edition was by Timothy F. Berry at Landfall Press, Chicago.

220
Claes Oldenburg 18☆
(b. Stockholm, Sweden, 1929)
**Store Window: Bow, Hats, Heart,
Shirt, 29ᶜ** 1972
Lithograph, 22½ x 26¾ (22½ x 26¾)
Ed: 75
Landfall Press Inc.
20th National Print Exhibition selection

Oldenburg has used store windows and their contents in many works and in a spectrum of mediums. This lithograph brings together a number of items familiar in themselves that the artist has made use of over the years. They are presented buoyantly, with all the verve and freshness of watercolor; the transparent hues are brilliant and exuberant and the items are drawn with Oldenburg's special feeling for soft forms. The lithograph was printed from six stones and four aluminum plates. Three stones were printed, in order, light yellow, blue, and orange; then four aluminum plates were printed brown, light red, white, and yellow; finally three further stones were printed red, green, and blue. The edition was printed on J. Green paper at Landfall Press, Chicago, by David Keister assisted by Laura Holland.

221
Claes Oldenburg 18☆
(b. Stockholm, Sweden, 1929)
Teapot 1975
Lithograph, 18¼ x 26 (18¼ x 26)
Ed: 34
*The Metropolitan Museum of Art,
John B. Turner Fund, 1975*

Oldenburg's *Teapot* is a lithograph printed from one stone on handmade Balinese paper tipped into Moriki paper at Universal Limited Art Editions, West Islip, New York.

222
Nathan Oliveira 10☆
(b. Oakland, California, 1926)
Bundle ii 7.13.75 1975
Monotype, 10¾ x 13½ (15½ x 21½)
Ed: unique
Smith Andersen Gallery
20th National Print Exhibition selection

Oliveira's attraction to monotype is its freedom from exacting technical demands. The monotype can perhaps be considered a painter's medium, for in fact a painting is taken up from a plate by use of a fine paper. A pressing—but not necessarily a press—is requisite. Oliveira feels that contemporary printmakers have become preoccupied with technical virtuosity, with size of editions and other commercial considerations. He prefers to see printmaking as a series of unique impressions evolving from an original drawn or painted plate. *Bundle ii,* made with printing ink, was pulled by the artist from a zinc plate.

223
John Overton
(b. Detroit, Michigan, 1948)
Crown of Thorns 1975
Woodcut, 27½ x 22⅞ (33 x 26). Ed: 10
The artist
20th National Print Exhibition selection

Overton's woodcuts are quite personal in their deployment of forms and colors. The cutting does not demand our attention through its vigor or the shapes through their severe edges or rough negligence. The handling is restrained, indicative as much as descriptive, the hues are clear but muted. It is as if *Crown of Thorns* were a loose drawing lyrically conceived, a series of relationships that gives the impression of continuing evolution. The artist has printed his own work with Winsor and Newton watercolor and gouaches on Japanese paper (Kizuki Hosho). The fragile, seeming long-fibered paper sustains image and hue as integral parts of the visual experience.

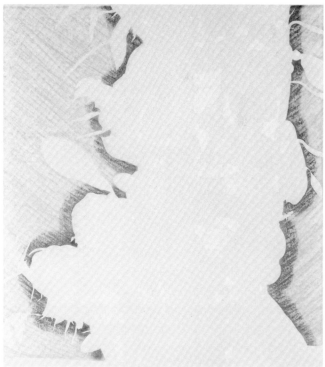

224
John Overton
(b. Detroit, Michigan, 1948)
Sunflower 1975
Woodcut, 44 x 31¼ (48 x 36). Ed: 10
The artist
20th National Print Exhibition selection

Overton's woodcuts appear to belong neither to the tradition of East nor West, though in materials and subtlety of coloration they are perhaps a bit more Eastern. The work has the intense lyricism of brush drawing without being involved in explicitly calligraphic gestures. This loose *Sunflower* is as expressive as shadow play. Overton printed the block with Winsor and Newton watercolor and gouaches on Japanese paper (Shiro Torinoko).

225
Vevean Oviette 3☆
(b. Graz, Austria)
The Dance—Variation II 1958
Woodcut, 24½ x 19¼ (24½ x 19¼)
Ed: 7
The Brooklyn Museum

Oviette studied painting with Fernand Leger, lithography with Adja Yunkers, and engraving with S. W. Hayter. This woodcut, shown at The Brooklyn Museum's 11th National Print Exhibition, has the clumsy grace and expressive gesture that marked an advanced position in the mid-1950s. The work is successful within the idiom. Note the use of flat color.

226
Gabor Peterdi 2☆
(b. Pestujhely, Hungary, 1915)
Alexander 1950
Etching, aquatint, and engraving,
28 x 21½ (29⅜ x 22¾). Ed: 15
The Brooklyn Museum,
Dick S. Ramsay Fund

Peterdi, a distinguished teacher and printmaker, has influenced not only the course of printmaking but the development of many individual practitioners. He has himself produced a body of work that has progressed toward greater freedom and an improvisatory style focused and illuminated by his technical mastery. *Alexander* was inspired by Peterdi's reading of a Franz Werfel novel on the life of Alexander the Great. Peterdi wrote: "Werfel's description of the Macedonian conquest in Persia evoked my own nightmarish experiences as a soldier in the Second World War. Obviously, my intention was not descriptive. . . .[*Alexander* is] an image that incorporated my visual associations with the subject." Peterdi began work on the plate with soft ground etching, which allowed him a great deal of freedom and flexibility. As the image clarified itself, the artist introduced hard ground etching, aquatint, and finally line engraving, plus some gouged embossment.

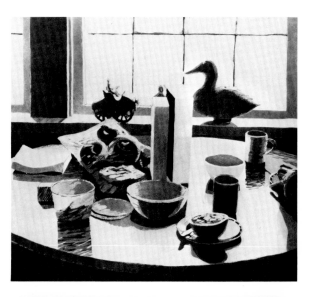

228
Linda Plotkin 15☆
(b. Milwaukee, Wisconsin, 1938)
Morning Light 1976
Intaglio, 21½ x 23¾ (26 x 29¼)
Ed: 150
The artist
20th National Print Exhibition selection

Plotkin's *Morning Light* suggests an attractive drawing that has been enhanced and enlivened by manipulations in the course of printmaking. Along with the basic intaglio, the artist has used drypoint, soft ground, and aquatint to achieve the variety of tonal modulations that give movement and pattern to the surface. Plotkin uses white effectively to set off the objects of the scene and to convey the intensity of light that creates space in the print. *Morning Light* was printed on Rives BFK by R. E. Townsend, Inc.

229
Rudy Pozzatti 6☆
(b. Telluride, Colorado, 1925)
Etruscan Lady 1963
Lithograph, 20½ x 19⅝ (20½ x 19⅝)
Ed: 20
The Brooklyn Museum,
Carll H. De Silver Fund

Pozzatti was a student of Wendell Black, himself a pupil of Mauricio Lasansky, the most potent influence on graphic arts in the Midwest. Pozzatti, a painter, made his first prints in 1949 in intaglio processes. In 1963 he received a Ford Foundation Fellowship to the Tamarind Lithography Workshop. *Etruscan Lady* is a fruit of that experience.

227 *above*
Gabor Peterdi 2☆
(b. Pestujhely, Hungary, 1915)
Time of the Beast 1964
Etching and engraving, 35½ x 21⅞
(37⅞ x 23⅞). Ed: 25
The Brooklyn Museum,
Gift of the Society of American Graphic
Artists in memory of John Von Wicht

Peterdi's *Time of the Beast* was begun the day of President John F. Kennedy's assassination. The image is the reflection of the artist's shock and confused feelings. The plate started as an automatic drawing on soft ground. As the image emerged, the artist reinforced it with hard ground etching and with line engraving.

230
Gordon Price
(b. Brooklyn, New York, 1944)
The Table 1975
Serigraph, 19¾ x 24½ (23 x 31). Ed: 23
Associated American Artists
20th National Print Exhibition selection

Price was trained in part at The Brooklyn Museum Art School, working with Manfred Schwartz for almost a year. Later he studied printing and etching at the Pratt Graphic Center. *The Table*—a variation of a painting also done in 1975—is a first attempt at symbolism. Everything in the picture is in pairs. Price chose silkscreen because he felt it was the medium closest to painting. The serigraph is in fourteen screens and was printed by the artist.

232
Richard Prince
(b. Panama Canal Zone, 1949)
Post Studio Artist 1976
Mixed media, 9 x 29 (20¾ x 33½). Ed: 5
Ellen Sragow, Ltd./Prints on Prince St.
20th National Print Exhibition selection

Prince works narratively in a linear format. Images are read sequentially to tell the story of the print. Typically there will be written explanations or interpretations (again in story form) supported by a typed version. Visual scale and the placement of materials are pleasing within a rectangular format. *Post Studio Artist* is "the first of eight proposed portable shelters." The print is a system for the delivery of information. But it is also a prod to imagination, both through the elements chosen for display and through their interactions. Printing was by the artist.

231
Ken Price 17☆
(b. Los Angeles, California, 1935)
Figurine Cup VI 1970
Lithograph and silkscreen, 22 x 18
(22 x 18). Ed: 63
Gemini G.E.L.
20th National Print Exhibition selection

Price produced a series of six prints involving images of cups whose handles were female figures. The series was printed at Gemini G.E.L., Los Angeles. The first two prints in the series were lithographs; the others combined lithography and silkscreen. One of the latter, *Figurine Cup VI,* was printed in ten colors on Special Arjomari paper by Charles Ritt. The print is the most complex and elaborately patterned in the series. In 1971 Price made another figurine cup print at Gemini as part of a suite titled "Interior Series." The entire series shows cups of one kind or another and are screenprints only. In 1975 Price produced two further cup prints at Gemini. These too are screenprints only.

233
Richard Prince
(b. Panama Canal Zone, 1949)
Property Owner 1976
Mixed media, 9 x 29 (21 x 33½). Ed: 5
Ellen Sragow, Ltd./Prints on Prince St.
20th National Print Exhibition selection

Prince's *Property Owner,* like his *Post Studio Artist,* involves four zinc plates etched and aquatinted with line. Each plate was then inked and laid out on the press bed. Photographs, Xerox, and written and typed pages (the information) were then placed face down on the inked surfaces. A sheet of Copperplate paper was laid over the information and inked plates, and the whole passed through the press. Printing was by the artist.

234
Kathleen J. Rabel
(b. Seattle, Washington, 1943)
Trinity 1975
Intaglio, 17 x 23¼ (17 x 23¼). Ed: 10
The artist
20th National Print Exhibition selection

Rabel's way with delicate color is revealed in *Trinity.* The artist, assisted by John Overton, printed this intaglio in Sinclair and Valentine inks (Stone Monastral Blue, Stone Green, Stone Purple, Stone Permanent Yellow, and Opaque White) and in Hanco Offset Fire Red, on Italia paper.

235
Kathleen J. Rabel
(b. Seattle, Washington, 1943)
Dobro 1976
Relief with hand-coloring, 14 x 19 (14 x 19). Ed: 5
The artist
20th National Print Exhibition selection

Rabel's *Dobro* was colored by the artist with Eagle Prismacolor pencils (lemon yellow, vermilion red, scarlet red, light blue, true green, and ultramarine blue) and with Janecke-Schneeman vine black. The artist printed her relief on GW Leaf handmade paper, limited to twenty-five sheets.

236 *below*
Keith Rasmussen
(b. Madelia, Minnesota, 1942)
House—Savannah Beach 1975
Lithograph, 13½ x 23 (22 x 30)
Ed: unique
The artist
20th National Print Exhibition selection

Whenever possible, Rasmussen's lithographs are done from direct observation of the subject matter or from watercolors done directly from the subject. Color separations are made visually. No photographic techniques are employed at any time. The image is printed in the three primary colors. Further printing is usually done to correct either drawing or color problems. In *House–Savannah Beach,* Rasmussen's typically vibrant light is dominant. He has used a blend roll for the sky.

237
Robert Rauschenberg 16☆
(b. Port Arthur, Texas, 1925)
Breakthrough I 1964
Lithograph, 41½ x 27⅞ (41½ x 27⅞). Ed: 20
*Museum of Modern Art, New York, Gift of
the Celeste and Armand Bartos Foundation*

Rauschenberg's *Breakthrough I* takes off from Velazquez's famous painting *The Rokeby Venus*. The lithograph was printed from one stone in black on Rives BFK paper at Universal Limited Art Editions, West Islip, New York. Rauschenberg later made a second version of the print.

238
Robert Rauschenberg 16☆
(b. Port Arthur, Texas, 1925)
Platter 1974
Relief and intaglio on fabric, 45 x 29 (45 x 29). Ed: 40
*Graphicstudio, College of Fine Arts,
University of South Florida, Tampa*
20th National Print Exhibition selection

Rauschenberg's *Platter,* part of his "Airport Series" of 1974, is a multicolor relief and intaglio print on fabric. Paper matrix plates from newspaper plants were printed both in relief and in intaglio. The six plates were printed as follows: Gammaset Turquoise, Gammaset Green intaglio and Gammaset Turquoise, Hanco Red Lake, Sinclair and Valentine Stone Neutral, Hanco Standard Orange, and Gammaset Green. All plates were relief rolled. Printing was on white cotton, cheesecloth, and blue satin with fabric shapes machine sewn together and machine buttonholed for mounting. The print was executed by Master Printer Paul Clinton assisted by Tom Kettner at the University of South Florida Graphicstudio, Tampa.

239 *not illustrated*
Robert Rauschenberg 16☆
(b. Port Arthur, Texas, 1925)
Sheephead 1974
Relief and intaglio on fabric with
collage, 34¼ x 51⅛ (34¼ x 51⅛). Ed: 40
*Graphicstudio, College of Fine Arts,
University of South Florida, Tampa*

Rauschenberg's *Sheephead* is a multicolor relief and intaglio print on fabric with collage. Paper matrix plates from newspaper plants were printed both in relief and intaglio. Seven plates were printed in black and inked rolled relief. Three plates were printed black and inked intaglio. A wooden ruler was sewn on the print. Printing was on white cotton, cheesecloth, and black polka-dot muslin with fabric shapes sewn together and machine buttonholed for hanging. The print, part of Rauschenberg's "Airport Series" of 1974, was executed by Master Printer Paul Clinton assisted by Tom Kettner at the University of South Florida Graphicstudio, Tampa.

240 *above*
Robert Rauschenberg 16☆
(b. Port Arthur, Texas, 1925)
Tampa 10 1973
Lithograph, 32½ x 100½ (34 x 118). Ed: 40
Graphicstudio, College of Fine Arts,
University of South Florida, Tampa
20th National Print Exhibition selection

Rauschenberg's *Tampa 10* is a four-color lithograph printed in nine press runs from three stones and six aluminum plates. The stones were printed identically in black (100% Stone Neutral Black). A mixture of La Favorite stick tusche and water was airbrushed on a piece of cardboard box, then run through the lithographic press and transferred to the stone. The stone was then printed. Three aluminum plates were printed beige by photographic process, two were printed black by photographic process, and one was printed in white (100% Opaque White) by photographic process on Rives BFK paper (white) by Master Printer and shop manager Charles Ringness at the University of South Florida Graphicstudio, Tampa.

241 *right*
Robert Rauschenberg 16☆
(b. Port Arthur, Texas, 1925)
Treaty 1974
Lithograph, 2 sheets, each (27½ x 40). Ed: 31
Museum of Modern Art, New York, Gift of Celeste Bartos

Rauschenberg's *Treaty* is a vertical diptych printed on the upper section from three stones with four printings and on the lower section with four stones and four printings. The lithograph is on J. Whatman handmade English paper and was printed at Universal Limited Art Editions, West Islip, New York.

242 *below*
Bill H. Ritchie
(b. Yakima, Washington, 1941)
Bridge's Heart 1974
Etching, lithograph, and relief,
17¾ x 24 (22¼ x 27½). Ed: 40
The artist
20th National Print Exhibition selection

Ritchie did studio work with Rolf Nesch in Norway in 1969 and studied at the Munch Museum in Oslo. He was awarded research grants from 1968 to 1975 by the University of Washington, Seattle, for printmaking and video art. *Bridge's Heart* was commissioned by the Henry Gallery at the university. The artist printed the bridge image in red and then in black on Japanese Etching paper. The image was then torn around a template and laminated into a relief printing from a single etched plate inked yellow, green, and blue on two rollers, registered.

243 *left*
Bill H. Ritchie
(b. Yakima, Washington, 1941)
My Father's Farm from the Moon 1976
Etching and relief, 37½ x 27½ (48 x 30). Ed: 40
The artist
20th National Print Exhibition selection

Ritchie's *My Father's Farm from the Moon* originated in a 1973 videotape. One frame of the videotape was photographed. The artist then used the negative to produce several paintings in the same scale as the print. Plates after the painting were produced by photo etching, hard and soft ground, and aquatint. Copper and zinc plates were cut by a fretsaw and filed for near-perfect fit. Ritchie used registered rolling for the blended colors and light vertical forms in the center plate. For the forms in the surrounding plates, he used surface woodblock, printing on Japanese Etching paper. These elements were laminated into the printing paper by means of chine collé. Sinclair and Valentine, Weber, and Hanco inks and watercolor were used. The artist printed on Arches Cover paper.

244 *top, right*
James Rizzi
(b. Brooklyn, New York, 1950)
It's So Hard to Be a Saint
When You're Living in the City 1976
Etching with hand-coloring, 7¼ x 10⅞
(8½ x 12¼). Ed: 100
The artist
20th National Print Exhibition selection

Rizzi's charming cityscape was etched on a zinc plate and printed by the artist in blue etching ink. Hand-coloring with pencils was added.

245 *right*
Clare Romano 5☆
(b. Palisade, New Jersey)
River Canyon 1976
Collagraph, 22½ x 30 (22½ x 30). Ed: 100
The artist
20th National Print Exhibition selection

Romano's *River Canyon* takes the Grand Canyon for inspiration. The plates were developed from color notes and drawings made on the site in 1975. The plate for *River Canyon* was a segmented collagraph in seven colors printed by the artist on Arches paper (buff). Cardboard forms were adhered to a cardboard backing with acrylic gesso. Thick gesso developed the textures. The plate was sprayed front and back with an acrylic coating to seal the surfaces. Some areas combined intaglio wiping and relief rolling to exploit color and texture. Segmentation of the plate allowed simultaneous printing through one run of an etching press.

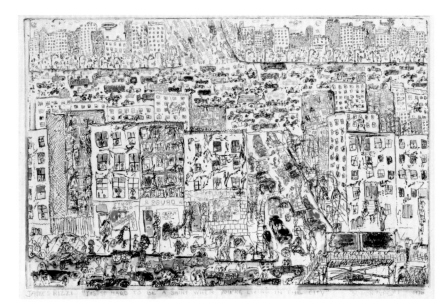

James Rosenquist 17 ☆
(b. Grand Forks, North Dakota, 1933)
Flamingo Capsule 1974
Lithograph and silkscreen, 28 x 68
(36½ x 76). Ed: 85
Multiples, Inc.
20th National Print Exhibition selection

Rosenquist's *Flamingo Capsule* required exacting and complex procedures to achieve registration and color balance. Yet the disparate elements have been brought together as if effortlessly. The print is in twenty-four colors hand-printed from seven aluminum plates and four silkscreens plus one two-color silkscreen blend, one four-color silkscreen blend, and one six-color silkscreen blend. It was printed on Arches paper (white wove custom-milled, 150 to 175 pound, deckle-edged top and bottom). Printing was at Styria Studio, New York.

248 *illustrated in color on p99*
James Rosenquist 17 ☆
(b. Grand Forks, North Dakota, 1933)
Iris Lake 1974
Lithograph, 36½ x 74¼ (36½ x 74¼). Ed: 40
Multiples, Inc.
20th National Print Exhibition selection

Rosenquist's *Iris Lake* is a nine-color lithograph from eight press runs on Arches paper (white) printed by Julio Juristo at the University of South Florida Graphicstudio, Tampa.

249 *not illustrated*
James Rosenquist 17 ☆
(b. Grand Forks, North Dakota, 1933)
Mirage Morning 1975
Lithograph with Plexiglas and shades,
36 x 74 (36 x 74). Ed: 60
Graphicstudio, College of Fine Arts,
University of South Florida, Tampa
20th National Print Exhibition selection

Rosenquist's *Mirage Morning* is a multicolor lithograph with Plexiglas face and window shades. Printing and assembly were complicated, to say the least, and involved such procedures as dipping a carpenter's snapline into Korn's liquid tusche and snapping it onto the plate. To obtain tire marks, Korn's stick tusche was dissolved in water and the image rolled across the printing elements. The assemblage involves strings, small stones, and hand-painted, dipped, dyed, and cut up window shades. The shades are hung from brackets supported with rivets on a Plexiglas sheet. Plexiglas and brackets were put together by Master Printer Julio Juristo assisted by Patrick Lindhardt. Printing was at the University of South Florida Graphicstudio, Tampa. The lithograph bears the chop of Graphicstudio shop manager and Master Printer Charles Ringness.

246 *left*
James Rosenquist 17 ☆
(b. Grand Forks, North Dakota, 1933)
Cold Light 1971
Lithograph, 22 x 30 (22 x 30). Ed: 100
Graphicstudio, College of Fine Arts,
University of South Florida, Tampa
20th National Print Exhibition selection

Rosenquist's *Cold Light* is a ten-color lithograph printed from four aluminum plates and one stone on white deckle-edged Arches Cover by Tamarind Master Printer Charles Ringness at the University of South Florida Graphicstudio, Tampa, between May 7 and October 12, 1971. The first aluminum plate was printed by photographic process using the blended roll inking method in five colors (red, dark blue, light blue, green, and rose red). The second plate (aluminum) was airbrushed with Korn's liquid tusche in green. The stone was printed in blue from Korn's stick tusche dissolved in water and Korn's liquid tusche airbrushed. The fourth plate (aluminum) was printed in black by photographic process, and the final plate (aluminum) was printed in silver. Execution was by gum stop out technique with lacquer rubbed in. The image was bled. *Cold Light* is one of Rosenquist's outstanding prints of the period.

Modesto Truck driver

Modesto Truck driver

Fresno, Ca 8/20 - 9 p.m.

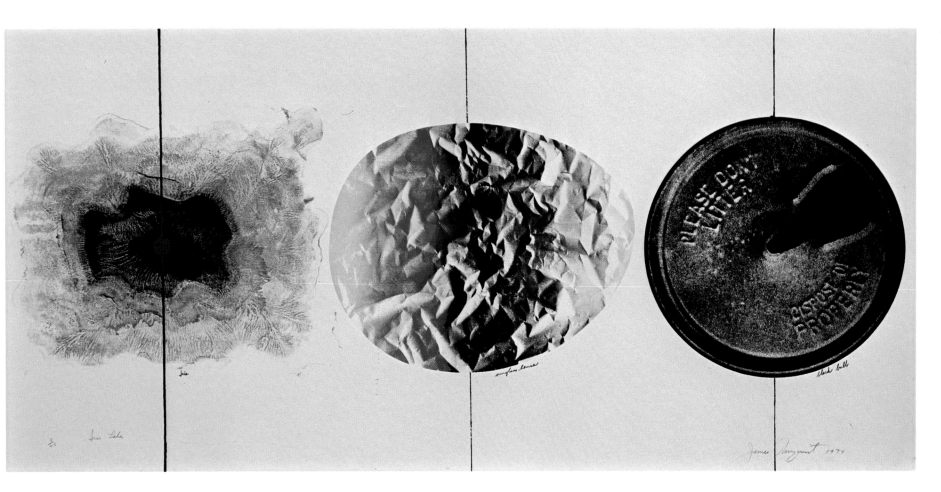

left
Nancy Mee
(b. Oakland, California, 1951)
A Modesto Truck Driver 1975
Diazo and Xerox transfer with
hand-coloring, 24 x 35½ (25 x 36¾)
Ed: 10
The artist
20th National Print Exhibition selection
Cat no 191

above
James Rosenquist 17☆
(b. Grand Forks, North Dakota, 1933)
Iris Lake 1974
Lithograph, 36½ x 74¼ (36½ x 74¼). Ed: 40
Multiples, Inc.
20th National Print Exhibition selection
Cat no 248

250
James Rosenquist 17☆
(b. Grand Forks, North Dakota, 1933)
Night Smoke 1969–70
Lithograph, 16⅜ x 21⅞ (22⅜ x 31¼)
Ed: 18
Museum of Modern Art, New York, Gift of
the Celeste and Armand Bartos Foundation
20th National Print Exhibition selection

Rosenquist is known for the prodigious size of his prints and for their technical complexity and experimental spirit. But he can work well also in relatively small compass and by more traditional procedures. *Night Smoke* is a lithograph printed from six stones on J. Green English paper at Universal Limited Art Editions, West Islip, New York.

251
James Rosenquist 17☆
(b. Grand Forks, North Dakota, 1933)
Spaghetti and Grass 1965
Lithograph, 27⅞ x 17¼ (31¼ x 22¼)
Ed: 23
Museum of Modern Art, New York, Gift of
the Celeste and Armand Bartos Foundation
20th National Print Exhibition selection

Rosenquist's *Spaghetti and Grass* is a small masterpiece of printmaking, apparently simple, but subtly memorable in form and color. The lithograph was printed from five stones on a Crisbrook English handmade paper at Universal Limited Art Editions, West Islip, New York.

252
Richard H. Ross
(b. Brooklyn, New York, 1947)
Printed Painter's Palette 1976
Serigraph, 16 x 16 (21 x 19). Ed: 75
The artist
20th National Print Exhibition selection

Ross's prints are photographically derived translations of color. He uses process inks in screen bases, inks of different densities without halftones. Typically he will use the image of all or part of a figure to present a central object; in this instance the palette. The figure forms part of the ground. The artist does his own printing.

253
Edward Ruscha 17☆
(b. Omaha, Nebraska, 1937)
Hollywood 1971
Silkscreen, 10 x 37½ (14½ x 42). Ed: 85
The Brooklyn Museum,
Gift of Mrs. Wendy F. Findlay

Ruscha's visualizations of language and his feeling for the imagery of the West Coast have made his reputation as a printmaker and photographer. *Hollywood* combines the two: a real sign on real hills treated imaginatively. The silkscreen is in eight colors printed in four runs.

255 *below*
Anne Ryan 1☆
(b. Hoboken, New Jersey, 1889;
d. Morristown, New Jersey, 1954)
In a Room 1947
Woodcut, 14 x 15½ (16⅛ x 22¾). Ed: 25
The Brooklyn Museum

Ryan is known principally as a collagist. She began making collages in 1948, stimulated by works of Kurt Schwitters on exhibition in New York. Previously she had been a painter and printmaker. Her most notable prints were color woodcuts such as *In a Room*. This print won a Purchase Award at The Brooklyn Museum's 2nd National Print Exhibition.

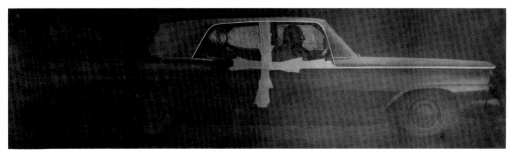

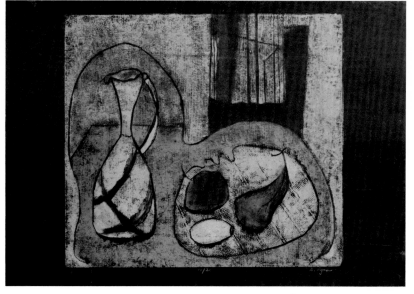

254
Janet Ruttenberg
(b. Dubuque, Iowa, 1931)
Reflections 1976
Etching, 27¼ x 94¼ (27¼ x 97¼). Ed: 7
The artist
20th National Print Exhibition selection

Ruttenberg etched the silhouette of an automobile on a steel plate. The plate itself is printable, but in this composition it serves as the framework onto which printed etchings of passengers are set. A further level of coating and corroding was introduced as a framing and unifying device: the reflections of buildings bouncing off the vehicle. The artist has achieved an unusual effect by uniting plate and prints. The image is both stylized and expressive—evocative in the best sense. The printer was Donn Steward.

256
Donald Saff 15☆
(b. Brooklyn, New York, 1937)
Triptych 1974
Intaglio, 6 parts, each 6 x 5⅜ (6 x 5⅜). Ed: 4
The artist
20th National Print Exhibition selection

Saff, Dean of the College of Fine Arts of the University of South Florida, Tampa, was a prime mover in the establishment and success of its Graphicstudio, which, over a period of years, has printed for artists as diverse as Rauschenberg and Anuszkiewicz. When he can find the time, Saff is an artist in his own right. *Triptych* reflects the range of images in his suite of the same name. Saff made *Triptych* with a dental drill on a phenolic resin plate. The process also involved solvent transfer and airbrushing. The printing was by Giovanni Galli.

257
Attilio Salemme 1☆
(b. Chestnut Hill, Massachusetts, 1911;
d. New York, New York, 1955)
One Against Many *circa* 1947
Serigraph, 9½ x 13½ (11¼ x 15⅛)
Ed: unknown
The Brooklyn Museum,
Dick S. Ramsay Fund

Salemme's established imagery is consistent in his paintings and prints. It is particularly appropriate to the flat clear colors and uninflected mat surfaces basic to serigraphy. *One Against Many* won a Purchase Award at The Brooklyn Museum's 1st National Print Exhibition.

258　　*right*
Lucas Samaras 19☆
(b. Kastoria, Greece, 1936)
Book 1968
Mixed media, 10 pages, each 10 x 10
(10 x 10). Ed: 100
Pace Editions Inc.
20th National Print Exhibition selection

Samaras's inventiveness and imaginative drive are abundantly matched by his technical abilities and insights. His works are always alive with surprises. *Book* was printed in ninety-eight colors involving silkscreen, offset lithography, embossing, diecutting, and thermography. *Book* was printed by Seri-Arts Inc. and Colorcraft Offset Inc. and published by Pace Editions, New York.

259
Lucas Samaras 19☆
(b. Kastoria, Greece, 1936)
Clenched Couple 1975
Silkscreen, 36 x 27½ (40 x 32). Ed: 125
Pace Editions Inc.
20th National Print Exhibition selection

Samaras's *Clenched Couple* was printed from twenty-eight screens by Ives-Sillman, North Haven, Connecticut.

260 *not illustrated*
Norie Sato
(b. Sendai, Japan, 1949)
Signal Interference II 1976
Lithograph, woodcut, intaglio, relief, and chine collé, 24 x 36 (30 x 40¾)
Ed: 12
The artist
20th National Print Exhibition selection

Sato's *Signal Interference II* was printed by the artist from two zinc plates in two press runs. First, however, she printed chine collé woodcut pieces on Japanese paper (buff) in various colors with gouache by Winsor and Newton. The photo lithographic overprint was from altered zip-a-tone lines. The first zinc plate was developed in hard ground line and with mezzotint rocker. The second zinc plate was developed in hard gound line, aquatint, and mezzotint rocker. The first printing was intaglio in seven colors, relief through stencil in light green, and chine collé. The second printing was intaglio in two colors (light green and purplish gray) and relief through stencil in buff and blue blended roll. The artist used Sinclair and Valentine and Handschy Chemical Company lithographic inks and printed on Arches 88 paper.

261 *illustrated in color on p106*
Norie Sato
(b. Sendai, Japan, 1949)
Video Sunrise II: Zoom In 1974
Relief and intaglio, 18 x 24 (22½ x 28). Ed: 10
The artist
20th National Print Exhibition selection

Sato's imagery relates to video processes, which she sees as an extension of print. Her particular concerns are the constituents of edges and horizons: the visual no-man's-land where space meets space, object meets object, surface meets surface, or where these elements meet in combination with one or both of the others. To reinvent these states, she has produced prints of uncommon technical strength and refinement. *Video Sunrise II: Zoom In* was printed by the artist from two zinc plates etched with hard ground line. There were two press runs, first in relief (blended roll in gray and grayish purple), second in intaglio (orange and purple) and in relief through stencils in green and blue. Printing was on Arches Cover paper using Sinclair and Valentine and Handschy Chemical Company lithographic inks.

262 *illustrated in color on p107*
Karl Schrag 1☆
(b. Karlsruhe, Germany, 1912)
Woods and Open Sea 1962
Lithograph, 25⅛ x 33⅛ (25⅛ x 33⅛). Ed: 20
The Brooklyn Museum

Schrag had a full-scale retrospective exhibition covering thirty years of his work at The Brooklyn Museum in 1960. As painter and printmaker, Schrag developed an energetic style based upon a loose drawing system of brushed lines and small color areas. His first recognition came as a printmaker, and printmaking continues to hold an important place in his art. *Woods and Open Sea* is a color lithograph. It bears the Tamarind chop of Joseph Zirker.

263
Elfi Schuselka 17☆
(b. Vienna, Austria, 1940)
Untitled 1975
Lithograph with hand-coloring,
22½ x 22½ (22½ x 22½). Ed: 25
The artist
20th National Print Exhibition selection

Schuselka's prints often join the familiar with the fantastic or treat a common image fancifully. Her work is witty but susceptible to serious interpretation. This lithograph was printed and hand-colored by the artist.

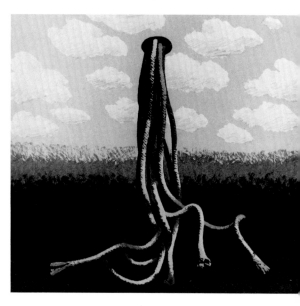

264
Thomas Seawell 15☆
(b. Baltimore, Maryland, 1936)
The First Street 1975
Serigraph, 5½ x 8½ (9⅝ x 17¾)
Ed: 25
Pace Editions Inc.
20th National Print Exhibition selection

Seawell's suite "The Streets" consists of seven images and a title page with a text written by the artist. Most of the prints in the series went through six to eight states with up to thirty colors printed for a single image. Seawell's use of the serigraphic medium is of uncommon interest. He layers the inks intricately to give effects from high gloss to mat, all with intensity of hue and evenness of value. His orchestration of the medium's potential finishes and his use of ink in all degrees between opacity and transparency are exemplary. Seawell prefers to work in intimate sizes and human scales; his images are to be examined rather than confronted. He treats his surfaces with a varnish, which accentuates the character of the various finishes he has used and restores some surface evidence of former printings.

265
Stuart Shedletsky
(b. New York, New York, 1944)
Seven Gardens for Matisse No. 5 1976
Etching, 8 x 7½ (22½ x 27⅜)
Ed: unknown
The artist
20th National Print Exhibition selection

Shedletsky's etchings present velvety blacks against the white paper in forms that are geometrically simplified, elegant, and precise. The printing of this series was by Michael Kirk.

266
Alan Shields
(b. Lost Springs, Kansas, 1944)
Scaba Pro 1974
Screenprint and relief with embossing,
13 x 13 (13 x 13). Ed: 30
Richard Gray Gallery
20th National Print Exhibition selection

Shield's *Scaba Pro* is a screenprint with relief printing and embossing. The printer was William Weege.

Norie Sato
(b. Sendai, Japan,
1949)
**Video Sunrise II:
Zoom In** 1974
Relief and intaglio,
18 x 24 (22½ x 28)
Ed: 10
The artist
20th National Print
Exhibition selection
Cat no 261

Karl Schrag 1☆
(b. Karlsruhe,
Germany, 1912)
Woods and Open Sea
1962
Lithograph,
⅛ x 33⅛ (25⅛ x 33⅛)
Ed: 20
The Brooklyn Museum
Cat no 262

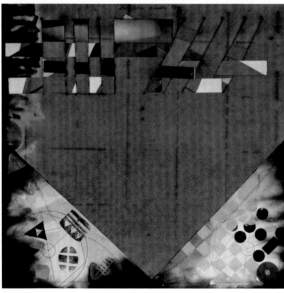

267
Alan Shields
(b. Lost Springs, Kansas, 1944)
Pampus Little Joe or **Sun, Moon,
Title Page** 1971
Screen and vegetable print, 2 sides (both illustrated),
each 26 x 26 (26 x 26). Ed: 100
Mrs. Alan Blair, Chicago,
Courtesy of Richard Gray Gallery
20th National Print Exhibition selection

Shields's *Pampus Little Joe* is a two-sided work, inventive
and visually arresting, making superlative use of differ-
ences in color and texture. The work involves screen and
vegetable printing on dyed, stitched, and woven paper.
The printer was William Weege.

268
Jody Shields
(b. Minot, North Dakota, 1952)
Book with Silk Papers 1975
Silk with hand-made paper, 6 pages, each
10 x 14 (10 x 14). Ed: 4
Ellen Sragow, Ltd./Prints on Prince St.
20th National Print Exhibition selection

Shields's paper forms may be read as objects. It was natural
that she should have gone to a book format where flat
printed leaves are assembled in free overlays. A Shields
book is displayable in as many ways as it has surfaces.

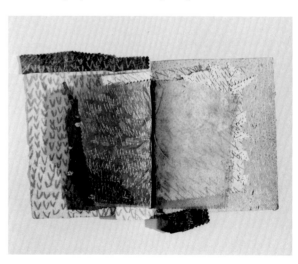

269
Jody Shields
(b. Minot, North Dakota, 1952)
#1 April '76 and #2 April '76 1976
Mixed media, 2 parts, 6 x 7 (6 x 7) and
7½ x 7½ (7½ x 7½). Ed: unique
Ellen Sragow, Ltd./Prints on Prince St.
20th National Print Exhibition selection

Shields is essentially a papermaker who prints her productions in free form images. These images, which also have the quality of objects, are indeterminate in scale. They make an impact at a reasonable distance but are also gratifying to examine. The artist is as much concerned with the wrinkles and folds of the surface as with the designs and the marks it may carry.

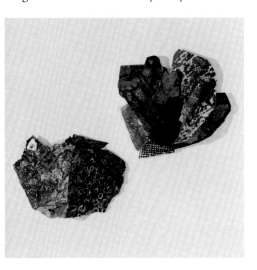

270
Robert C. Skelley
(b. Bellvue, Ohio, 1934)
War 1974
Woodcut, 30 x 40 (30 x 40). Ed: 100
The artist
20th National Print Exhibition selection

Skelley's *War* is a woodcut that calls upon many resources from the artist, not only of a technical order (though the cutting is varied and elaborate, a small textbook in itself) but of imagination and tradition. In short, more is to be found in this print—more of a narrative, illustrative, emblematic, and graphic character—than is common in the work of contemporary woodcut artists. This is, of course, not to comment perjoratively upon works that are simpler in design or that move forcefully to unity of effect. It is only to point out that inclusiveness is alive and well.

271
Arthur Skinner
(b. Atlanta, Georgia, 1950)
Lost Train 1976
Etching and photo etching, 17½ x 21⅜
(19½ x 24½). Ed: 40
The artist
20th National Print Exhibition selection

Skinner studied at the Santa Reparata Graphic Arts Center in Florence, Italy, during 1972–73 and took his M.V.A. degree at Georgia State University in Atlanta in 1976. His work as an etcher is characterized by a feeling for black and white that must owe much to an appreciation of the subtleties of photography. In fact, he mixes traditional etching techniques with photo etching, but the photographic element is absorbed into the general effect of his prints. Methods and means are integrated into a powerful imagery that appeals both to memory and fantasy. An important ingredient in the ambiguous world of Skinner's *Lost Train* is the anomalous scale presented by the engine in its site.

272
Moishe Smith 3☆
(b. Chicago, Illinois, 1929)
The Cow 1976
Serigraph, 17¼ x 23½ (20 x 26¼)
Ed: 20
ADI Gallery
20th National Print Exhibition selection

Smith is a master of the intaglio plate. His etchings have typically dealt with rural and urban landscape. In *The Cow,* from "Common Barnyard Animals," he shows himself to advantage as a serigrapher and as a portraitist. The animal is marvelously rendered, a real presence in her rich blacks and browns.

273
Raphael Soyer
(b. Borisoglebsk, Russia, 1899)
The Artist's Parents 1963
Etching and aquatint, 7¼ x 7¾
(11¼ x 15). Ed: 85
Associated American Artists
20th National Print Exhibition selection

Soyer's paintings and prints have recorded and commented upon the life of urban man for over half a century. New York City has been his setting and humaneness his inspiration. *The Artist's Parents* is an etching and aquatint from the portfolio "Sixteen Etchings by Raphael Soyer" published in 1965 by Associated American Artists, New York.

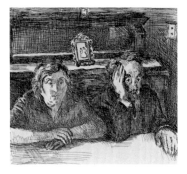

274
Albert Stadler
(b. New York, New York, 1923)
Diptych: Cross Creek 1976
Etching, 24 x 36 (29 x42). Ed: 25
The artist
20th National Print Exhibition selection

Stadler has been doing some very large drawings—eight-by-ten feet and thereabouts—that are in fact assemblies of panels whose individual imageries and styles find complex referents and relationships within the total configuration of the work. Drawing of this kind set Stadler on to multiple interrelated images and plates in etching. *Diptych: Cross Creek* is a remarkable example of the development of Stadler's multi-leveled but harmonious imagery. The artist used sugar lift, hard ground, and aquatint in the preparation of a single etching plate. Printing of the edition on Arches paper was by Mohammed Khalil.

275
Albert Stadler
(b. New York, New York, 1923)
Lifting 1976
Etching, 28 x 22 (33 x 26). Ed: 25
The artist
20th National Print Exhibition selection

Stadler's etchings are notable for diversity of marks, shapes, and tones. The eye is led over an intricate surface in motion, into the sense of illusionistic space without perspective and out of it again to visual incidents on the picture plane. Not only is there visual movement in the surface, but there is visual movement of several kinds at the viewer's option, for the possibilities of combination and recombination are numerous. At the same time, we are not facing a bewilderment of alternatives; once we have entered the activity of the image, many ways of looking become clear. The image also has an inclusive or in-dwelling power that can be taken in all at once. The artist has used sugar lift, hard ground, and aquatint in the production of the etching plate. Printing of the edition on Arches paper was done by Mohammed Khalil.

276
Julian Stanczak
(b. Borownica, Poland, 1928)
Solar 1973
Silkscreen on steel foil, 34 x 34 (36 x 36). Ed: 40
The artist
20th National Print Exhibition selection

Solar is one of a portfolio of five images titled "Nocturnal Five." The print is a silkscreen on stainless steel foil laminated to a plastic backing.

277 *not illustrated*
Julian Stanczak
(b. Borownica, Poland, 1928)
Boreal 1973
Silkscreen on steel foil, 46 x 22 (48 x 24). Ed: 75
The artist
20th National Print Exhibition selection

Boreal is one of a portfolio of five images titled "Nocturnal Five." The print is a silkscreen on stainless steel foil laminated to a plastic backing.

278
Saul Steinberg 16☆
(b. Bucharest, Romania, 1914)
The Museum 1972
Lithograph, 15⅞ x 22½ (20¾ x 28⅛)
Ed: 34
Museum of Modern Art, New York,
Gift of Celeste Bartos

Steinberg's *The Museum* was created for the benefit of Spanish refugee relief. The lithograph was printed from one stone and one plate on handmade English paper with a blind embossed seal handstamped by the artist at Universal Limited Art Editions, West Islip, New York. The artist's wit requires no commendation.

279 *not illustrated*
Saul Steinberg 16☆
(b. Bucharest, Romania, 1914)
Main Street 1972–73
Lithograph, 15¾ x 22 (22⅝ x 30)
Ed: 40
Museum of Modern Art, New York,
Gift of Celeste Bartos

Steinberg's *Main Street* was printed from four stones on Arches paper at Universal Limited Art Editions, West Islip, New York.

112

280
Frank Stella 18☆
(b. Malden, Massachusetts, 1936)
Star of Persia I 1967
Lithograph, 26½ x 32½ (26½ x 32½). Ed: 92
Gemini G.E.L.
20th National Print Exhibition selection

Stella's *Star of Persia I* was the first print the artist executed in the workshops of Gemini G.E.L., Los Angeles. It marked the beginning of a fruitful collaboration. In that first year—1967—Stella made twenty prints with Gemini, including his two much-admired black series. Stella's artistic ideas are essentially graphic; the motifs of his paintings lend themselves admirably to lithographic and serigraphic interpretation. Typically Stella works with bands or areas of flat color set off in white. An exception is the recent series of hand-colored prints issued by Tyler Graphics. *Star of Persia I* is a seven-color lithograph printed on English Vellum Graph paper by James Webb.

281
Frank Stella 18☆
(b. Malden, Massachusetts, 1936)
Double Gray Scramble 1973
Silkscreen, 29 x 50¾ (29 x 50¾)
Ed: 100
Gemini G.E.L.
20th National Print Exhibition selection

Stella's *Double Gray Scramble* conceals in its simple configuration a wealth of color printing problems. The screenprint is in one hundred and fifty colors. The edition, on Arches 88 paper, was printed by Jeff Wasserman, Gemini G.E L., Los Angeles.

282 *right*
Frank Stella 18☆
(b. Malden, Massachusetts, 1936)
Grodno 1975
Paper relief with hand-coloring,
26 x 21½ x 1¾ (26 x 21½ x 1¾)
Ed: 26
Tyler Graphics Ltd.
20th National Print Exhibition selection

Stella's principal print project for 1975 was a series of paper reliefs. These were produced in three basic images and hand-colored in editions by the artist. The technique for making these shaped papers was developed by Kenneth Tyler and papermakers John and Kathleen Koller. Molds for the series were constructed by Betty Fiske and Kim Tyler from hand-sewn brass wire and mahogany. After the first trials were formed in white pulp from the mold, the artist designed patterns of color dying and paper collage that the papermakers used for each individually formed relief. This was done in the wet stage of forming each relief. Once the paper dried the individual molds were hand-colored by the artist using casein, dyes, and water colors. The project took fifteen months. Work was done at the Koller Workshop and at Tyler Graphics Ltd., Bedford Village, New York.

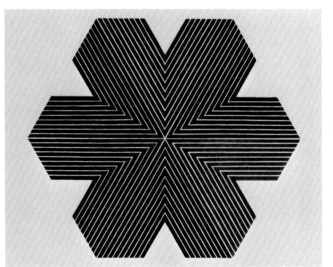

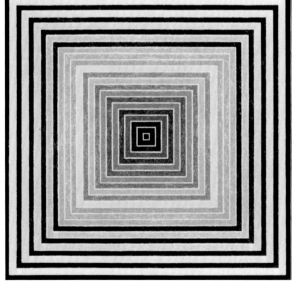

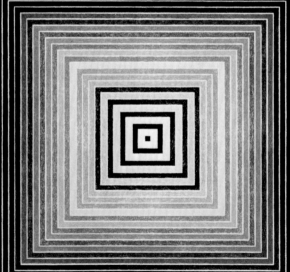

284 *below*
Carol Summers 5☆
(b. Kingston, New York, 1925)
Road to Ketchikan 1976
Woodcut, 37 x 37 (37 x 37). Ed: 75
ADI Gallery
20th National Print Exhibition selection

Summers uses a variety of printing methods for his woodcuts. In *Road to Ketchikan,* he cut the blocks conventionally, except that the images were not reversed. Printing was almost exclusively by a rubbing technique. The paper was laid on the blocks and the ink rolled very thin directly on the paper. The relief of the cut areas of the block determined the area to be covered. All colors were built up through successive rollings. The central red area of the mountain was printed conventionally on the back of the paper in opaque pink, then later rolled on the front with a deep red. The blue area with stars was rolled on the back so that the white stars closed a little coming through the paper. Summers uses quarter-inch plywood and cuts on both sides. After inking the paper, the artist sprays the print with mineral spirits, either by mouth atomizer or by a small electric sprayer to dissolve the inks and transform them into dyes. The paper is handmade Japanese Suzuki, and the inks all letterpress from various manufacturers.

283 *right*
Mark Stock
(b. Frankfurt, Germany, 1951)
Keys 1975
Lithograph, 5 parts, each 7⅜ x 7⅜
(8 x 8). Ed: 12
Gemini G.E.L.
20th National Print Exhibition selection

Stock was a student in lithography of Theo Wujcik at the University of South Florida, Tampa. He also assisted in the production of several projects at the university's Graphicstudio. While at South Florida, Stock executed and printed his lithographic suite "Keys," consisting of four images and a title page. This delightful work, sprightly, imaginative, subtle in color, and beautifully printed, establishes him both as artist and craftsman. Stock now prints for Gemini G.E.L., Los Angeles.

286 *below*
C. David Thomas
(b. Portland, Maine, 1946)
Banana 1976
Lithograph, 21 x 13¼ (22 x 30). Ed: 20
Impressions Workshop Inc.
20th National Print Exhibition selection
Thomas feels that his recent work is taking off toward non-objectivity. His growing emphasis upon lithographic texture seems to him to support this conclusion. He has described his present work as "evolving into plants and ornamental spaces." *Banana* is an example of the artist's shift in subject matter and of his re-sorting of technical matter. The print's brilliant blacks and persuasive forms reveal the strengths of simplicity. Printing was by the artist.

287 *below*
C. David Thomas
(b. Portland, Maine, 1946)
Moonrise II 1976
Lithograph, 22 x 14 (22 x 30). Ed: 25
Impressions Workshop Inc.
20th National Print Exhibition selection
Thomas's early works expressed his experienc in Vietnam through the faces of children h worked with there. He concentrated on emo tions to be found in particular faces. But he soo moved away from portraiture; the face in hi prints became neuter, without gender. His aim i to reveal universal feeling in a stylized imag *Moonrise II* is one of a series of imaginative por traits that aim at emotional recognition and con currence in the viewer. Printing was by the artist

285 *above*
Wayne Thiebaud 12☆
(b. Mesa, Arizona, 1920)
Rabbit 1971
Lithograph, 22⅓ x 30 (22⅓ x 30). Ed: 50
The Brooklyn Museum, Gift of the
National Endowment for the Arts and
Bristol-Myers Fund
Thiebaud is a painter, filmmaker, and graphic artist whose imagery is centered in the idiom of new realism but whose style, whatever the medium, is wholly his own. This print is from the portfolio "Seven Still Lifes and a Rabbit" published by Parasol Press, New York.

288
Larry Thomas 19☆
(b. Washington, D.C., 1939)
Forgotten Moments in History #4
1975
Lithograph, 10¾ x 11¼
(15¼ x 14¾). Ed: 5 artist's proofs
The artist
20th National Print Exhibition
selection
Thomas's technical method is to make
Kodalith negatives of his print ele-
ments and to shoot the Kodalith com-
posite on a lithographic plate. Colors
are arbitrary and expressive, though
consideration is given to their effect on
the underlying photographic struc-
tures.

289
Larry Thomas 19☆
(b. Washington, D.C., 1939)
No Kid of Mine Works for Peanuts 1975
Lithograph, 10⅞ x 16⅞ (16⅛ x 22)
Ed: 8 artist's proofs
The artist
20th National Print Exhibition selection

Thomas's images are assembled from a va-
riety of sources—junk mail, newspapers,
old magazines, you name it. The artist
makes Kodalith negatives of people, props,
and sets for his visual dramas. He begins
with no predetermined plan, but brings to-
gether a number of elements in the hopes of
establishing commanding relationships.
Thomas's prints are plainly funny, though
the humor often has a bite of acid in it.
There are certainly social commentaries of
an oblique kind.

290 *above*
Mark Tobey 17☆
(b. Centerville, Wisconsin, 1890;
d. Basel, Switzerland, 1976)
Flight over Forms 1966
Lithograph, 18¼ x 26½ (25¼ x 32¾)
Ed: 200
The Brooklyn Museum,
Bristol-Myers Fund

Tobey began to make prints in 1961 after a
long and successful career as a painter. His
first works were in lithography, where he
was able to give free range to his impulses as
a draughtsman. *Flight over Forms* is a color
lithograph printed in blue, brown, gray,
red, yellow, and black on Rives BFK paper
by Kurt Meier, Basel, Switzerland. The
publisher is Galerie Beyeler.

291
Mark Tobey 17☆
(b. Centerville, Wisconsin, 1890;
d. Basel, Switzerland, 1976)
Blossoming 1970
Aquatint, 12 ³/₅ x 9 ²/₅ (21 ²/₅ x 17). Ed: 75
Jane Haslem Gallery
20th National Print Exhibition selection

Tobey's *Blossoming* is one of a suite of seven color aquatints printed on Lafranca paper and published by Edition de Beauclair. Aquatint and lift ground processes were particularly congenial to Tobey because of the quality of surface they produce. The kind of space and the calligraphic systems to be seen in his paintings can be approximated with aquatint and lift ground. *Blossoming* was printed in two colors, blue and blue-black.

292
Mark Tobey 17☆
(b. Centerville, Wisconsin, 1890;
d. Basel, Switzerland, 1976)
Summer Joy 1971
Aquatint, 10⅞ x 8¾ (26 x 19¾). Ed: 96
Jane Haslem Gallery
20th National Print Exhibition selection

Tobey's *Summer Joy* is a color aquatint printed in red and turquoise on Richard de Bas paper. The publisher is Edition de Beauclair.

293
James Torlakson
(b. San Francisco, California, 1951)
51st and Coronado 1973
Etching and aquatint, 10¾ x 7½
(14¾ x 10¾). Ed: 50
Ellen Sragow, Ltd./Prints on Prince St.
20th National Print Exhibition selection

Torlakson works from color slides for his black and white etchings with aquatint. This forces him to reinvent the values, to stress this and suppress that. The resulting masses are often hypnotically, hauntingly real without being the literal record of the camera. At the same time, the artist is quite conscious of the formal and aesthetic bearing of his activity. *51st and Coronado* was printed by the artist from a zinc plate on Rives BFK paper.

294
James Torlakson
(b. San Francisco, California, 1951)
19th Avenue Booth, 1:00 A.M. 1975
Etching and aquatint, 6½ x 4½
(14¾ x 11¼). Ed: 50
Ellen Sragow, Ltd./Prints on Prince Street
20th National Print Exhibition selection

Torlakson's imagery often emphasizes emptiness or lone-
liness: a deserted street, parked trucks, a suburban house
and its wall. Here, a telephone booth, itself empty, illumi-
nates the great emptiness beyond. The etching with aqua-
tint was printed by the artist from a zinc plate on Rives
BFK paper.

295 *above*
David Trowbridge
(b. Hartford, Connecticut, 1945)
Untitled 1972
Silkscreen on Mylar, 10½ x 16½ (18 x 24). Ed: 45
Cirrus Editions Ltd.
20th National Print Exhibition selection

Trowbridge's fascinating print surface was achieved by
silkscreening on acetate, first with clear varnish, then with
red, then with lavender. Printing was at Cirrus Editions
Ltd., Los Angeles.

296 *above*
Janet Turner 3☆
(b. Kansas City, Missouri, 1914)
Dead Snow Goose II 1974
Intaglio and silkscreen, 18 x 17¾
(22¼ x 20¾). Ed: 40
ADI Gallery
20th National Print Exhibition selection

Turner's prints are mainly woodcuts or linocuts with silk-
screen additions, but as she has written, "about one a year
is etched metal plate." *Dead Snow Goose II* was deeply
etched on metal, the second stage of a four-stage version.
The first stage was predominantly linear in texture. It was
relief inked and printed; thereafter, the artist made silk-
screen additions. The print is based upon direct observa-
tion of nature. Printing was by the artist.

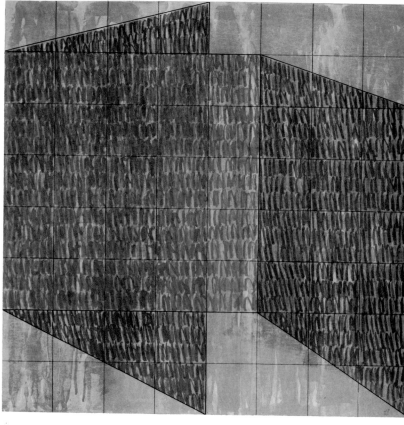

297
Cy Twombly 18☆
(b. Lexington, Virginia, 1929)
Note I 1968
Etching, 8⅞ x 10¾ (25½ x 20). Ed: 14
The Metropolitan Museum of Art,
Stewart S. MacDermott Fund, 1968
20th National Print Exhibition selection

Twombly is basically a calligraphic artist, whatever his medium. In *Note I* he expresses his dexterity of hand in the etching medium. The plate was printed on Auvergne French handmade paper at Universal Limited Art Editions, West Islip, New York.

298 *not illustrated*
Cy Twombly 18☆
(b. Lexington, Virginia, 1929)
Untitled 1968
Mezzotint, 8⅝ x 5¾ (19¾ x 16)
Ed: 12
The Metropolitan Museum of Art,
John B. Turner Fund, 1968
20th National Print Exhibition selection

Twombly's mezzotint makes brilliant use of this discredited medium. Mezzotint is more than a means for copying in the hands of truly creative intelligence. The print is from one plate on Auvergne French made paper. Press work was done at Universal Limited Art Editions, West Islip, New York.

299
Jack Tworkov 15☆
(b. Biala, Poland, 1900)
L.P. #3 Q3-75 1975
Lithograph, 32 x 32 (37 x 37). Ed: 30
Nancy Hoffman Gallery
20th National Print Exhibition selection

Tworkov's "L.P." series are lithographs printed at Landfall Press, Chicago. They are closely related in imagery and in technical procedures. *L.P. #3 Q3-75* was printed from two stones and one line plate. On the first stone, wash was printed as a background. The color in the second stone, the figure stone, was overprinted. Finally the line plate was printed.

300
Tony Vanderperk
(b. Rotterdam, Holland, 1944)
Untitled 1974
Wood intaglio, 19¾ x 10⅞ (30 x 22¼)
Ed: unknown
The artist
20th National Print Exhibition selection

Vanderperk's print was made from a block
assembled from single strips of wood that were
laminated to masonite. The block was inked
and wiped like a regular intaglio and printed by
the artist on damp Arches Cover paper on an
etching press at the Parsons School of Design.

Andy Warhol
(b. Cleveland, Ohio, 1931)
Print #8 from the set
Mick Jagger 1975
Silkscreen and
watercolor, 29 x 44
(29 x 44). Ed: 250
Multiples, Inc.
20th National Print
Exhibition selection
Cat no 310

301 *left*
Beth van Hoesen 13☆
(b. Boise, Idaho, 1926)
Nap 1961
Drypoint, 17½ x 19¼ (23 x 23⅞)
Ed: 50
The Brooklyn Museum,
Dick S. Ramsay Fund

Van Hoesen is a prolific printmaker and fine technician whose images are sometimes allowed to exist in isolation on the sheet. In *Nap*, she has created pictorial space as she has filled it. The drypoint technique is expertly managed to give life to the sleeping figure muffled in bedclothes.

302 *left, top*
Romas Viesulas 11☆
(b. Lasai, Lithuania, 1918)
Annunciation 1970
Vinylcut on fabric, 96 x 54 (96 x 54)
Ed: 10
The artist
20th National Print Exhibition selection

Viesulas's interest in getting beyond paper size in printmaking led him to experimental printing on fabric, first from linoleum, later from vinyl. Getting beyond paper size meant also getting beyond the size of a press bed. That the outsize image would have to be printed manually in itself presented no overriding difficulty. Theoretically, it would be possible to ink and print an image taken from a six-by-eighty–foot roll of linoleum, so long as the requisite pressure could be applied evenly. The problem that Viesulas had to solve was the character of the print support. A multicolor print from a number of plates would be extremely difficult to register accurately because fabric stretches and behaves differently each time it is printed. Viesulas developed methods for dampening, placing, printing, and lifting fabric that are effective.

304
John Von Wicht 8☆
(b. Holstein, Germany, 1888;
d. Brooklyn, New York, 1970)
Black and White 1960
Stencil, 37 x 24¾ (40 x 30). Ed: 10
The Brooklyn Museum,
Dick S. Ramsay Fund

Von Wicht's *Black and White* won a Purchase Award at The Brooklyn Museum's 12th National Print Exhibition. Von Wicht was also awarded first prize in The Brooklyn Museum's Watercolor Exhibition in 1945. An artist trained in Germany, Von Wicht studied applied art, mosaics, and the techniques of stained glass. He produced murals in the United States and Canada, exhibited paintings in oil and wax, and still managed to produce a body of prints of distinguished quality.

303 *left, bottom*
Romas Viesulas 11☆
(b. Lasai, Lithuania, 1918)
On the Brass Gate 1971
Vinylcut on fabric, 59 x 157 (59 x 157)
Ed: 10
The artist
20th National Print Exhibition selection

Viesulas's *On the Brass Gate* was cut from vinyl and inked heavily with brayers (fabric is more absorbent than paper and requires more ink). Dampened fabric was laid onto the plate, pressure was applied to the back of the print with hard rubber rollers, and the print was pressed with a hot iron before it was lifted from the plate to dry. The print was tacked in the drying process. (A week or more may be needed for the drying of a print of this size. When the print is dry, it can be stretched like a canvas or draped; it can be rolled for storage or shipment or shown in a three-dimensional structure.) Viesulas printed *On the Brass Gate* with assistance. Several people were needed to lift the print from the plate.

305
Todd Walker
(b. Salt Lake City, Utah, 1917)
Untitled 1975
Serigraph, 13 x 19½ (20 x 25½)
Ed: 47
The artist
20th National Print Exhibition selection

Walker's serigraphs are based directly upon his photography, but are not therefore literal. The artist's interest in color—in the color of his feelings about the world he records with his camera—is decisive. He has written: "I separate the continuous tonal values of the photograph by photographic and graphic process methods into many alternatives, then reassemble these in arbitrary color." These manipulations give us a refreshed sense of the subjects pictured.

306 *right*
Todd Walker
(b. Salt Lake City, Utah, 1917)
Untitled 1975
Serigraph, 12¼ x 8¼ (14⅞ x 10½)
Ed: 57
The artist
20th National Print Exhibition selection

Walker is a fine colorist. Though his work in serigraphy is based directly upon photographs, his assignment of arbitrary color to his prints extends our perceptions of his subjects, both formally and in feeling. Walker is his own photographer and printer. His serigraphs require from eight to twenty printings of hand-mixed color.

307 *left*
William Walmsley 12☆
(b. Tuscumbia, Alabama, 1923)
Ding Dong Daddy #4 Oars 1966
Lithograph, 16 x 21¼ (20 x 25¼)
Ed: 15
The artist
20th National Print Exhibition selection

Walmsley left painting for lithography in 1964 after receiving a printmaking grant from Florida State University. He was captivated by unexplored possibilities in the medium, particularly in color printing. *Ding Dong Daddy #4 Oars* is a fourteen-color lithograph hand-drawn and hand-printed by the artist.

308 *right*
William Walmsley 12☆
(b. Tuscumbia, Alabama, 1923)
Ding Dong Daddy Whew 1973
Lithograph, 17½ x 23¼ (20 x 26)
Ed: 14
The artist
20th National Print Exhibition selection

Walmsley's experiments with lithographic color printing convinced him that the concept of color merely as an adjunct to lithographic black was outmoded. He began to make his forms directly from color. He worked with the available range of color inks and has used fluorescents (the material of *Ding Dong Daddy Whew*) since 1970. Walmsley is among the most innovative colorists in printmaking. He now works from a line drawing of areas and from color to color, making changes as needed.

123

309
Andy Warhol
(b. Cleveland, Ohio, 1931)
Marilyn Monroe 1967
Silkscreen, 36 x 36¼ (36 x 36¼)
Ed: 250
Brooke Alexander, Inc.
20th National Print Exhibition selection

Warhol used Marilyn Monroe's image or parts of her image—her lips, for instance—in a number of paintings and prints during the 1960s. The present print is from a portfolio of ten images, each in different colors, silkscreened and printed by Factory Editions, New York, in 1967. This image was printed in five colors: brilliant green-blue, vivid purple-red, brilliant green, very light green, and vivid orange-red.

310 *illustrated in color on p119*

Andy Warhol

(b. Cleveland, Ohio, 1931)

Print #8 from the set Mick Jagger 1975

Silkscreen and watercolor, 29 x 44 (29 x 44). Ed: 250

Multiples, Inc.

20th National Print Exhibition selection

Warhol pioneered the transformation of celebrity photographs by way of printmaking techniques (see his *Marilyn Monroe*). In the "Mick Jagger" suite, the pop star's image is manipulated to yield as many senses of his personality as there are prints in the series. Did Warhol know what he was after? Perhaps not. But the images make visual sense: the color additions and the elements of drawing provide lively commentary on the basic image, whoever is portrayed. Does it really matter if the viewer identifies Jagger or thinks he has hold of an in joke? In Warhol's Marilyn and Jackie prints, the elaborations of image were clearly related to the story of the subjects. Not so here. With his "Chairman Mao" series and with this one, Warhol is closer to decoration, in the sense of makeup, than to probing social commentary. The Jagger prints are color silkscreens on Arches Watercolor Rough paper. They were printed at Chromocomp, New York.

311 *right*

Shane Weare

(b. England, 1936)

Meeting Place 1975

Etching, 19¾ x 14½ (30 x 22¼). Ed: 50

ADI Gallery

20th National Print Exhibition selection

Weare's draughtsmanship describes a large area at the same time that it invites us to inspect closely the details that enliven it. The interest of the print, apart from its diverse subject matter, is in the quality of its surface. Apparently random incidents on the picture hold our attention and move us about. It's all rather like hunting pretty shells on a beach.

312 *right*

William Weege 16☆

(b. Milwaukee, Wisconsin, 1935)

He----in Chicago 1973

Serigraph, 29½ x 41¼ (29½ x 41¼)

Ed: 39

Richard Gray Gallery

20th National Print Exhibition selection

Weege is a Master Printer and a publisher of prints. This serigraph might serve as a lesson for his students, with its varied imagery, superlative manipulations of scale, and effective use of descriptive and emotionally keyed color. Printing is of the finest quality.

315
Stow Wengenroth 1☆
(b. Brooklyn, New York, 1906)
Quiet Hour 1947
Lithograph, 8¾ x 15 (11 x 17⅞). Ed: 60
The Brooklyn Museum,
Gift of John W. James
Wengenroth was born in Brooklyn in 1906. He graduated from the Friends School here and after study abroad enrolled in the Art Students League of New York. There are few artists who have used the lithographic medium as easily in the production of their images. Wengenroth seems always to have known how to draw with lithographic crayon on stone. Though Wengenroth is perhaps best known for his work centered upon nature and the out-of-doors, his cityscapes are also effective, although possibly more often stylized than his works more directly inspired by nature.

313 *above*
Neil Welliver
(b. Millville, Pennsylvania, 1929)
Si's Hill 1973
Silkscreen, 35½ x 35½ (40 x 40). Ed: 144
Harcus Krakow Rosen Sonnabend Gallery
20th National Print Exhibition selection

Welliver's *Si's Hill* is one of a suite of six silkscreens based upon paintings by the artist. This print is in ten colors from ten screens and was executed by Fine Creations Inc. on Buckeye Cover paper. The suite is published by HLK Limited, Boston.

314 *left*
Neil Welliver
(b. Millville, Pennsylvania, 1929)
Brown Trout 1975
Etching with watercolor, 19¾ x 29½
(26½ x 36). Ed: 37
Brooke Alexander, Inc.
20th National Print Exhibition selection

Welliver's etching was printed in black and was hand-colored by the artist in watercolor. Hitoshi Nakazato printed the edition on Arches Cover paper.

316
Stow Wengenroth 1☆
(b. Brooklyn, New York, 1906)
Untamed 1947
Lithograph, 12¼ x 18 (15⅛ x 20¾)
Ed: 65
The Brooklyn Museum,
Gift of John W. James
Wengenroth's *Untamed* shows him dealing with the kind of wilderness subject matter he has made completely his own. Subtlety of draughtsmanship and tonal control make this one of his most satisfying prints.

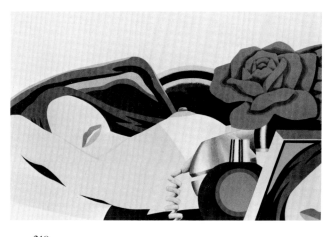

317 *above*
Tom Wesselmann
(b. Cincinnati, Ohio, 1931)
Untitled 1965
Serigraph, 24 x 29¾ (24 x 29¾) Ed: unknown
The Brooklyn Museum,
Gift of Philip Morris, Inc.

Wesselmann's images of nudes come in all sizes and shapes, are seen at all distances, and in all degrees of environmental complication. This one is a close–up with a standardized smile. The patterns of body and head suggest landscape.

318 *left*
Tom Wesselmann
(b. Cincinnati, Ohio, 1931)
Smoker 1976
Lithograph with embossing, 14½ x 23
(22⅜ x 30). Ed: 75
Multiples, Inc.
20th National Print Exhibition selection

Wesselmann's *Smoker* gives a characteristic nod to advertising art; but the elegance and personality of this artist's stylization dominate the billboard theme. The greatest care has been taken to raise the visual experience several levels in color refinement and tonal artistry. As usual, Wesselmann is a master of shape, making his apparently neutral forms carry a load of feeling. *Smoker* is a twenty–color lithograph hand-printed from nine aluminum plates, four lithographic stones, and one embossing plate on Arches Cover paper (white) at Styria Studio, New York. The publisher is Multiples, Inc., New York.

319
Tom Wesselmann
(b. Cincinnati, Ohio, 1931)
Nude 1976
Lithograph and silkscreen, 13½ x 23½
(22½ x 30). Ed: 75
Multiples, Inc.
20th National Print Exhibition selection

Wesselmann's nudes have appeared in print in a profusion of stylized postures. Their abstract pulchritude, constantly reinvented by the artist, plays upon a wealth of strictly graphic ideas. This image is a thirty-four–color lithograph hand-printed from fifteen aluminum plates, nine silkscreens, and one embossing plate. *Nude* was printed on Rives BFK Deluxe paper at Styria Studio, New York.

320 *below*
William T. Wiley 18☆
(b. Bedford, Indiana, 1937)
Ecnud 1973
Lithograph with wood veneer, 19 x 25 (23 x 29). Ed: 10
Landfall Press Inc.
20th National Print Exhibition selection

Wiley can always be counted upon for a visual joke of quality or for an odd turn of imagination. In *Ecnud,* which is *dunce* spelled backward, both impulses are present. Dunce caps are the dominant motif of this print with its folksy, homemade look. We seem to be confronting a wooden sign somewhere, whose graffiti and verbal directions both conceal and reveal meaning.

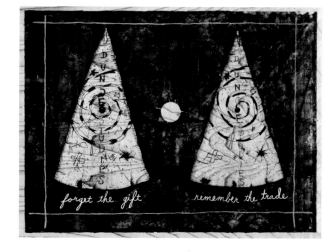

321
William T. Wiley 18☆
(b. Bedford, Indiana, 1937)
Scarecrow 1974
Etching and aquatint, 9¾ x 8
(22½ x 18). Ed: 60
Landfall Press Inc.
20th National Print Exhibition selection

Wiley's *Scarecrow,* with its rich associations in naive art, was printed on Arches Cover (white) from three copper plates by Timothy F. Berry at Landfall Press, Chicago. The first two plates, printed respectively orange and blue, are hand-burnished aquatint. The third plate, printed in brown, is line etching.

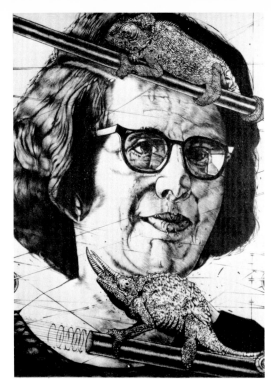

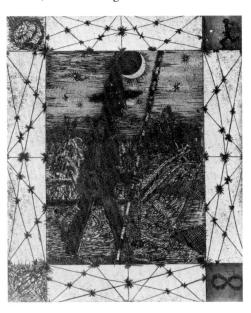

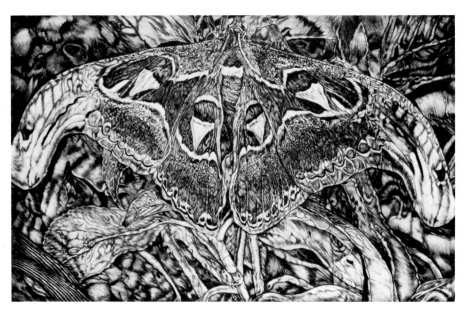

322
Ralph Woehrman
(b. Cleveland, Ohio, 1940)
Henrietta 1974
Intaglio, 33 x 22½
(36 x 25½). Ed: 50
The artist
20th National Print Exhibition selection

Woehrman's prints are powerfully evocative and involving. They reflect a distinctive draughtsmanship and an identifiable surface. They are expertly printed. As images, they often bring together unusual components, bizarre couplings that are visually forceful and intellectually and emotionally provocative. The study of *Henrietta* is a case in point. The reptile and animal life pictured seem to comment upon the dominating head of the woman. The overlaid lines, the incomplete perch, add to tensions reflected in the face and carriage of the head. The intensity of image and of treatment is pervasive.

323
Ralph Woehrman
(b. Cleveland, Ohio, 1940)
Attacus Edwards ii 1975
Intaglio, 22½ x 35½ (28 x 39¾)
Ed: 60
The artist
20th National Print Exhibition selection

Woehrman's management of texture in *Attacus Edwards ii* is masterful. The softness of the moth's wings finds a visual echo in the treatment of the supporting and surrounding foliage and in the markings that read as the ground. The artist works on sixteen-gauge zinc plates. His imagery is developed with a combination of drypoint, roulette, and finally (for larger areas) with mezzotint rocker. The same plate will be printed twice to enhance the image, first in brown, then in black. Registration is crucial, since Woehrman insists upon accurate description and explicit line. He uses either Rives BFK or Arches paper.

325
Theo Wujcik 14☆
(b. Detroit, Michigan, 1936)
Portrait of June Wayne 1973
Lithograph with hand-coloring,
18½ x 13 (21½ x 21). Ed: 21
Brooke Alexander, Inc.
20th National Print Exhibition selection

Wujcik's *Portrait of June Wayne* was printed by the artist from one plate on Arches Cover paper. The print was later worked in colored pencil.

326 *illustrated in color on p6*
Adja Yunkers 2☆
(b. Riga, Latvia, 1900)
The Big Kiss 1946
Woodcut, 15¾ x 11½ (17⅝ x 13¼)
Ed: 50
The Brooklyn Museum

Yunkers has made prints in several mediums throughout a long artistic career. Some of the most engaging and among the strongest are his woodcuts. The serio-comic *The Big Kiss* is one of a group of three woodcuts that Yunkers made and published in Sweden in 1946.

327
Martha Zelt
(b. Washington, Pennsylvania, 1930)
A Glimmering 1976
Mixed media, 11½ x 16 (11½ x 16)
Ed: unique
The artist
20th National Print Exhibition selection

Zelt began *A Glimmering* by making the paper in the workshop of Joseph Wilfer in Oregon, Wisconsin, in February 1976. Wilfer mixed the pulp in the color the artist desired and Zelt formed the sheets themselves. Later, in her own studio, she added sections of earlier screenprints and lithographs as well as transparent and opaque fabric, colored pencil, machine stitching, and airbrushed watercolor. Elements not attached by stitching are fixed with methyl cellulose glue.

324
Theo Wujcik 14☆
(b. Detroit, Michigan, 1936)
Larry Bell, John Altoon, Ed Moses 1970
Stipple engraving, 3 parts, each
1⅜ x 1⅞ (8 x 9). Ed: 40
The artist
20th National Print Exhibition selection

Wujcik was a student of Garo Antreasian in 1967 and worked at the Tamarind Lithography Workshop the following year. He is a Master Printer who has worked closely with many artists on important graphic projects. He printed for Jasper Johns in 1968 at Gemini G.E.L., Los Angeles. He was shop director of Graphicstudio at the University of South Florida, Tampa, in 1970–71. But this introduction does not do justice to Wujcik. He is a draughtsman of high standards, an artist of rare taste. These three portraits in stipple engraving were developed from photographic sources and from life. Every aspect of this work is expertly managed. The artist printed the plates.

328 *not illustrated*
Richard Claude Ziemann 11☆
(b. Buffalo, New York, 1932)
Story Hill 1970
Etching and engraving, 29½ x 39⅝
(35¼ x 44¼). Ed: 100
Jane Haslem Gallery
20th National Print Exhibition selection

Ziemann's *Story Hill* is a triumph of tonal control. Slender trees with small foliage and many leafless branches are seen upon and against the receding hill. The artist establishes space by the dense growth; the swelling of the land is sensed rather than observed. The edition was printed at Impressions Workshop Inc., Boston.

329
Richard Claude Ziemann 11☆
(b. Buffalo, New York, 1932)
Edge of the Woods 1968–69
Etching and engraving, 29⅜ x 39⅝
(35¼ x 44¼). Ed: 100
Jane Haslem Gallery
20th National Print Exhibition selection

Ziemann draws on a zinc plate coated with hard ground directly from nature. After the first state proof, he completes the plate with burin engraving in the studio. His plates will typically have tens of thousands of marks and will take many months to complete. *Edge of the Woods* shows how Ziemann's many marks are built into tones that both define space and describe the natural forms pictured. The edition was printed at Impressions Workshop Inc., Boston.

330
Richard Claude Ziemann 11☆
(b. Buffalo, New York, 1932)
Back Woods 1971–76
Etching and engraving, 3 parts, each
39⅝ x 29¾ (46⅜ x 35½). Ed: 100
Jane Haslem Gallery
20th National Print Exhibition selection

Ziemann is among the best printmakers working today. While not an experimentalist or an innovator, he has developed a style in the etching and engraving of his subjects from nature that goes well beyond mere reaction or description to a formal reordering of what he sees. In this sense, one might say that his prints are the essence of drawing, for they render the real world comprehensible through means that are abstract and arbitrary—by lines and other marks made with tools that impress the surface. But the etching and engraving processes require that the artist utilize the characteristics of printing ink in the design conception. The intervention of the press and the acid must be taken into account and controlled. Drawing yields to an embracing idea—the finished print—that is even more theoretical; yet the vision of it must be followed over a road rocky and pitted with practical problems. Ziemann's triptych, *Back Woods*, was some five years in preparation. These large plates (Think of accurately wiping and printing *one*, let alone three!) can stand individually as finished prints. Taken together, they are a masterwork. Printing was by the artist.

Artists' statements

Since the beginning of 1976, each of the living artists whose work appears in The Brooklyn Museum's 20th National Print Exhibition was asked, either directly or through a lender or dealer, for a statement covering his or her involvement with printmaking. Of those who responded, some commented upon technical procedures. This material was incorporated into the notes dealing with individual prints or was used elsewhere in the text. Some other artists preferred to give detailed accounts of their careers. Material appropriate to the intent of this section is quoted from these documents. The author has exercised only the options described above.

Ripley F. Albright:

The problem for the artist is to find a language for communication which becomes more widely understood and at the same time does not sacrifice artistic merits.

I feel that perhaps one of the better solutions to such a dilemma is to restrain oneself from the idea of "art for art's sake." In contrast, one should choose subject matter from a source of information which is more common to a wider social spectrum. With this in mind a more human interest in work can be felt.

Within recent years, I have attempted to move in a direction which I feel is a partial solution to the isolation of the artist and his statements. My work has become merely a reflection of my past, everyday events, personal thoughts and concerns, and my various physical and social environments. As a result, I am creating a sort of visual diary which displays personal reactions and concerns and a glorification of ordinary objects and events.

In addition, these thoughts are manifested in a manner which is not necessarily completely understood at first glance. I want to make my work visually interesting enough to invite the viewer into my work. However, the elements that I use to communicate my ideas are put together in a pattern demanding the viewer to examine my work and all the various elements carefully before the subjects can begin to be understood or appreciated.

I do not consider myself primarily a printer. I consider myself an artist who uses printmaking as one of his mediums in addition to drawing and painting. I enjoy the process of printmaking, but I most admire the idea of my work being available to a larger audience. It seems appropriate that not only my ideas hope to communicate to a wider community but the process I often use lends itself to this principle as well.

Richard Anuszkiewicz:

Printmaking as a medium has been a truly unique and rewarding experience for me. It has provided a wealth of new materials and techniques that only modern technology made possible. It has afforded me the pleasure of collaborating with some of the finest and most gifted people in the printmaking field.

As a colorist, it has broadened my vocabulary, permitting me to achieve other solutions in addition to those in my painting. Printmaking has made it possible for my original work to travel and be shown in areas of the world that virtually would be out of reach with most other media.

My posters, multiples, and prints have found their way into homes and public places of a most wide and diverse economic spread. Most of all, printmaking has provided me an alternative way to develop my own images and to explore, to search and learn, another means of expression.

David Becker:

Working on a copper plate is for me an extension of drawing, permitting me to develop drawn images to a state I would not do with ordinary drawing tools and paper. Thus the plate inspires within me a confidence not felt in any other medium.

Having the plate develop over the space of time of at least a year seems to foster a sort of internal guidance within the plate form. It is as if the total image is present at some early state, and my task is to give it final form. Once established, I tend to find the nature of the imagery somewhat baffling, and communicating on a level that eludes rational analysis.

Marc R. Bjorklund:

When we are able to concentrate upon the inner current of ideas then our unconscious can produce remarkable images and thoughts. The imagination takes over and guides the hand apart altogether from conscious intention.

Just took a walk,
Cold winter wind,
The change is all around.
I've been seeing it for several days now.
Today I had to go and feel it.
Walking through the fields of dead flowers,
Weeds and grass
My feet and legs sow next year's crop;
I turn and see myself walking to where I now stand.

Nancy Anna Bonior:

In printmaking the plates alone are not more important than the paper and inks. I find the image inseparable from the paper and its inherent qualities (weight, tone, surface, and acceptability to the ink). The color (inks) seem to grow from this. Time. And the distant search of something next to me is as close as I can come to a verbal statement.

David Capobianco:

The colors, forms, and positionings have more to do with symmetry than they have to do with the images themselves, which only serve as a foundation or diagram. The images used are basic so that the identification of them will remain vague. Then personal values that are associated with images will be reduced, or, at best, absent and viewer response will be emotional not analytical.

Robert Conover:

I am a printmaker and a painter. At this time the relief print seems to be the medium best suited to my work which consists of solving problems of composition and color.

Problem-solving art involves much conscious planning. However, I believe that the intuitive or unconscious is equally important in my work. The planning process which is so necessary in printmaking clarifies my ideas and strengthens my compositions.

Over a period of years my work has evolved from linear, black and white woodcuts to cardboard-cut compositions using full color and flat masses.

Elaine Breiger:

To create in my work that multi-depth of space and color with which I am concerned, I am experimenting with the superimposed printing of multiple plates. The overprinting of these abutting plates build up layered color levels, a process unique to the etching medium. Its potentialities are an ongoing challenge.

Jon Carsman:

My major concern while working in the graphic medium is to create an image that captures the depths, subtleties, and articulated shadows present in my works on canvas. In the effort to achieve an image similar to a work on canvas, I am forced to work backwards in the terms of the printer. Many detail areas, such as telephone wires, highlights on the sides of building, and accent areas in foliage are worked up from the early states of the work. The wire is not merely laid down at the end of the print. Other colors are then worked around these detail areas to create a negative space. It is through this process that I achieve the depth and detail that I desire in the image.

Gordon Scott Cook:

These are pictures of the Headlands where the city of San Francisco meets the sea, referred to locally as Land's End. Since the city is where I live and the water around is where I swim and row (I have swum across the Golden Gate about ten times), these prints are a record of myself.

134

Thomas Cornell:

Printmaking is a way of intensifying experience. The act of working with lines is a means to greater awareness; it forces me to see what is usually glossed over. Each line records a perception/feeling about living in the natural world. The content of my work is the process of learning to see.

Agnes Denes:

My art is constant probe, an analytical process which requires diversity and total freedom for its mode of expression.

The flexibility of the print medium (working on paper) lends itself to free experimentation and is versatile when its unexplored potentials are sought. This kind of freedom and control is absolutely necessary when one is trying to visualize that which is generally invisible, such as systems, structures, or the esthetics of logic.

I have tried to blend the classical aspect of the medium with new techniques, such as photo processes in lithography and etching, X-rays, and electron micrographs.

Roy R. Drasites:

My paintings, prints, and drawings for the last six years have dealt with ecological concerns. It sounds hopelessly romantic, but nature and natural processes are important. I live in a suburb and am guilty as the next man of exploitation and manipulation of nature. My work, if it serves no other function, acts by its good-humored scolding to remind me of certain priorities.

Daniel Dallmann:

The lithographs chosen for The Brooklyn Museum exhibit make use of the simplest theory of color printing: the triad of primary colors and black, plus the white of the paper. The plates are drawn with this basic four-color process in mind and then with seemingly endless proofing the plates are corrected, additional plates are made if necessary, and the colors are adjusted to bring into balance the form of the final image.

Images change as themes change, but my intention is to project positive values, positively. In printing, as in painting and drawing, I wish to deal with that relationship between values and images as directly as possible. This directness has nothing to do with speed of execution or "truth to materials"—it refers only to the mental and emotional bridge of making images from values and seeing values from images.

John E. Dowell, Jr.:

Years ago, I made prints because the processes gave me a certain flexibility which did not exist for me in painting or sculpture. Searching for order, concepts of movements, space, time, and then finally music grew due to my involvement with prints. After about a three year absence, I've returned to prints to realize some of my ideas of theater. Using my work as musical scores and notation for choreography, my prints become the actual sheet music and the directions for movement. The forms and their environment in my work are the visual realizations of my ideas of sound and movement.

Arthur Deshaies:

Any account of graphic work must begin with INVENTION; for until then no printmaking whether directly determined by formal characteristics and/or thematic materials of special and lesser artistic categories can survive. All else is superficial and dead.

Michael Ehlbeck:

I am moving away from flat two-dimensional prints and am involved with cutting out and layering to make three-dimensional prints. I am experimenting with photo intaglio methods combined with more traditional techniques. My aim is to emphasize the sculptural qualities of the plate by producing low-relief surfaces and building up actual three-dimensional parts on my prints.

Marsha Feigin:

The sequential nature of printmaking supports my own need to order. All art seems to expand into the space it eventually fills but printmaking defines this expansion at every stage. It is as objective a medium as photography but as physically involving as sculpture. I make etchings because the medium allows me to express what I want to say with maximum force and clarity.

Richard Fiscus:

My work is primarily concerned with the laws of nature. Though I personally consider myself a realist, in so far as my work reflects the way I truly see the landscape, I am sure that the purist would say, "You need glasses, Richard Fiscus." It is a fantastic world working with Mother Nature.

Karl L. Folsom:

In my work, my aim is to achieve a fusion of photography and etching techniques to produce an end result which goes beyond the limitations of both mediums. This is brought about by the use of linear and spatial elements which re-enact and continue the elements of the photo etching in an abstract manner, thereby reducing the actual objects to non-specific forms. The use of subtle collagraphic repetition of the elements which appear within the actual photo etching results in the stretching of the boundaries of the photo etching into infinite space. These techniques allow for a melding of photo etching and traditional printmaking processes.

Patricia Tobacco Forrester:

Committing myself to an etching means that I have a strong attraction to a natural place and its mood and will want to spend time over a five- or six-month period there, for my drawings on the grounded plates are long in coming about and are done always on the site. Further, the act of beginning an etching requires that I need that work as a kind of refuge; a state of being and concentration, of quietness, of delight in slow growth, that will relieve the broadness and the quickness of my work in painting. As I keep returning to my "place," the salient features recede and the subtleties of mood and form assert themselves. Thus, the idea with which I begin is often altered; or better, the obvious thrusts of forms and lights and darks have added to them some subsequently discovered dark caves and swinging rhythms. Often, these waylays suggest themselves quite accidentally in the five or six stages of etching through which the drawing emerges. These layered observations are the attraction of the medium for me, the reason why photographs have no usefulness for me, and the point of coming again and again to some place in the woods.

Sam Gilliam, Jr.:

I realized when I began making prints that I must make a transition between media, not merely duplicate my paintings. As I have learned to work in the various print areas, I have come to value the ease of repetition, and the multitude of ways in which a finished work can be achieved. I have grown to enjoy the necessary delays and required pauses needed with the making of prints, and have utilized this time to review the progress of the work, consider the next step, and contemplate the eventual outcome.

Finally, I have learned to accept the fact that a print can never be a painting, although the experience of making them can be as gratifying and rewarding.

Christine L. Goodale:

My prints are created solely as a color treat for the eyes. The size does not engulf or surround, but rather invites one to come close and enjoy.

I avoid complicated systems of structure but rather concentrate on simple frameworks into which I can flow sensuous color modulations. These are free to remain as pure color or they can react with each other and create a space which moves gently forward and back.

Kenneth Grebinar:

The physical interaction between myself and the spatial expansiveness of the land gives me a feeling of grandeur. The green mountains, broken by the patchwork farms of Vermont and northwestern Massachusetts hold me captive when I am in their presence. I try to work with the relationships I see, but I am always struggling against the scene to make the composition work as a graphic image. Although my landscape imagery might be small in format I try to create a scale which makes you feel enlarged by the whole experience.

Bernard Greenwald:

I have always made series of works based upon motifs which were repeated again and again, in a sense of improvising off of a set of circumstances as they became more familiar to me. Printmaking allows me greater freedom of improvisation because of the multiplicity of possibilities inherent in a given plate.

Further, the process of preparing the plate is broken up in time, forcing me to consider events in the development of a work in a series of specific, strategic moves. This temporal resistance and the resistance of the materials themselves are very helpful in slowing the rush of events so that I can better cope with them.

And it feels very good to make prints.

Laura Grosch:

I have always had a great passion for flora of all kinds particularly those flowers and vegetables that have voluptuous shapes. Drawing their images gives me some kind of possession over their illusive nature that is always in flux: opening and closing; living and dying. I feel a relationship in attitude to primitive artists as they inscribed images of animals on cave walls.

I perceive forms as made up of many strong abstract units. Before 1972 I composed pictures coloring each space with a single hue. The graphic challenge of making my first lithograph was the catalyst in the development of the coarse crosshatching that now defines each form. Working in this manner enabled me to layer color over color thus creating new colors while glints of each major color remained. The "wovenness" of my prints' surfaces suggested to me the cloth and baskets that I now use to heighten the presence of the natural images.

Richard Haas:

After becoming interested in architectural subject matter some ten years ago, I have become increasingly aware of its historical precedents and have studied and collected both master works and minor works in this vein. Also, once my confidence in the subject matter was fixed I have increasingly attempted to broaden my own mastery both in terms of subject matter and technique in order to make the experience of each print as rich as possible. The print in this show is the first attempt to deal with the interior view.

Katherine Halton:

Printmaking, especially silkscreen, is a unique way of applying color to a surface. I use printmaking techniques when there is no direct method of creating the effect I need.

Marvin Harden:

i feel it appropriate to paraphrase T.S. Eliot by saying i feel it unnecessary to explain art, a process which too often results in explaining it away. personally i'd rather not speak of my work or myself (to me one and the same). i feel one is what one does, and what one does is the statement of who one is.

Janet Hildebrand:

The landscape of the American West has fascinated me for many years. The vast spaces, magnificent forms of the mountains, mesas, canyons, and deserts, and the magical presence of light and color are sources for my drawings, paintings, and prints.

Clinton Hill:

About three years ago I was doing drawings by tearing and cutting the surface of unmarked paper. It seemed at that time interesting to work even more directly by doing the same kind of mark-making in the wet pulp as the sheet was being formed. My preconceived ideas were not compatible with the process of papermaking, however, in looking over samples of the paper at the John Koller mill in Connecticut, I was intrigued by the possibilities of using the idea of watermark as drawing. This watermark-drawing is still the beginning of each print. I have now built up a larger vocabulary of techniques that come from experimentation and through familiarity with the process.

Papermaking has continued to interest me as the process enables me to keep that directly felt unconscious flow.

Sue Hirtzel:

It is important for me as an artist to accord the essential integrity of each work on its own terms, mirroring and refining my own experience as it is ordered and embodied by the most necessary and accessible visual form. I see the artist's commitment as a continuing act. An act which yields the tangible, direct embodiment of a pursuit to truthfully define an understanding himself. It is the creative effort which has and continues to stand as an enduring realization of common human bonds.

Irwin Hollander:

As artist I draw suites in dozens, small enough to please the printer me for adding more again by hand of varied art.

Herb Jackson:

I approach the plate or stone as a painter. The image must come through, and as long as I can make it happen in the intimate context of a print, technique is not a major concern.

Because of the lag (the press) between gesture and image, graphics require a different discipline and sharpen my eye.

Jacob Kainen:

I make prints as a change of pace from painting. Painting is a direct art in which the image always appears as it is executed. All is under control; I can see only too well what is right or wrong and can shift or change from the very beginning; nothing latent can strike its element of surprise.

What I like, chiefly, about printmaking is that element of surprise. I work only at the matrix of the image, which is also in reverse—the resulting print can only be guessed at. The approach is indirect; what finally appears as the print is the result of inspired calculation. I work as a kind of blindfolded calligrapher; the final image is either better or worse than I had imagined. The whole art of printmaking, in its most fascinating aspect, is, therefore, in building better than one knows.

Donald Hopkins:

My images consist of symbols (of philosophies and/or physical objects) used in visual conflict; a collage of events, objects, time, and space. Visual logic is purposefully deformed to form coherent intellectual structures. While not supplied with the artist's own symbolism, spectators should be able to develop their own meaning to images.

Yvonne Jacquette:

With monoprints, the marks that print faintly can be as surprising as those that are bold. A color lithograph has to be conceived more deliberately, yet the densities of overprinted colored lines are still unpredictable. The heavy printing press and the hard physical labor of hand-rubbing have brought me to a new way of thinking about atmosphere, light, and the dancing movement of objects.

David J. Kaminsky:

Working with the gum bichromate and related processes allows me not only the freedom of manipulating color photographically to give an almost realistic rendering, but also the ability to let the process itself control much of the results. This creates a sort of dialogue between the process and printmaker which forces one to be open to new possibilities which are not originally intended.

Hugh Kepets:

I am a painter, but printmaking is not an extra for me as much as a separate involvement. I don't make imitations of paintings. My prints are conceived individually. I like to see the multiple thing come off. A painting is gone when you've sold it. I keep a print; the work stays with me. At the same time, a print is something that many people can have.

Kenneth A. Kerslake:

I like to etch metal plates, I like to draw, I like to take photographs, and above all I love the printed image. About a decade ago all of these things began to interact in a way that made sense to me.

As my skills with the photomechanical processes improve I gain freedom and greater flexibility in manipulating all of these elements toward the realization of my vision. My most recent work seems to come closer to that inner vision than ever before, and that is encouraging.

True or not, I believe that I have discovered, within myself, a sensibility that operates to unite different modes of seeing, and that at the same time creates a poetic rationale for their co-existence. The important thing, for me at least, is that the juxtaposition of these modes of seeing forms images that I find stimulating and that could not otherwise exist.

My main interest today is to create images that stand as visual equivalents for human feelings and emotion. To bring forth the shadows of my mind, to surprise, to delight, to move, has become my passion.

Tchah-Sup Kim:

Recently I have been deeply obsessed with the light which produces the shadow, and synchronized light and shadow producing a certain kind of visual form which reflects on the retina. Finally, the reflected form can be conceived by the intelligence at a specific time. What I am interested in is the relationship among light and time and infinity. Art deals with very specific items of information concerning concrete things and events, for which color (hue) and tonality (light and dark) are metaphors. But now, when I see even a stone, I see two realities: the form which is conceived mainly by the light and shadow, and the second reality which is an invisible architectural structure according to the principles of geometry.

Carolyn Law:

My images have become increasingly more literal abstract concerns, which have begun finding full development during the time they are printed or actually made. The process has become a progressive collaboration that translates my mental image via the mutual working of mind and technique into a resulting piece which appears at the finish of a particular period of working time.

Merle Leech:

I am philosophically attempting to lead the viewer to another level of spirituality or awareness. This is done in the art work through the juxtaposition of several perspective systems, making it impossible to analyze the spacial illusions from a traditional viewpoint. To fully perceive the relationships of these ambiguous planes the viewer must suspend familiar cognitive processes which generally are linear and lead to a single solution. The art work forces the individual to partake of several realities simultaneously.

Martin Levine:

My prints deal mainly with the American landscape and with how man has altered our environment: "sometimes for the better, but in many cases, for the worse." Several people have commented that some of my landscapes are somewhat "depressing images," but to me one can find beauty compositionally in anything from decaying buildings to piles of junk.

Paul M. Levy:

It's hard to find the appropriate words to describe one's own work. I've wanted to call it "Artorials" (Visual Editorials) but somehow its not right. For now let me say that my work is "serious humor."

Vincent Longo:

Abstract systems rely on constants: visual elements in sets, patterns. As such they are syntactical material to be considered as given; by themselves not an issue. It's what's done with them that counts. In context (as art or means to art) they direct attention to the ideas and inventions they embody.

For over a decade my prints and paintings have consisted of systemic constructs: quadrants and their inherent lattices of verticals, horizontals, diagonals, that deal with centering, regularity (often played off by random breaks and marks), tempo and duration of cognitive information, and other abstract concerns. But the primary function of these formal elements is to serve as containers of feeling, an intuitive, introverted way of seeing.

The prints are approached with a lot less rigorous planning than their look often indicates; that is to say without preliminary sketches or working drawings of any kind. Direct handling of essentially indirect printing processes permits greater spontaneity, freshness in statements intrinsically suited to the medium, and avoids facsimilies, reproductions, and multiplications of images already created in other media.

Jim McLean:

My prints have, for the past several years, been based on "found objects" or "urban fragments" that I have retrieved from the streets and trash piles of the city. I think that the objects we discard are often more visually interesting than the ones we keep and value. I have been drawn to such "found objects" because of their richness of shape, color, and texture.

In my earliest prints from such sources, I simply drew or photographed the complete objects, transforming them through changing scale, environment, and color. In the current prints I have tried to expand the original sources by altering or destroying them, making them components of new forms in a kind of personal landscape.

Sherry Markovitz:

Most recently my work has been focused on autobiographical material. My own body, as well as the bodies of those with whom I share genes have been utilized. The issues of gender, family position, and transformation are of most interest to me. In essence, I rewrite my own personal history.

Nancy Mee:

The apparent reveling in the deformed and maimed is not what may be the obvious concern with my work. It is not enough to exhibit "Side Show" curiosities in the guise of aesthetics. The work is concerned with "Transformation" from diseased/handicapped to "Normality." The artist then becomes the shaman/doctor/magician and causes the transformation. It is healing work.

Gordon Mortensen:

I have to feel right about each thing in my work, so, for the most part, they are conceived and created on the intuitive level. Colors abiding by rules of contrast as well as intuition. The line and detail are used to create textures.

I leave the human element out of my landscapes for two reasons. First, in terms of aesthetics, I find the human form too rigid; secondly, I psychologically find the human form incompatible to the landscape, for I see him as the destroyer of nature rather than part of it.

George Nama:

My subject matter is energy. I find energy through stress, tensions, and magnetic fields.

Peter Milton:

About my work, what can I say? I would be a sad father indeed if these children weren't able to speak for themselves. But also, I would think the artist should be the last to want to ruin the fun with explanations. Even worse, what must be explained has already failed as art. And would this artist hope to be a practitioner of magic? At least he knows that secrets revealed are mysteries destroyed.

Frances Myers:

My prints are concerned with showing dimension of man through his architecture. Man's attitude toward nature is evidenced by his attempt at conquest of it through leveling his planet, quarrying it, pushing against its gravity, tampering with its every strata. His attitude toward his fellowman is expressed too through his facade building activity, through those facades from behind which he retreats to examine the "other," to intimidate it, or to hide from it.

Kenjilo Nanao:

Presently, and for the past six years, I have been engrossed in drawing objects that are close to me and suspending them in an utter silliness. I am, after all, interested in creating an illusion of timeless space around which the purity and sensuality of the object can be evoked.

Jim Nawara:

I tend to think of my prints as multiple drawings and began making them five years ago while working on a series of meticulous pencil drawings. The prints, like the drawings, are technically simple. I am somewhat resistant to the great range of technical possibility in the print mediums. I like the obvious benefit of a print's multiplicity—more people can see an image. On the other hand, as a friend said, "There are all of these artists, everywhere, constantly cranking out more and more stuff. Have you ever thought of art as a form of pollution?"

Robert A. Nelson:

My work is given over to compositions which utilize fantasy as the main foundation structure of their content. I have bent historical figures of the American past into hero icons which fit personal imaginative narratives.

I have shaped a nostalgia of good and evil to fit a fantasy of revamped history, of moods based on a comedy of swords and sorcery. I have pressed the images of Washington and Lincoln, of Annie Oakley and George Armstrong Custer, of Lindbergh and Dillinger, of Billy the Kid and Sam Bass into modern moments of time and geographic conditions or sets of actions which would become the despair of the accurate historian. And these real figures have now been mixed with the superheroes and caped crusaders of twenty-first– and twenty-second–century science fiction.

The result is a complex assemblage of signs, symbols, and signets which appears much like fantastic book illustration, tobacco can advertisements, problems in mechanical drawing, or a foolish surreal resurrection of multi-purposed ghosts and shades escaping from both the main halls and little-studied side cubicles of American historical time.

I have become a visual mercenary "hired" to sketch or lithograph the life events of long-dead Cheyenne chieftains, faded cavalry officers, ancient aliens from the dead sea bottoms of Mars, aviators fighting for the French skies of 1916, spacemen at duel position on the dark side of the moon, and a long march of animated dinosaurs and Atlantean green swordsmen. Such main figures are supported by the robot, the top hat, the ray gun, boots, the sword, the machine, the bow tie, the roast turkey, the transparent body, the air helmet, fishes, non-human bodies and bones, the mechanical heart, rocket ships, etc., which fill my drawings, prints, and painting—a kind of endless belt of film-like images that can never be terminated. At present I am satisfied with this crazy imaginative documentary position—and, as of now, I would trade it for no other.

Lowell Nesbitt:

I've been active in printmaking in New York since 1963. One of the things that interests me most about printmaking is the kind of interpretation of my normal visual vocabulary into the medium of printmaking. This has been always challenging and always exhilarating.

Don Nice:

Printmaking is for me an extension of my work and not a method of reproducing it.

I find in lithographing and etching, vehicles with unique and independent properties. Among these are the brilliant transparency of the inks, the fluidity of the brush on stone and plates, the systematic recording of the step-by-step procedure, and most importantly working with a printer in his workshop.

With a printer, proofing an edition is an intensive trial-and-error method that has endless variety: how much pressure on the stone, how much transparency in the ink, how much sizing and tone to the paper, and so on. It is by working with these given properties and some luck that an edition can be fulfilled.

Nathan Olivera:

I have chosen to make monotypes simply because of the lack of technical involvement. Since the medium is a bit of both painting and printmaking, one merely makes a painting directly on a metal plate with ink and then prints that painting onto fine paper. Print quality, those beautiful concerns, come from experience of having made prints for many years. Quality occurs as a matter of fact and exists when a worthy idea, ink, fine paper, and press combine.

John Overton:

In part, these pictures are about other places. Brazil, the Xingu, the Kreen-Akrore. Hawaii, lava, the sea, fertility.

They are photographs. Exposures on handmade film of ordinary objects through non-ordinary lenses. Particle generated, heat sensing, light filters open for time dwell.

Spirit catchers.

Gabor Peterdi:

My involvement with printmaking is to use it as an original creative medium. I am not concerned with it as a reproductive medium. When I am working on a metal plate, it is unlike any other type of drawing. It has possibilities and limitations totally different than any other way of creating an image.

I would make a print even if only one print could be pulled from the plate; I am not as concerned with large editions. For example, I am now working on a drypoint; I may print only twelve and that's my edition.

When I work in a media, I am involved with the uniqueness of the media and the innovations come from this concept. I want to see the entire print through as the artist. Many artists doing prints today are concerned with the trend of large editions as a commercial asset; those artists involved in the development of the print as fine art are concerned about this trend.

Richard Prince:

My work deals with conceptual ideas, events, documentation, information, and discovery. It is presented in a narrative form. An "open page" form.

Keith Rasmussen:

In my work, lithography offers a challenge in reducing subtle effects of light, value, and color to three basic colors and the excitement of seeing the three colors magically reunited to produce an interesting but different image than what was started with.

144 **James Rizzi:**

No hidden meanings or pertinent statements, just art that's meant to entertain its audience by a generalized familiarity of subject matter and city life.

Richard Ross:

Technically I use all or parts of a figure to present a central object with the figure forming a part of the ground.

 Personally my images are objects and pets isolated and presented by my friends, family, and self.

Donald J. Saff:

Locations . . . microscope/Dreams/telescope/philosophy/spectroscope—markings and mappings linked by visual syntax, shaped by the locus of place/people, and rendered with remembrances.

Clare Romano:

Since I come to printmaking as a painter, I find the collagraph offers a great flexibility in the use of color, form, and texture for expressing my images through the material.

Janet Ruttenberg:

I feel privileged to be a printmaker. For me it is the aristocrat of the artist's media.

Norie Sato:

The work grew out of an exploration of horizons, taken away from the traditional landscape horizon to include the interface between any two objects, surfaces, or spaces. From this, the interface space was magnified and a closer view of this space minus the original objects was considered. This then expanded to include edges, especially important to define whatever they contain and the limits of the interface between two objects. Parallel work in video led to the exploration of the edge/horizon through electronics and to the realization that video is an extension of print and print process both historically and philosophically. Close examination of prints and video revealed a similarity in surface. Therefore, there is a combination of video and edges in the prints. Glass edges are especially obvious due to the fact that glass is transparent and only because of the edges is it ever visible. And only through the interference of the video signal is the edge of the video image ever visible, and horizontal roll, a result of interference, becomes important because it relates back to the original exploration of horizons.

Elfi Schuselka:

A play with reality links between unrelated images images that are opposed, that may not or do not exist unlikely connections making an unlikely situation concrete

When this is done successfully consciousness and with it perception is altered.

Thomas Seawell:

I have a fascination for prints as well as for the processes of making them and I enjoy looking at them (including my own) from distances from a wall, at arm's length, and through a close-up glass. My inclination is toward small prints that can be held in one's hands and examined closely, enjoyed intimately for image and/or technique. I appreciate the stilled and isolated quality of the thing.

Although I had made prints since 1957 it was only after 1968 that I turned my full attention to them and drawing. I have chosen to restrict my efforts to these techniques because I feel that the images that I want to make feel best in small format and in the mediums of printmaking. My recent primary interest has been screenprinting. I use the screenprint because of the way in which I can build form, correct, and change through layering. My interest in detail and surface draws me to this medium. The character of the various kinds of stencils and the ability to manipulate gloss, satin and flat finish inks, opacity and transparency, and hue make it a natural for the way that I work.

My pictures are small dramas and I want them to operate in the sense of drama both literally and abstractly.

Stuart Shedletsky:

145

Seven Gardens for Matisse, 1976, are the first intaglio prints I've produced. Printed at the Parsons School of Design Workshop with the assistance of Michael Kirk, the prints represent a linear and graphic extension of the measured physical absolution of my painting. Thus these seven prints move me into an idiomatic alternative that reduces and compresses a moment's order into quiet resonances.

Robert C. Skelley:

Woodcutting, one of the oldest printing processes, has always intrigued me from my early high school days when I attempted a linoleum cut, but miserably failed. I did not think seriously about woodcutting until many years later in the Army. I turned to woodblock printing somewhat out of necessity. I had done etching in college, but with all the plates, equipment, acids, and space required, I could not practice this in my barracks. I found that woodcutting tools, small blocks of wood, a small inking glass, brayers, and a few tubes of ink could be stored neatly in a shoe box in my footlocker without calling much attention during inspections. And when I finished a block, I could mail it home.

Woodcutting requires no special place to practice and it is not very expensive. There is no noise, no smells, and little mess except small chips that do not bother anyone. It is a good method of reproducing line drawings with the simplest of technique. It is a delight to perform pure skill without being too concerned with viewer's reactions.

Primarily, for graphic interest, I select animals, geometric objects, plants, foliage, type, letter forms, calligraphy, decorative designs, motifs, textural things, and objects. All are simple in design but rich in linear potential. Objects with line are particularly adaptable to the medium of woodcutting. Preferably, I draw from life but frequently use photographs that I have taken. These forms can be improvised with various techniques of cross-hatching, elaborate linear designs, strippling, swirls, dots, and other devices that are intriguing to cut. I like to make my images look as if they have been drawn by hand and are not renderings of photographs. I believe "the hand" gives the work a personal articulation. No matter what the subject of the print, I try to insert as much graphic content as possible without subordinating the imagery. At times I believe that "graphic content" can be the dominate image and the subject only the vehicle.

Arthur Skinner:

My primary fascination is with the structure of things: mechanical, architectural, anatomical. I have industrial fantasies in which this concern is realized in a natural context, and the traditional conflict between technology and nature follows as an integral idea in my work. The images that arise from this juxtaposition and synthesis of opposites are almost invariably apocalyptic or post-apocalyptic, but only rarely void of some degree of humor.

Moishe Smith:

I prefer to let my work speak for itself. However, if it is necessary to speak out, I might say that my interest is in the poetry of the prosaic. Specifically, my subject matter is the landscape, natural and man-made, hoping to find the place and size of the contemporary human being within nature.

Albert Stadler:

The sheer doing of an etching and the resulting print is an expressive art form of considerable interest, instruction, and stimulation. Tonally it relates strongly to drawing; in color it relates strongly to color painting. I intend to pursue these directions in future etchings.

My method in the black and white prints chosen is a combination of lift etch, hard ground, stopping out, and aquatint on one plate.

Julian Stanczak:

Seen, felt—real? . . .
 vast—
Surrounding, penetrating—filtering . . .
 shattered!
The frozen, eternal-nocturnal North!
 and I? . . .

Mark Stock:

I am told that I am a surrealist. Never before realizing it, I now can accept it as being true for the time being. My intensity as a surrealist is far from a Magritte or Dali in that I treat surrealism as soft as possible. Using sentimental commonplace scenes, these whimsical occurrences become as humorous as they are haunting, pushing towards a romantic quality.

Carol Summers:

I think of myself as a tree through whose metabolism the juices of Mother Earth are transformed into fruit. What my hand produces is as much a mystery to me as to any other, and my reading of it as idiosyncratic as any other reading.

I think that a river of mysterious meaning flows through us all and is part of our common humanity.

Larry Thomas:

The elements of my images are unapologetically photographic. They come from newspapers, old magazines, second-hand books, and mail addressed to "Occupant." Kodalith negatives are made of promising characters and stage settings. What remains is to regress to kindergarten days and the instructions to "cut, color, and paste." I do not start with a total picture in mind and look for the parts, but gather the parts and hope that some of them will combine to form a logic. The Kodalith composite is shot onto a litho plate and printed. The pictures are about the need for heroes. They mourn the sophistication of today which denies Tom Swift, Lucky Lindy, Roy Rogers, Babe Ruth, hidden staircases, arch enemies, winning the big game, pluck, and making good. While on the other hand turn a mediocre World Series into the quest for the Holy Grail, make the race for the presidency a sporting event, marvel at men who walked on the moon and now endorse credit cards and Olympic stars who sell tooth paste.

My pictures are about television.

James Torlakson:

My primary interest in aquatint etchings is dealing with the aesthetics of black and white. My imagery is derived from color slides, which forces me to create my own black and white value scale. I tend to hype up value contrasts and dramatize my subjects. I work to make my images realistic, but am not interested in achieving a super-slick photo-real surface.

The realism in my etchings is not based on the desire to communicate specific social, political, or environmental messages about our world today. My focus is more oriented toward the sensuous consumption and reinterpretation of the real world. I am not interested in how closely I can mimic physical images in ink, but rather how I can change them and distort them to suit my personal aesthetic. Often the reality of the image is secondary to the abstract compositional elements that make it up. There is a flatness in many of my prints which reinforces the integrity of two-dimensionality of the images. It brings into focus the plane upon which the plastic elements of line, shape, texture, and value play and intermingle. The black and white nature of my etchings avoids the seductive nature of color, which can sometimes be distracting. I feel the black and white format of my aquatints emphasizes the plastic components and thereby helps the images to function on both realistic and abstract levels.

Although my images are derived from photographs, I do not use a photo-process in the making of my work. My aquatint etchings are entirely hand-drawn.

Tony Vanderperk:

I am interested in the subtleties of surface. When making prints I print exactly what was made. The fact that the image was printed from an object with a surface interests me. For that reason the images usually look like nothing more or less than the objects themselves.

Todd Walker:

My working process has to do with initially confronting the world with my camera, observing, allowing it to respond. With a myriad of images to select from, I try to find a single image to clarify my responses to that world. The print, by whatever process, silver, pigment, or ink, attempts to clearly state that response.

Color is extremely important to me. Scientifically correct color seems less correct than I feel. I separate the continuous tonal values of the photograph by means of photographic and graphic process methods into many alternatives, then reassemble these in arbitrary color. The color, too, becomes a means to more clearly and strongly state my response.

Shane Weare:

A river flowing into a deep crevasse. A sculpted Greek head . . . A sail billowing in the wind . . . Objects real and imagined, whether I like it or not . . . I am continually surprised by them. And it is only later, rather like interpreting the landscape of a dream that I can find the keys. . . .

Romas Viesulas:

The idea of an oversize print in my work started without much intent on my part—it started with my renting an apartment in Rome that was somewhat too large for our needs. As I was staring in desperation at those damned empty bare walls—images started to appear in my mind, and, I think, my old instinct came to life: an urge to overcome the traditional bondage of manufactured paper (the usual thirty-by-forty inches or somewhere thereabouts. . .) which has strapped printmakers for too long. In my case fabric was the answer.

Of course, handling new materials and sizes brought new excitement and problems. To print and handle an image of this size takes at least two people. Consequently, my wife, a biochemist by vocation, had to be enticed into a full "partnership." And sometimes in printing this help alone was not enough, and the doorman, our closest neighbors, and their nephews came to help.

William Walmsley:

My background is painting and so when I became a lithographer (full-time) in 1965, I worked exclusively in color and then fluorescent color (since 1970). I used to begin a litho with no preliminary sketch—working color-by-color until I considered my print complete. Now I start with a line drawing of areas—and like the others—from color-to-color—making changes when I feel they are needed. I have printed as many as fourteen times on the same print, considering only the quality of the work—not the economics.

Ralph Woehrman:

My imagery is diverse and dependent on current emotion. The ideas are always methodically planned to allow full intensity and visual thrust of an idea. Imagery is limited, so as not to divert or compromise essential images. Most construction of objects is developed with the comprehensible road map and maze situation. The images' scale increases as building continues so they feel awkward within the total matrix. From one idea to the next a plan of further extrapolations is always a major contention. My works are as an offering for the viewer's scrutinous interpretation.

Theo Wujcik:

The intermediate steps in my image-making derive necessarily from photographic information, but my work is based primarily on real experiences with the collaborative processes of creating art and of living.

Richard Claude Ziemann:

I have a romantic attachment to nature and feel a sense of exhilaration when viewing the interior of woods, fields of grass, the forest floor, flowers, and foliage. I work directly on etching plates in the landscape experiencing the play of light and daily atmospheric changes along with the form and textural variety of the seasons. Nature with its combination of serenity and wildness is an inexhaustible visual source for my work.

Glossary of printmaking terms

acetone A highly flammable, volatile solvent used by Russian-American artist Boris Margo to dissolve celluloid as a stage in a printmaking technique invented by him called cellocut.

acid-resist A substance applied to the etching plate that prevents the biting action of acid on the area covered.

air brush A device to propel fluid paint or ink in smooth gradations of color and tone by means of compressed air or carbonic gas.

air eraser A device used to remove ink or paint from paper through spraying a fine abrasive from a source of compressed air or carbonic gas.

à la poupée (French, "with a milliner's block") An intaglio technique for printing multiple colors at one time from a single plate by applying each color with a separate folded felt or pad.

anastatic printing Relief printing.

aquatint An etching plate treated with a porous ground of resin, heated, cooled, and etched, leaving a distribution of tone where the acid has bitten between the grains of resin. The aquatint process can be used to produce a range of tones.

artist's proofs Proofs printed specially for or retained by the artist. These are excluded from the numbering of an edition. They are sometimes numbered separately and differently to distinguish them from the edition. For instance, when the edition is numbered in Arabic numerals, artist's proofs may be numbered in Roman numerals.

asphaltum A bituminous material used in intaglio as an acid-resist. Asphaltum is used in lithography as a substitute for tusche or for rolling up stones and plates.

assemblegraph A method of printing in multiple colors from many plates, developed and described by artist Tom Fricano. The process is similar to collagraphy.

baren A round, padded, convex tool used for rubbing the back of paper when printing from inked relief blocks.

bath In etching, an acid-resistant tray in which the plate is bitten.

bench hooks Cleats fastened at ends and sides of a board or block to prevent it from slipping during cutting.

bite In intaglio, the action of acid on a plate.

blankets Foam rubber or felt pads used between paper and roller on an etching press. Usually three blankets are used.

bleed To extend the print image to the edges of the paper.

blind printing The technique of printing uninked plates to produce embossed texture.

bon à tirer (French, "good to pull") The proof approved by the artist to establish a standard of printing for the edition. Sometimes called the printer's proof.

brayer A roller used for spreading ink on the plate or block.

bridge A support of wood or other material that keeps the artist clear of the surface of a work while he continues to develop unfinished parts of it.

burin A tool with a steel shaft in a sharpened square or lozenge shape used for engraving metal plates or endgrain woodblocks. The term is interchangeable with graver.

burnisher A hand tool, usually of metal or bone, used to reduce intaglio lines.

burr The ridged metal raised on both sides of the lines needle-cut in the drypoint process. In mezzotint, burr is the surface of the plate when worked with a rocker.

cancellation proof A proof made from a plate, stone, block, or screen marked to prevent further prints being made and passed off as the original art works once an edition is printed.

cellocut A print technique developed by Russian-American artist Boris Margo during the 1930s in which a raised image on a rigid surface is created from celluloid dissolved in acetone.

chine collé (French, "Chinese paste") A process for obtaining color in an etching through the use of colored paper that has been dampened and lightly coated with paste.

chop A printed or stamped symbol used by printers and print workshops and sometimes by artists and collectors as a mark of identification. The chop may be inked or merely embossed.

cliché verre (French, "glass print") The process or a print made on light-sensitive paper from an image drawn through a light-resistant coating on glass.

collage print A print with collage elements adhered to the surface or incorporated by photographic transfer or by stamping, inking, or other methods.

collagraph A print made from a surface developed with collage elements.

collotype A photomechanical process in printmaking in which the image is taken directly, without the imposition of a halftone screen, from a

hardened film of gelatine or other colloid that has ink-receptive and ink-repellent parts.

color prints Prints produced in the several processes in which separate blocks, stones, plates, or stencils are used for printing the basic colors. Additional colors may be added by overprinting or by hand.

color separations Proofs of each individual color of a multicolor print.

counterproof An impression in reverse taken by passing a print or drawing through an etching press with a sheet of dampened paper. Counterproofs are used principally as aids in correcting plates.

crayon manner The use of roulettes and other tools on a plate to create effects like those of a crayon drawing.

creve Overbiting of an etching plate, resulting in fusing of lines or undesirable depth of the etch. The affected area must be resurfaced and re-etched.

cribbled In engraving, having white dots produced from a plate punched or otherwise pocked with holes.

dabber A device older than the brayer made of a pad of wadded leather or flannel with which ink is applied to a block or plate. The dabber is still sometimes used in intaglio processes.

damp press A box sometimes lined with oilcloth or rubber in which printing papers are dampened.

deckle edge The untrimmed edge of handmade paper and this edge imitated in commercial papers.

deep etch A method for printing color in relief and intaglio at the same time.

desensitize In lithography, the use of acidified gum etch making the undrawn areas insensitive to grease and therefore unprintable.

diamond point A needle with a diamond tip used for drypoint drawing.

diazo A reproduction process in which a diazonium salt is destroyed by exposure to ultra-violet, violet, or blue light. Materials using this system are also known as dyeline materials.

direct transfer In lithography, to transfer an inked image directly onto the stone.

dropout In photoengraving, an area of halftone painted out on a film with opaque fluid or etched out on the plate. Dropout is used to create highlights.

drypoint An intaglio process in which drawing on the plate is done with a steel or diamond point. The plate is then inked, wiped, and printed. Drypoint gives a velvety line owing to the burr raised by the cut. This soft line typical of the medium is suitable only to small editions. It breaks down with repeated printing.

dustbox A box, usually of wood, in which an aquatint plate is coated with powdered rosin. The box is shaken and the plate to be treated only inserted after a minute or two when all but the finest particles have settled.

Dutch mordant A solution of potassium chlorate and hydrochloric acid used to bite plates. This slow-biting solution is specially suitable when very fine etched lines are required. This mordant came into use in the nineteenth century.

edition The total prints of a single image or series of images in portfolio numbered and signed by the artist that are not retained as proofs for his use.

embossing The process or a raised element printed without ink.

endgrain block A woodblock, usually of boxwood, maple, cherry, or other fruit wood, cut across the grain and used for wood engraving.

echoppe A needle whose point is oval, used in etching to draw lines of varying width and in engraving to augment the work of the burin.

engraver's pad A sand-filled leather-covered pad, usually circular and convex, used to cushion and facilitate the turning of the plate in line engraving.

engraving The cutting of lines with a burin or graver into a plate or endgrain woodblock or the print obtained from a plate or block incised in lines.

etch An intaglio process in which an image is cut through an acid-resistant ground applied to a metal plate. Acid is used to bite this image into the plate.

etching ground A thin, acid-resistant coating applied to the face of a metal plate through which a drawing is made with a needle.

etching needle A rounded steel point used to cut through the ground on an etching plate.

extender In screenprinting, a white used to give additional body to ink. Also a dilutant or pigment employed to condition black or colored ink.

feathering In intaglio, a method of controlling drops of acid, originally done with a feather. In lithography, a method of rolling ink on a stone or plate inward toward the center while gradually lifting the roller to avoid leaving the impression of lines.

film-stencil method A technique for silkscreen printing in which stencils are cut from a paperbacked stopping-out film. The image intended for printing is traced onto the film and cut out with a stencil cutter, then stripped from the backing paper. The film is attached to the underside of the screen. The design areas are open to paint that is applied with a squeegee.

foul biting Irregularities bitten into a plate because of imperfect grounding.

ghost In lithography, the image or partial image of a previous drawing on the stone that reappears when the stone is wet.

gouges V- and u-shaped tools used for cutting wood and linoleum.

grain To prepare a lithographic stone by grinding the surface with an abrasive in order to get a desired texture.

hard ground A compound supplied in a ball shape to be melted on a hot plate and used as an acid-resist in the etching process. Sometimes hard ground is supplied in liquid form.

gum bichromate A contact printing process in which the image is formed on a coating of sensitized gum containing a colored pigment.

gum etch In lithography, nitric acid mixed with gum arabic used for sensitizing the stone or plate.

India oil stone Sharpening implement for engraving and woodcutting tools.

ink slab Glass, marble, or stone on which ink is prepared and rolled.

inkless intaglio A print of a raised image without ink. A print made by blind embossing.

intaglio A print in which an image is either cut or bitten by acid into a metal plate. Ink is forced into this cut or bitten image, the plate is wiped clean, and a print is made when plate and paper are run together under pressure through an etching press.

intaglio relief A print made by inking the plate surface and ignoring the etched or engraved lines.

key block A block or plate carrying the full design with which all other blocks and plates are registered during printing in more than one color.

levigator A circular tool of cast iron or aluminum used to grain lithographic stones.

lift ground An etching process in which the image is painted with a sugar solution and covered with the ground. When the plate is soaked the ground lifts off where the image was painted or drawn in sugar solution. The print is then etched.

light-sensitive plates Plates treated so that images may be transferred photographically. These plates are manufactured for photo lithography or photo intaglio, but a light-sensitive coating may also be applied by hand to an ordinary plate.

line engraving A print made from a metal plate cut with a burin, inked, wiped, and printed.

linocut A relief print whose image was cut from a piece of battleship linoleum.

lithographer's needle A steel point used to make white lines in crayon or tusche drawings and to moderate accents.

lithographic crayons and pencils Grease crayons and pencils manufactured specially for lithography.

lithographic stones Printing stones cut from Bavarian limestone in various sizes, usually from three to four inches thick.

lithography A printmaking process in which a drawing is made on stone or plate with greasy materials. The surface is prepared for printing so that the image takes ink while the non-image areas repel ink. The print is made with a lithographic press.

makeready The technique of preparing plates so that they print evenly.

mezzotint An intaglio process in which the plate surface is roughened with a tool called a rocker, producing a black background. The printmaker then works from black to white in establishing his design, scraping the roughened surface to the desired degree of white. In this sense, true white will be unprinted paper.

mixed media In printmaking, the combination of two or more mediums in a production of a print.

monotype A print made from a wet painting on glass, stone, or metal. This transfer process allows only a single print to be made.

mordant Any of a number of acid solutions capable of biting an etching plate.

muller A tool used for grinding inks and pigments.

offset A technique of commercial printing in which the image is taken by the paper from the roller of the press after transfer to the roller from the plate. In letterpress printing, the image goes directly from plate to paper.

open In screenprinting, the areas that will receive ink and print the image.

photo intaglio A photomechanical technique for transferring the image to a light-sensitive plate, which is then etched normally.

photo lithography A lithographic technique for transferring an image photographically onto a light-sensitive plate.

plank-grain block A block used for woodcuts where cutting is parallel to the grain.

planographic printing A term applied to lithography for printing from the flat. It is distinct from intaglio or relief printing.

plaster print An impression taken from incised plaster, or a print cast in plaster from an intaglio plate instead of being printed on paper.

plate mark In intaglio prints, the impression of the plate itself forced upon the paper by pressure of the etching press.

plug A wooden shape corresponding to the cut out area of a woodblock, used as a new surface for cutting or as a correction for miscutting.

pochoir A process for making multicolor prints and for coloring black and white prints using stencils and stencil brush.

progressive proofs A set of color proofs showing a first color, then a first and second color, and then a first, second, and third color, and so forth.

proof An impression taken at any stage in the making of a print that is not part of the edition.

pull To print; to transfer ink to paper.

pumice An abrasive used to polish lithographic stones.

rainbow printing The rolling of several colors simultaneously, usually in a continuous blend, onto a stone or plate from a single roller.

register marks The guides artist and printer use to correct registration; a variety of small marks placed diagonally opposite margins of the paper or in relation to the key block.

registration Correct relationship of succeeding colors to the impression of the first color printed; proper overlapping and overlaying of color.

relief printing Printing from a block or plate where the nonprinted areas have been cut away.

repoussage A technique for leveling the surface of a copper plate after repairs or alterations by hammering the back against a hard, flat material.

restrike A print made from a plate, stone, block, or stencil beyond the original edition. Usually restrikes are offered long after the original edition has become unavailable.

retroussage An intaglio technique in which cheesecloth is whipped over the surface of a wiped plate so that ink will spill over the incised lines.

reverse etching An intaglio plate surface inked and printed by woodcut techniques.

reverse image Showing as white lines and areas those that have been printed as black and showing previously white lines and areas as black.

rocker A tool for laying a mezzotint ground. Many-toothed and of steel, the tool is rocked across the plate many times in all directions to produce the characteristic burr.

roller A tool used for applying ink. For linocut and woodcut, the roller is usually of rubber in a metal frame. For lithography, the roller is usually covered in leather and double-handled like a rolling pin.

roll out The inking of a stone or plate.

roulette A tool used to make lines or areas of dots in a metal plate or ground. The roulette has a toothed wheel that revolves, making a track.

rubbing ink In lithography, ink from a cake applied with the fingers to obtain soft tones on the stone.

rub up In lithography, a method of making the drawing visible on the stone by sponging the stone with thin lithographic ink and then sponging it with a solution of gum arabic and water.

sandpaper aquatint An aquatint ground obtained by passing the conventionally grounded plate through the press with fine sandpaper placed face down on it.

salt aquatint An aquatint ground made by sprinkling salt on a thinly grounded plate, heating it to fix it, and dissolving the salt with water when the plate is cool.

scorper A scoop used in wood engraving. The tool has a rounded, beveled metal point.

scraper In intaglio, a steel tool used for removing burrs and for moderating other effects of etching or engraving. In lithography, a leather-covered blade that presses the paper against the inked stone or plate.

serigraphy Screenprinting considered as a fine arts process; screenprinting executed by the artist rather than by a printer.

silk screening A wooden frame stretched with a piece of silk or metal mesh.

slip sheet A paper placed between prints for their protection after drying.

smoking The technique for blackening transparent or light-colored etching ground by holding the plate face down with a hand vise or tongs over candle flame to coat the surface with soot, which gives the image more visibility when it is drawn through the ground.

snake slip A stick abrasive used to polish intaglio plates and clean the margins of lithographic stones.

soft ground A mixture of ground and grease that will not harden.

soft-ground etching An etching method that involves a ground that is about 50 percent tallow. Drawing paper is placed on the grounded plate; the artist draws on the paper in pencil, pressing hard. When the paper is lifted from the plate, it will pull away the ground beneath the drawing. The plate is then etched. The technique gives prints a soft graininess also characteristic of lithography.

squeegee A tool used for applying ink or paint in stencil printing. It has a wooden bar and a rubber blade to force ink or paint through the screen.

state A proof that shows a print in a particular stage of development.

stencil printing A process in which paint or ink is pressed through a silkscreen onto paper with a squeegee and in which nonprinted areas are blocked out.

stipple engraving A process suitable to engraving, etching, and wood engraving in which the image or areas of the image are made up of small dots or incisions. The stipple engraving is usually relief inked, the dots or flecks showing white.

strike off To print or pull an edition.

suite Prints related in theme or image and sometimes in technique, often issued in a portfolio with title page and colophon.

surface-rolled Inked for relief printing.

tack The stickiness of ink.

tap-out A test of ink color that shows variations in intensity. A finger is dipped in the ink and run along a piece of paper making a track of gradations.

tint tool A graver with a fine steel point used in creating tints or tones of very fine hatching or cross-hatching in wood or metal engraving.

transfer lithography A technique for transferring to stone or plate a drawing done on grained paper that will take lithographic crayon.

transfer paper In lithography, a paper that allows the image to be transferred from one stone or plate to others.

transparent base A substance that reduces the opacity of color without changing the hue.

trial proof An early proof often incorporating the artist's revisions.

tusche Grease in stick or liquid form, principally used for drawing in lithography.

tusche wash-out A technique in silkscreen and serigraphic printing where the drawing is done directly on the screen in tusche. Water soluble glue is spread over the entire screen with a squeegee. The screen is then washed with mineral spirits, dissolving the tusche and flushing its covering of glue. The resultant open areas are printed.

tympan A material placed between the scraper of the lithographic press and the paper to cushion the action.

typehigh Height corresponding to that used in letterpress printing.

underbitten A plate taken from the acid too soon for the desired effect.

vegetable print A print involving the use of inked vegetables such as potatoes.

washout In lithography, sponging the stone with turpentine before rolling it with ink.

wipe-on plate A light-sensitive plate for photo lithography.

wiping The process of removing ink from the unbitten surface of an intaglio plate, leaving ink only in the lines and areas to be printed. The plate is usually wiped with a ball of muslin or with the hand.

woodcut A relief print cut with knife, gouges, and chisels from a plank-grain woodblock.

wood engraving A relief print cut with a graver, tint tool, or scorper on an endgrain block usually of boxwood, maple, or fruit wood.

working proof A trial proof bearing artist's or printer's notes and corrections.

Index by medium

Each work is preceded by its catalogue number. When more than one printmaking technique has been used, the work is indexed under all mediums involved. For example, a work made with etching and relief is indexed under both etching and relief.

Index to lenders

All works not listed here were lent by the artists